Typography Workbook

ROCKPORT

© 2004 by Rockport Publishers
First paperback edition published 2006.

First published in the United States of America by
Rockport Publishers, Inc., a member of
Quayside Publishing Group
100 Cummings Center, Suite 406-L
Beverly, MA 01915-6101

Telephone: 978.282.9590
Fax: 978.282.2742
www.rockpub.com

Library of Congress Cataloging-in-Publication data available

ISBN-13: 978-1-59253-301-5
ISBN-10: 1-59253-301-9

Text and cover design | Timothy Samara

Printed in Singapore

A Real-World Guide to
Using Type in Graphic Design

Typography
Workbook

BEVERLY MASSACHUSETTS

ROCKPORT PUBLISHERS

Timothy Samara

contents

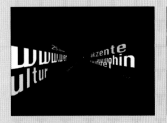 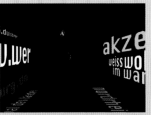

TYPOGRA IS

Type surrounds us at every moment of our waking hours—from the mundane line items on the bills we pay and the labels on our food to transcendent explosions of alphabetic experience in posters, on the Web, and on TV. We pass thousands of typographic messages every day, most of which we discard or fail to see at all.

Typography stands at the crossroad of the beautiful and the useful. Like a painting, it is something to look at and contemplate for its form. Unlike a painting, it is also something concretely functional since it is meant to be read. It's helpful to think about type as being like architecture—designing a house is ultimately useless if, in the end, the house falls down or fails to keep out the rain. Typography that cannot be read is no longer typography. But far from the banal gray texture that stark imperative would seem to dictate, typography as a communicative form holds the potential for deeply meaningful and emotional expression.

Designing with type means understanding the inescapable functionality of its nature: a functionality defined not by trends or philosophy, but by the simple and powerful mechanism of human perception.

Over thousands of years, humanity discovered a way to transmit its thoughts to each other—language—such that all its members, now and in the future, understand what is being said. Language is a function of the group; as individual as we would like to be, we rely on communal understanding as the foundation of the words we speak. When that understanding is codified for visual transmission, we further rely on shared assumptions about those visual codes—letterforms—and on the limitations of our eyes and brains to interpret them. The rules that govern typographic design are not the dogmatic enslavement of creativity that some would have us believe. They are simply objective descriptions of how the human eye sees form, and what

the human brain does with that information upon seeing it. Like it or not, for example, a darker form will appear spatially in front of a lighter form. Our view of the outside world is genetically hardwired in us. Working effectively with typography depends on mastering ways to manipulate perception objectively on its own terms, and typographic designers can explore these visual codes to expand the range of human perception.

Like all things functional, typography is created at varying levels of quality. How do we estimate the quality of something that seems ultimately subjective? The metaphor of architecture or, better yet, a car, is useful in looking for an answer. We will arrive at our destination whether we drive a cheap get-around or a luxury sports sedan, but the luxury car will get us there faster and in greater comfort; the

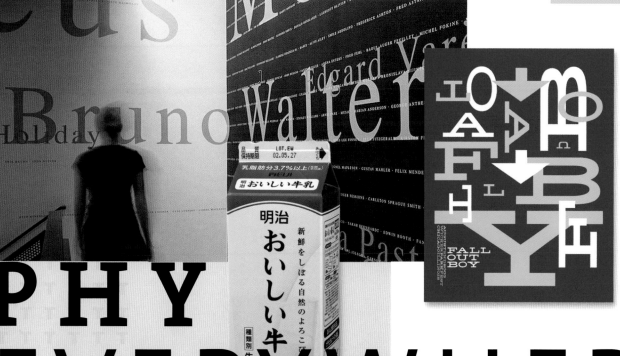

PHY
EVERYWHERE.

materials used and the engineering are clearly of greater value. Good typography is different from bad typography in much the same way—aside from being basically more functional and expressive, it offers a greater level of sensitivity in its craft, from its overall composition down to the spacing of its punctuation. Good typography is easy to use, beautiful to look at, and pays attention to the way its forms are arranged to achieve these ends. Another helpful metaphor is the comparison of fast food to three-star culinary excellence; both are tasty and filling, but the latter is likely to be more nutritious and richer in experience.

There are many books about typography. This one is a guide for navigating through the mass of detail that makes up typographic form—the shapes of letters, the spaces between words, ligatures, rags, and grids—and bringing those pieces together to create a visual whole that is far more than the sum of mere parts. It differs from other books on the

subject by focusing to a great degree on the relationship—optical and conceptual—between the crafting of typographic form and the meaning that form carries. Novices can follow a progression from basics to experimentation and then practical application; working designers can likewise reacquaint themselves with familiar ideas and also find new ways of working. The goal of the typographic designer, whether new or seasoned, will be the same: discovering how the word and the image become one.

Left to right:

Animation stills
Qwer Design | Germany

Web page
Rocholl Projects | Germany

Stairway mural
Poulin+Morris | New York

Milk container
Taku Satoh Design Office | Japan

Poster
Stereotype Design | USA

Book jacket
Gary Fogelson, Pratt Institute
(Scott Santoro, Instructor) | USA

Talking Type |

A Discussion with Philippe Apeloig

Philippe Apeloig is a graphic designer whose extraordinary typographic sensibility is internationally recognized. Fusing a Modernist approach that necessitates clarity and function with an abstract, three-dimensional, and often kinetic or pictorial space, Apeloig's work in branding and posters marks him not only as an innovator, but also one who knows his craft inside and out. Within the luminous, textural, and painterly typography of his projects, a core understanding of how type works—and why—is evident. With this solid knowledge of typographic form and function, its optical and perceptual capabilities—as well as its limitations—Apeloig is able to manipulate type in astounding ways without sacrificing its informational utility.

Apeloig heads his own studio in Paris, France. Upon graduating from the École Supérieure des Arts Appliqués, he interned with Total Design in Amsterdam and April Greiman in Los Angeles, before returning to Paris as a designer, then art director, for the Musée d'Orsay (1985–1987). During the 1990s, he taught typography at ENSAD (the École Nationale Supérieur des Arts Décoratifs); in 1996 he became a consultant to the Louvre Museum, and its art director in 2001. From 2000 to 2002, he was curator of the Herb Lubalin Study Center for Typography and Design at New York City's Cooper Union—where he was also full-time faculty—and is a member of AGI (the Alliance Graphique Internationale).

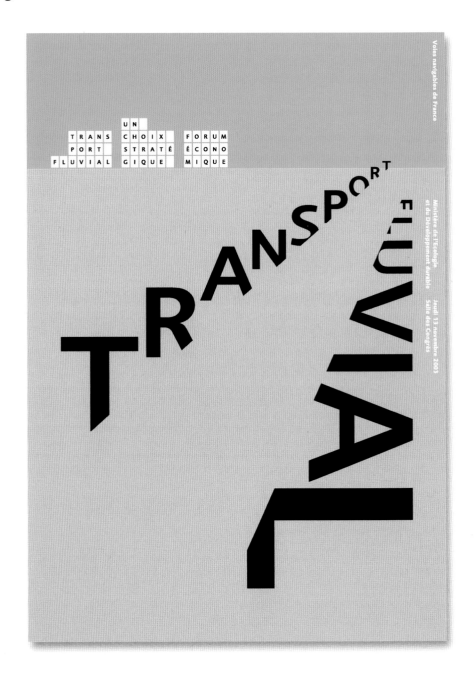

Transport Fluvial *poster*
Philippe Apeloig | France

Many designers are fascinated by typography. What inspired your interest? Why is typography such a profound component of your work, as opposed to other kinds of image and symbol? Typography is a perfect balance between shapes, images, and significations. I am fascinated by the way letters can work in unlimited combinations to create form and meaning. The playfulness and power of designing with letters to give readers an unexpected, conceptual dimension is also very important to me. I first became interested in typography when I learned about calligraphy in art school. Later, in Holland, while working at Total Design, I discovered Dutch modern typography, which echoed my earlier fascination for the abstraction of type. I still remember the strong impression I had as a student when I first saw *The Black Square* by Malevitch of the Suprematist Movement and Mondrian's paintings of the De Stijl period. It was a great moment of enlightenment. The simple shapes, organized with a mastery of light and geometric dynamism, had a powerful effect on me, something that I had never felt before. The discovery of modern typography opened up a whole new world for me.

I have little interest in illustration, which lacks a kind of transcendental quality. It is too literal. I find typography more straightforward, conceptual, and appealing, with its strict geometric vocabulary. There is a bridge between typographic design and fine art, especially since typography possesses a complex subtlety. The idea, the method, and the honesty in expression are central to a designer who works with type. While following these principles and realizing the goal of communication, I try to go beyond pure functionalism of type in my work to create something that is fresh and liberating.

Describe the kind of training in typography you had— what kinds of things did you learn? I learned about calligraphy even before I touched upon typography in an art school in Paris, the École Supérieure des Arts Appliqués. I was trained in the traditional way; there was no computer at that time. We designed all the letters by hand. Later, we learned about the composition of the letters: serifs, sans serifs, lowercase and uppercase, bold and light weights, among other components. We learned to copy the letter shapes and to observethe design of their countershapes. Our teacher taught ushow to see the white spaces inside the letters and between the letters. There are so many issues to focus on in typography: its technical, historical, stylistic, and semantic dimensions must be taken into account. The curriculum at the school was very well structured, from the basics to the more complex. Through my experience at school, I learned to be open and daring in the exploration with type. After all, it is a way of expressing my ideas by using visual elements. Later, I was introduced to the computer. This way of working with extraordinary speed and versatility really expanded my horizons. There is a long history behind typography. And this history is enriched everyday by new technological advances. Now, everything is possible. However, while this new technology creates a sense of freshness and freedom in design, I have always found that the most remarkable design is also the simplest.

Describe your approach to typography in general. Typography is my starting point for design. Every concept is invented with type: the selection of a font, the shape of the letters, and of course, the type's semantic dimensions. I see type as abstract shapes carrying a lot of meaning. It must first attract the attention of the viewer and then communicate. Each person uses and transforms type in his own way, and it shows the designer's personality— it is individual and unique.

A designer's specific typographic concerns vary among projects. What is important to you (typographically) when you design a poster? Typography is central to the design of a poster. Both the form and function of the type must come together in a poster. The type must be lively, readable, expressive, visually arresting, and never neutral or merely decorative. It must also relate to context—type in a poster, for example, must also be bold and striking. Posters exist in public places over which designers have no control. They are looked at first from afar. The experience of looking at a poster is communal, not personal the way books are experienced. Posters live in the streets as pieces of art that can speak and interact with their audience.

Describe your thought process for the poster entitled *Transport Fluvial (River Transport).* *Transport Fluvial* was commissioned by the company Voies Navigables de France (Navigable Roads of France). It was designed to promote a conference about river transportation and its economic development. This mode of transport is still very much useful today despite its fierce competition with air, railway, and road transportation. I looked at ports along rivers. The flat landscape surrounding the river is expansive, and the river is pregnant with possibilities. I wanted my poster to evoke a feeling of being immersed in the landscape without the use of decorative or figurative elements. At the same time, the economic challenge and the implications of the redevelopment of the river transportation should be present throughout the poster. I strove to achieve this goal by using the most minimal elements, with no images, illustrations, or boats. This sense of space and ambiance is evoked by the perspective effect of the title text, which becomes smaller and smaller as it approaches the horizon line. The subtitle is found on the horizon, inside boxes that are evocative of containers waiting to be loaded. I chose to use black for the text and soft colors for the background to create a stark tension between the two, which also points to the powerful impact of modernity on the environment.

Whose typographic design has influenced you the most? Russian Avant-Garde, Dutch De Stijl, and Modernist design have influenced me for decades. I am also very moved by A. M. Cassandre's [a French designer active in the 1920s and 1930s] creative use of typography in many of his posters. I also find influences in architecture. The way architects deal with three-dimensional space is similar to the way graphic designers deal with the two-dimensional surface of a printed page.

How do you feel about rules in typography? Are there any that should never be broken? The readability of type should always be the foremost concern, even if it is pushed to the very edge of being legible. To me, creating a poster that is impossible to read or be understood is a failure on the part of the designer.

TYPOGRAPHY
FUNDAMENTA

Type Mechanics

FUNDAMENTALS

The Visual Tool Kit

Letterform Basics
The Foundation of Typographic Design

Typography in Western culture happens simultaneously on two visual levels. The macro level of overall composition guides our eyes around a format, and the micro level of minute details provides the basis for how we perceive the big picture. The individual forms and interaction of alphabetic characters is the key to understanding and working with typography at the macro level.

The Roman alphabet used in Western typography can be understood as a system of line drawings. The drawing of individual letters is archetypal; each form has been steadily codified and passed along over the generations. The archetypal form of a particular letter is what distinguishes it from other letters and makes it recognizable. Letterforms are iconic, so ingrained into Western consciousness that their visual form holds sway over the perception of other images—many objects remind us of letters. This proposition is profound, since the letters of our alphabet were originally derived from pictographic drawings—like the hieroglyphs of the ancient Egyptians—representing real-world objects. Western culture has evolved such that the image of the letter is preeminent over its pictorial origin. Its visual qualities drive modern typography at every level.

E F H I J L T

A K M N V W X Y Z

C D O S P U Q

B G R

The essential structure of letters has remained unchanged for 2,000 years.

Left, the basic strokes of the capital, or uppercase, letters are shown in their simplest form.

Above, the modern archetypes of Roman forms. Each grouping of letters is related by structure.

Archetypal Structure

Letters are composed of lines that have continuously evolved, but have remained relatively unchanged for 2,000 years. The twenty-six letters in the Roman alphabet are interrelated, a closed system of lines and spaces that forms a code for our understanding of typography. The **capital,** or **uppercase,** letters are the oldest forms in the alphabet, and the most simply drawn. Capital letters are direct descendants of those used by the Romans for imperial inscription. They are the forms that were first standardized from the legacy of the Greeks and Phoenicians after Rome conquered most of Europe and the Middle East in the first and second centuries (see *Alphabet Variation,* page 22). The capital letters are made up of a variety of linear forms: straight vertical and horizontal lines, diagonal lines, and circular lines whose inherent qualities are simplicity and differentiation. Drawn with a minimum of strokes, each form is as different as possible from all the others. Some forms—**E, F, H, I, J, L, T,**

for example—are related visually and historically, but while they are similar—being composed only of horizontal and vertical strokes—they are different enough to be easily distinguished. The same holds true for letters sharing another structural variation, the diagonal: **A, K, M, N, V, W, X, Y, Z.** A third group of letters is drawn with curved strokes, sometimes in combination with straight ones: **C, D, O, P, S, Q, U.** A fourth category mixes curved, straight and diagonal strokes—**B, G, R.** The small letters (also called **miniscules** or **lowercase**) were developed much later, between the seventh and ninth centuries, and assimilated into written language within a few hundred years. Their drawing is more complex and characterized by rounded strokes. The lowercase letters show much greater variety and visual distinction.

Letterform Anatomy

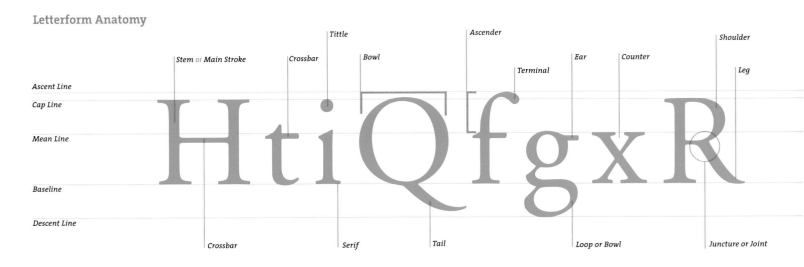

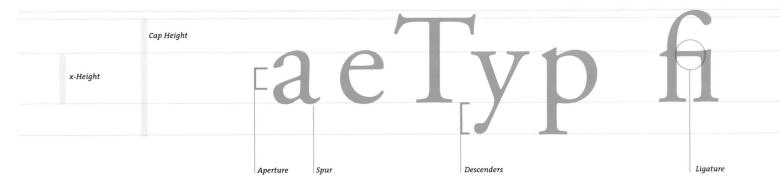

The Anatomy of Letterforms

The evidence of letterforms' development through drawing and, later, inscription into stone is a factor in their modern construction. Modulation within the strokes—the appearance of thicks and thins—and the shapes of the strokes' ends, or terminals, are holdovers from their original drawing by brush or flat reed pen, as is the internal distribution of thins and thicks. The right-diagonal of a letter **A,** for example (or **V** or **X**) tends to be drawn more boldly, even in modern typefaces, because the angle of the brush (or reed pen) held by the ancient scribes who drew them determined how thick the strokes would be—the brush presented its thick or thin edges to the paper in different ways depending on the angle and direction of the stroke.

In older typefaces, the terminals, especially in the lowercase letters, are clearly marked by this drawing origin. A bulbous flare at the entry stroke of a lowercase **a,** for example, is the result of a fully inked brush being compressed against the page. These details of construction have morphed over time at the hands of thousands of type designers to create an amalgam of characteristics that constitute the essential anatomy of letterforms.

The letters of all alphabets, whether classical or modern, display the same basic structural characteristics and adhere to similar conventions in drawing and detail.

The specific proportions, contrast of stroke thickness, and drawing details may change, but the essential architectural framework of their structure always remains the same.

Serif Structures

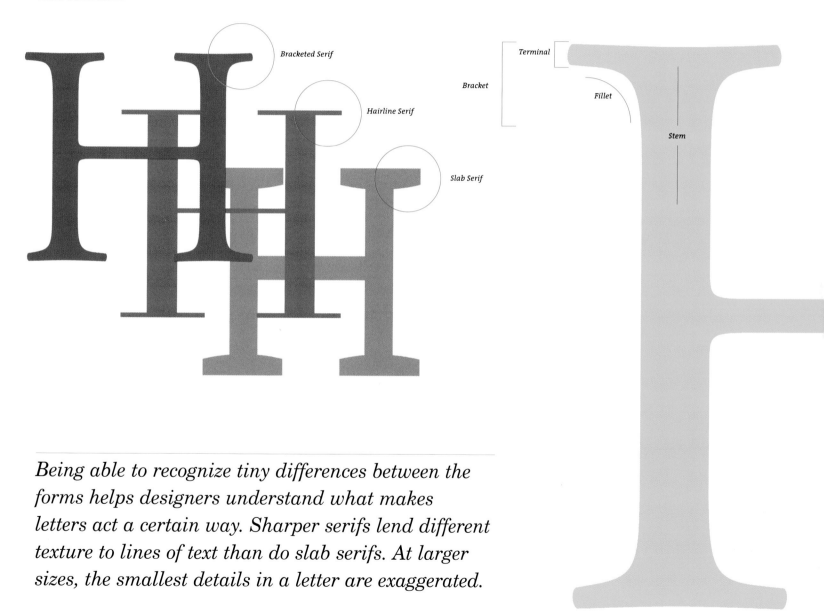

Bracketed Serif

Hairline Serif

Slab Serif

Terminal

Bracket

Fillet

Stem

Being able to recognize tiny differences between the forms helps designers understand what makes letters act a certain way. Sharper serifs lend different texture to lines of text than do slab serifs. At larger sizes, the smallest details in a letter are exaggerated.

Optical Compensation for Form

The goal of a type designer in creating a character set is to impart a uniform texture and optical gray value to the letters, so that when set together, the letters create an undisturbed line that won't distract the eye through changes in color. To read efficiently, the fewer stops the eye encounters, the better. Because letters are drawn using inherently different-shaped lines, the visual interaction of those lines is of great concern to the type designer. Horizontal and vertical lines of the same weight appear to be different weights because of how our eyes and brains are conditioned to understand such forms. A horizontal line appears heavier, being understood by the eye and brain to sink and stretch under the pull of gravity. To correct this, the horizontal strokes of letters are drawn slightly thinner than their vertical counterparts. Similarly, rounded strokes appear thinner than either horizontal or vertical strokes, and so are drawn more boldly. In addition, round forms appear to contract: set at the same mathematically measured height as an **M,** a letter **O** will appear

smaller, creating a visual hole in a line of text. The same is true for every curved form, whether an **S, C, Q, U,** or **G.** To make the curved forms appear the same height as the square forms, the type designer must extend the outer edge of the form slightly above the cap line and below the baseline. This difference in height at a text-reading size is measurably invisible, but the eye can see it nonetheless. Every letter in the alphabet is drawn with these optical compensations.

Correcting for Optical Disparities

Minute changes in character height, stroke width, and shape must be made to each letter so that they work together to create a uniform gray value. At a standard reading size, the eye perceives them to be all the same weight, height, and width without pausing. When the same sentence is enlarged, the optical corrections become apparent. The curved forms extend higher and lower than the square forms. The widths of an **E** and **F** are clearly very different,

although they appear the same at reading size. The diagonal strokes are canted at different angles. The angled joints of the **N** extend above and below the cap height. Even the lengths of the horizontal strokes within the **E** are adjusted. If the middle stroke of the **E** were the same length as the upper and lower strokes, for example, it would appear to stick out.

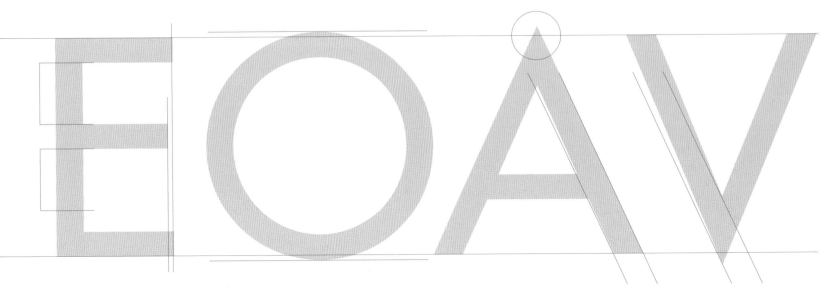

The seemingly simple structure of an uppercase E reveals minute optical corrections. The middle cross bar is always shorter than the others. The top counter is smaller than the bottom.

Curved forms appear to contract, and must be drawn to extend above the cap line and below the baseline to appear optically the same height as squared forms.

Diagonal forms also appear to contract and are adjusted in height accordingly. The interior and exterior angles of the A's right stroke appear the same, but are actually different.

The diagonal strokes of the A and V are drawn with different slopes to adjust for different lateral emphasis due to their respective directions.

ABCDEFGHIJKLMNOPQRSTUVWXYZ
abcdefghijklmnopqrstuvwxyz
1234567890.,:;?!...@#$%^&*ß()[]{}/
£¢∞§œ†¥¨ˆøπ"'«åß∂f©˙˚æΩ≈ç√∫˜
µ≤≥÷‹›fifl‡°·‚—±Œ„´‰ˇÁ¨ˆØ∏"'
»ÅÍÎÏ˝ÓÔÒÚÆ¸¸Ç◊ı˜Â¯˘¿

ABCDEFGHIJKLMNOPQRSTUVWXYZ
abcdefghijklmnopqrstuvwxyz
1234567890.,:;?!...@#$%^&*ß()[]{}/
£¢∞§œ†¥¨ˆøπ"'«åß∂f©˙˚æΩ≈ç√∫˜
µ≤≥÷‹›fifl‡°·‚—±Œ„´‰ˇÁ¨ˆØ∏"'
»ÅÍÎÏ˝ÓÔÒÚÆ¸¸Ç◊ı˜Â¯˘¿

ABCDEFGHIJKLMNOPQRSTUVWXYZ
abcdefghijklmnopqrstuvwxyz
*1234567890.,:;?!...@#$%^&*ß()[]{}/*
£¢∞§œ†¥¨ˆøπ"'«åß∂f©˙˚æΩ≈ç√∫˜
µ≤≥÷‹›fifl‡°·‚—±Œ„´‰ˇÁ¨ˆØ∏"'
»ÅÍÎÏ˝ÓÔÒÚÆ¸¸Ç◊ı˜Â¯˘¿

Character Sets and Type Families

The complete character set of an alphabet—its total component parts—may consist of upwards of 250 characters, including the upper- and lowercase letters, the numerals (numbers), punctuation, diacritical marks, and mathematical symbols. Together, this character set, distinguished from others by the specific qualities of its drawing, is called a typeface. A group of typefaces that are drawn the same way, but are different from each other in overall thickness, is called a type family.

It's in the Details
Pay careful attention to the shapes of characters within a given typeface. At large sizes, it may be necessary to substitute a character from another face so that its details look better in the layout.

The complete character set for the Rotis Sans typeface, designed by Otl Aicher of Germany (1989). In addition to the letters themselves, punctuation marks, accent marks, and symbols have all been drawn using the same visual logic so that these secondary characters remain stylistically consistent. The roman and bold weight character sets, along with the slanted italic variations, comprise the Rotis type family.

Typeface Classification

The individual characteristics of a typeface's drawing are what distinguish it from other typefaces. These characteristics are related to the historical development of typefaces, and our sense of a typeface's style is sometimes colored by this historicity. Classifying type helps designers grasp the subtle differences among styles and further helps them to select an appropriate typeface for a particular project; sometimes the historical or cultural context of a particular style will add relevant communication to a typographic design.

Classification is by no means easy, however, especially as our typographic tradition becomes increasingly self-referential and incorporates historical formal ideas into modern ones. The typeface Optima, for example, drawn in 1958 by the German designer Hermann Zapf (b. 1918, Nuremburg), is a modern sans serif face sharing characteristics associated with oldstyle serif types: contrast in the stroke weights, modulation of weight within major strokes, an oblique axis, and a bowl-formed lowercase **g.** Type designers have traditionally used older forms as a basis for exploration, and so even in earlier centuries, classifying a typeface was difficult. The historical development of type is tied very directly to the evolution of technology used to make and print it. From early Roman times to the fifteenth century, type was drawn by hand, either with a brush, a flat reed pen, or a chisel. These archaic methods influenced the aesthetic of older typefaces. In the mid-1500s, casting letters in lead allowed for a new precision in form. From that point forward, the evolution of typefaces moved away from those inspired by brush and stone carving toward a more rational aesthetic and typefaces that were more finely drawn and technically demanding.

Categories of Type Classification

The progression from archaic to modern and then sans serif faces becomes clear in comparison as the hand-drawn influence steadily disappears and the assertion of a rational aesthetic begins to dominate.

Archaic

Roman Inscription

QVAE COELI

Uncial [Majuscule]

ANSEMIS

Miniscule

fidem uram

Oldstyle

de rigeur, c'est la

Transitional

in the rules of

Modern

Palazzo del Giglio

Sans Serif

utility and beauty

Slab Serif

eccentricities of form

Graphic

globalization jitters

Archaic

Characterized by a relatively consistent stroke weight, Imperial Roman characters form the basis for type design over subsequent millennia. In these forms, the essential structure and proportions of letters are codified. The origin of the serif, the small "feet" at the terminals of the strokes, is the chisel, used by stone carvers to finish the dirty ends of the strokes, and emulated by scribes drawing their letters on paper. The scribes of Charlemagne (b. 742, d. 814) mainstreamed a secondary set of forms—the minuscules—derived from poorly copied Christian manuscripts. These less formal letters were eventually assimilated into the modern character set as the lowercase letters.

Oldstyle

Renaissance type designers looked to the archaic forms for inspiration but refined their structure and expression into the kinds of typefaces we call classical, or oldstyle. They are characterized by Roman proportion, organic contrast of weight in the strokes—from brush or pen drawing—an angled, or oblique, axis in the curved forms; and a small x-height defining the lowercase letters. The terminals are pear-shaped and the apertures in the lowercase letters are small.

Transitional

This term describes faces that evolved out of oldstyle types but show a marked change in their structure. They appeared in England in the eighteenth century as type drawing began to move away from the written model and toward a more rational approach. John Baskerville (English, b. 1706, d. 1775) introduced one of the first such faces, in which the stroke contrast is remarkably less derivative of the drawing tool: rationally applied and of greater variety, so that the rhythm of the strokes is greatly pronounced. The x-height of the lowercase is noticeably larger; the axis, while still oblique, is more upright; and the serifs become sharper and more defined, their brackets curving more quickly into the stems and producing a sharper angle.

Modern

In the late eighteenth century, reference to the hand-drawn form was diminished, first by Giambattista Bodoni (b. 1740, d. 1813) in Italy and then by Firmin Didot (b. 1764, d. 1836)—son of François Didot, founder of the Didot Foundry. The drawing of a modern typeface, although dependent on its derivation from brush or broad-nibbed pen, is a radical departure. The contrast in the strokes is extreme, with the thin strokes reduced to hairlines and the thick strokes made bolder; the axis of the curved forms is completely upright; and the brackets connecting the serifs to the stems have been removed, creating a stark and elegant juncture. The serifs are completely rounded to correspond to the logic of the stroke contrast and the circular structure of the curved letters.

Sans Serif

These typefaces are an outgrowth of "display types" of the nineteenth century—aggressively stylized faces designed for the Industrial Revolution's new industry: advertising. They were designed to be as bizarre as possible or bold and simplified, stripped of nonessential details. Designers began to explore them as a new form; in the twentieth century they became widely used. Sans serif types are characterized by a lack of serifs (sans means "without" in French): the terminals end sharply without adornment. Their stroke weight is uniform, and their axis is completely upright. Sans serif types set tighter in text and are legible at small sizes; during the past 50 years, they have become common as text faces for extended reading.

Slab Serif

Another outgrowth of display types, the slab serif (or Egyptian) face is a hybrid form. Mixing the bold, solid presentation of a sans serif and the distinctive horizontal stress of a serif face, the slab serif is characterized by an overall consistency in stroke weight. The serifs are the same weight as the stems, hence "slabs;" the body of the slab serif is often wider than what is considered normal. These faces were sometimes referred to as Egyptian because of their exotic, foreign qualities.

Graphic

These typefaces are the decorative, experimental children of the display types. Their visual qualities are expressive but not conducive to reading in a long text. This category of faces includes specimens like script faces, fancy and complex faces inspired by handwriting, and idiosyncratic faces that are conceptually interesting or illustrative.

A direct, modern asymmetrical composition is enhanced by the designer's selection of an oldstyle face, bridging past and present in one gesture.
Philippe Apeloig | France

Alphabet Variation

The construction of letterforms in the Roman alphabet remains largely unchanged after 2,000 years. As readers, we rely on the consistent forms of our letters to understand them. Their design is a syntax of line shapes, a visual grammar that allows us to know that we're looking at a **V** rather than a **U.** Too much deviation from the master shape, and we lose our sense of the letter.

And yet, there are thousands of different typefaces that we're able to read with ease. Our alphabet's letterforms are strong, simple structures, and this makes them very flexible for manipulation. A typeface is a closed system of stylistic exploration; the essential shapes of each letter are modified according to the same criteria in one typeface, and modified by other criteria in another. Each typeface has its own internal logic that, while subordinate to the essential forms of its letters, provides an unlimited range of expressive variation.

There are five aspects of form that distinguish one typeface from another and that create the contrasts in rhythm and feeling that typographers depend on to add dimension to text and composition.

Case

Selected letters in uppercase and lowercase forms

Aa Gg Mm

Each letter in the alphabet has two forms: an **uppercase,** or **capital,** form and a **lowercase** form. The capitals are the big letters—older, official forms the Romans used for imperial inscriptions. They are considered more formal than lowercase letters and serve several functions, from starting sentences to creating acronyms to marking proper nouns. The lowercase letters are a development of the Middle Ages (476–1200 AD), and are generally attributed to the work of Charlemagne's scribes (see *Classification,* page 20). Lowercase letters are more varied in shape and are distinguished from uppercase letters by ascenders and descenders; their differentiation allows them to be recognized more quickly. The uniformity of height and width in the uppercase tends to require more space between the letters to allow each to be recognized individually.

Weight

Light Medium Bold Black Stroke con

A A **A A** A

The overall thickness of the strokes, in relation to their height, is called their weight. A **regular-weight,** capital letter I has a thickness equal to one seventh of its height. Variation in weight within a typeface is what determines the basic family. Standard weights within a family often include **light, medium (or regular), bold,** and **black** or **heavy** weights. A designer may choose to use a variety of weights within a text or an overall composition to enhance rhythm or emphasize particular words or phrases. The weights of the strokes within the individual letterforms in a typeface may also change. This contrast in stroke weights is a clue to their origins in brush and pen drawing. These tools, held at a specific angle, produce strokes of differing thickness depending on the direction the stroke is drawn: the upward-left diagonal of a capital A is narrow; the right-downward stroke is always heavier (see above, far right).

*This logo incorporates a variety of letterform styles to communicate specific aspects of the client, a not-for-profit AIDS awareness organization: health, optimism, philanthropy, and education (the client's mission). The designer has relied on culturally perceived conceptual qualities intrinsic to the typefaces to help transmit ideas, and their formal variety adds depth and interest to the cluster of forms. The **H** is a robust, heavy sans serif; the **O** has been redrawn so that its counterform transforms it into a sun; the **P** is a classic Roman capital that implies money; the **E** is a lower-case black italic whose round forms and smiling aperture allude to learning.*
Timothy Samara | New York

The forms in this logo were exaggerated to create a custom typeface for the client. The designer focused on the aspects of width and stroke shape to differentiate these letterforms from those of a standard text face while retaining their legibility.
Niklaus Troxler | Switzerland

Posture

AA GG MM

The posture of a letterform is its vertical orientation to the baseline. Letters that stand upright, their center axis 90° to the baseline, are called **roman.** Letters that slant are called **italic.** A true italic letter has been drawn at an angle **12 to 15° less upright** than its roman counterpart. Italic characters began to appear during the Renaissance, when scholars became interested in type that was more organic than roman forms. They based their slanted letters on handwriting. In general, italic letters read with greater stress than roman letters. They serve a number of functions in text, from adding emphasis to helping distinguish one type of information from another.

Width

Regular *Condensed*

AGM AGM

How wide the letterforms in a typeface are in relation to their height is referred to as their **width** or **extension.** Regular width is based on a square dimension: a capital letter **M** of regular width is optically as wide as it is tall. The width of other letters in the same typeface is derived from this initial ratio, although they themselves may not be as wide as the letter **M.** A typeface in which the letterforms are narrower than regular is referred to as **condensed** or **compressed;** a face that is wider than regular is referred to as **extended** or **expanded.** Like posture and weight, varying the width of letterforms lends a different cadence to the reading; the rhythm of the text is changed by condensing or expanding type.

Style

Serif *Sans Serif*

AGM AGM

Style is a broad term that refers to several aspects of a typeface. First, style can be divided into two basic categories: **serif** and **sans serif.** Second, style refers to the typeface's historical classification and the visual idiosyncrasies related to its historical context. Third, style refers to the specific form variations that the designer has imposed on the letters (i.e., its decorative qualities). In this sense, the style of a typeface is referred to as **neutral** (not particularly decorative or manipulated—sticking close to the basic forms) or **stylized** (decorative or idiosyncratic manipulation of the forms).

Typeface Attributes and Their Effect on Text

The choice of typeface style and its setting profoundly affects the legibility and visual rhythm of type. Knowing the implications for text that is set all uppercase or lowercase, or including a bold weight or an extended width within text, allows the designer to make decisions that will facilitate reading, as well as enhance compositions.

Case and Legibility

Uppercase letters share an optically uniform width, and their shapes are similar, compared to the lowercase. Further, the uppercase forms tend to be closed, while the lowercase are more open on both sides. This means that when set together, uppercase letters produce a visual rectangle with few differentiating details. In terms of legibility, words set all uppercase are less recognizable, because their overall shape interferes with the recognizability of individual letters. In reading, the eye makes quick snapshots of word groups. The less defined the individual forms are in a sequence, the harder it is to understand what forms have been read. Settings in uppercase, therefore, must be spaced more loosely than normal to permit the eye to recognize each character. Uppercase setting is not conducive to comfortably reading extended texts, and is often reserved for small groups of words, such as titles or subheads.

The lowercase letters are greatly varied in their shapes. The variety of curves, loops, ascenders, and descenders provides a wealth of clues for the eye and brain. In grabbing a snapshot of a several words, the eye transmits the exterior shape of the configuration to the brain first and a sense of the individual letters second. Very often, the brain doesn't even need to recognize individual letters because it is able to interpret them from the exterior shape. For this reason, extended texts are best set lowercase, with the uppercase reserved for the beginnings of sentences and the initials of proper nouns. In English, this structure results from its evolution from German, in which all nouns are capitalized.

Functions of Weight and Posture

One asset to the designer is the use of bold weights and italic faces in concert with regular and roman faces within a family. Weight and posture changes express changes in rhythm or cadence, sometimes called stress or emphasis. The use of weight and posture changes within type is an invaluable tool for enhancing the "voice" of a text, similar to how oral communication relies on emphasis and cadence to convey subtle shades of meaning. A word or phrase set in a heavier weight from surrounding text is interpreted as being louder, more aggressive, or of greater importance. Similarly, lighter-weight text is perceived as

more quiet, more reserved, less important, or as supporting a heavier text. Similarly, posture changes the rhythmic alternation of strokes and counters within a text. Slanted type is often perceived as reading faster or having a more intense cadence than roman text around it. Italics are usually used to provide emphasis to a phrase; they are also used to distinguish titles in running text as a way of reserving quotation marks for their official use—distinguishing spoken phrases. Both heavier weights of text and italics require spacing correction. Bold and black types have smaller counterforms because of their thicker strokes, and can withstand a slightly tighter setting to keep their rhythm consistent in sequence. Italics tend to appear crowded together if set with the same spacing as the corresponding roman, and so need a bit more space to maintain optimal rhythm. As minute as a change in weight or posture is, it creates significant alteration in gray value, introducing fixation points that stop the eye and demand attention. Because of this effect, changes in weight and posture are extremely effective in helping to create a sense of hierarchy among text elements in a format. Hierarchy is explored in depth in the following section, Form and Function (pages 44–81).

TYPOGRAPHY

Typography

A word set all in uppercase and then again in lowercase. The word set in lowercase offers a distinctive exterior shape, improving reading efficiency and understanding.

TYPOGRAPHY

TYPOGRAPHY

Adding space between the letters in the uppercase setting allows the eye to interpret the letters individually by giving their specific shapes enough space to be recognized.

uniform uniform
uniform uniform
uniform uniform

pentameter
pentameter
pentameter

Optical correction for weight and width within a type family. The letters in a bold-weight face must appear to be the same width as those in the regular weight; consequently, they are drawn wider as their weight increases. The letters in an extended face must appear the same weight as the corresponding regular-width face, and so are drawn heavier. Again, these minute details are visible only when the letters are increased in size for comparison.

Above, the cadence of italic and bold type, compared to regular posture and weight. The even alternation of stroke and counter is continued in the bold weight, but its increased darkness calls attention to the individual letters. The italic, on the other hand, maintains the same color but appears to speed up.

The tremendous power of slight changes in weight is evident in this minimal identity (below). The bold words advance into the foreground and are considerably darker than the regular-weight text that follows them. In the context of the logotype, the bold creates an emphasis on the initial word, as well as separates the two words without need for a wordspace.

Taku Satoh Design Office | Japan

Text Width and Tempo

Changes in the width of letters in a text setting can alter cadence or tempo. Extended faces are often perceived as reading more slowly because of the relationship between our linear sense of time and the linear sequence of reading. Text is often perceived to be taking place over time; this is especially true of dialogue, in which words of a quotation seem to happen as they are being read. As we read, our internal rhythm of digesting the words becomes congruent with the type's visual cadence; when that cadence is altered, we experience a change in time. Words set in an extended typeface seem to get stretched out in time. Conversely, words set in a condensed face stress the verticals and take up less linear space—the sense of time decreases, and we perceive these words at a faster tempo. The width of letters plays a role in the drawing of bold weights. Whether regular width or extended, the bold version of a face must be widened so that it appears to be the same width as the regular weight. This is simply another example of optical compensation. Similarly, an extended typeface must be drawn with slightly heavier strokes so that it appears the same weight as its regular-width counterpart; condensed faces must be drawn slightly lighter or they will be perceived as bold.

VILLA FRESCA 201, 2-30-22 Jingumae, Shibuya-ku, Tokyo 150-0001, Japan

SEEKBASIS

SEEKBASIS

The Optics of Spacing
Form and Counterform within Text

Every typeface has a distinct rhythm of strokes and spaces. This relationship between form and counterform defines the optimal spacing of that particular typeface and, therefore, of the overall spacing between words and lines of type, and among paragraphs.

The spacing of letters in words, sentences, and paragraphs is vital to create a uniform gray value for minimal reader distraction. Looking at letters set together as a word offers a clue to how they should be spaced in that particular typeface and size. Creating a consistent gray value in text depends on setting the letters so that there is even alternation of solid and void—within and between the letters. A series of letters that are set too tightly, so that the counterforms within the letters are optically bigger than those between letters, creates noticeable dark spots in the line: the exterior strokes of the letters bond to each other visually where they come together. At the other extreme, letters that are set too loosely become singular elements, divorced from the line and recognizable as individual forms, making the appraisal of words difficult. Evenly set sequences of letters show a consistent, rhythmic alternation of black and white—form and counterform repeating at the same rate from left to right.

The primary difficulty in achieving evenly spaced type is that the letters are of different densities. Some letters are lighter or darker than others. Added to this phenomenon are the directional thrusts of different strokes and the varied sizes and shapes of the counterforms. Some are very open, some are closed, and some are decidedly uneven in relation to the distribution of strokes in a given letter. To correct for these disparities, digital typefaces are programmed to add and subtract space from between different pairs of letters depending on what the combinations of letters are. These sets of letters, called kerning pairs, provide for most circumstances of letterform combination, but not all. Invariably, a designer will need to correct unusual spacing that the computer's software is unable to address.

The alternation of strokes and counterforms creates a distinctive optical rhythm in a given typeface. The pace and density of an alphabet's strokes is a clue to optimally spacing them in text.

Here, two typefaces reveal intrinsically different rhythmic alternation between their strokes and counters, affecting the space between letters. The serif, above, sets more loosely; the similarly sized condensed sans serif sets more tightly.

words

words

words

words

words

words

words

words

words

words

words

words

Mathematically uniform spacing

Optically uniform spacing

Optimal spacing (above) and tight spacing (below)

The study above shows optical spacing for the Univers (top) and Garamond (bottom) regular weights, compared to mathematically spaced or overly tight or loose spacing.

The optimally spaced lines show consistent rhythmic alternation between dark (the strokes) and light (the counterforms), both within characters and between them. Dark spots are evident in the examples spaced too tightly, where the strokes are closer together between letters than within them.

A designer must be conscious of spacing problems that may occur in text, especially at larger sizes.

Tightening or loosening the spacing between certain pairs of letters corrects for the awkward counterspaces inherent in their forms. Shifting the lowercase **Y** to the right, under the right crossbar of the **T**, for example, allows the spacing between them to become optically similar to that of subsequent letters.

Other letter pairs that benefit from this sort of correction are shown at right.

Type

Default spacing

Type

Corrected spacing

To

Ti

Pe

We

Yo

Type Sizes and Spacing Considerations

Until the eighteenth century, there was no standard measuring system in use for type size or spacing. Lead type was produced at fixed sizes by different foundries and so was incompatible with those of other foundries. In 1737, Pierre Fournier (b. 1712, d. 1768) created a measuring system by dividing an inch into 12 lines and further dividing those each into 6 points. In 1785, Francois Didot (b. 1689, d. 1757) created a new standard related to the official French measure, the *pied du roi* (a somewhat foot-long measure based on the size of the king's foot) that was also broken into points (the D or Didot-point); type and paper measurements were now compatible. After the French Revolution of 1789, that standard was replaced with the metric system, and eventually the Didot point was fixed at 0.376 mm; this system is still in use in Europe today. The Anglo-American system of points is similar, using an inch divided into 6 picas that are subdivided into 12 points. The measure of a line of type can be expressed as 30 x 12 (30 picas long by 12 points high or 12 points in size). There is a hazy correspondence between the point measure and its use in determining type size. Historically, a type size was measured from its cap line to its descent line; but this measuring system has been thrown off over the years. Sometimes, this measurement still holds true, while, in other cases, the measure is made from cap line to baseline only.

The drawing of a typeface has an impact on the perception of its size. A sentence set in an oldstyle serif and a similar-weight sans serif at the same point size will appear to be two sizes. The discrepancy results from the sans serif's larger x-height: its lowercase letters are larger in relation to the cap height than those of the serif. The difference in set size and apparent size can vary as much as 2 or 3 points depending on the face. A sans serif such as Univers may be perfectly comfortable to read at a size of 9 points, but an oldstyle such as Garamond Three at that size will appear tiny and difficult to read. Setting the Garamond at 11 or 12 points will make it more legible, as well as make it appear the same size as the Univers.

Setting type smaller or larger than the optimal reading size for text also has an impact on spacing. Comfortable and efficient reading of long texts, such as books, newspapers, or journals, takes place when the type size ranges between 10 and 14 point—the texture of the type is a uniform gray and the letterforms are small enough that their details are not perceived as distinct visual elements. Optimal spacing at reading size means that the strokes and counterforms are evenly alternating. As type is decreased in size, the letterspace must be increased to allow the eye to separate the letters for clarity. At the other extreme, space between letters must be decreased as the type size increases beyond reading size.

Trips Trips Trips

The word "trips" is set here in three faces at the same size. Type is measured in points; all the words are set at 60 points, but because the sans serif lowercase letters are larger in proportion to the cap height, they appear larger; the same is true of the modern serif to the right. Note also the difference in the depth of the descenders.

Space That Type!
Never take digital spacing or sizes for granted—always check it for loose or tight characters, and size different type styles by eye to make them similar.

The printing process exacerbates the issue of space between letters, especially at smaller sizes. Ink bleeds when it hits paper; as a result, the spaces between letters are made smaller.

Trying to judge proper spacing on a monitor, with its coarse resolution, is nearly impossible; a laser or inkjet printer creates some bloating in the type, but not nearly as much as will happen on press. A designer's prior printing experience can help judge these spacing issues.

The line is spaced one way at this size.

The line is spaced one way at this size.

The line is spaced one way at this size.

The line is spaced one way at this size.

The same words set at 14 points (top) and at 6 points. Uncorrected (middle), the spacing in the smaller type is inadequate for good character recognition. Adding space between letters (bottom) greatly improves their legibility and look. The difference in spacing of the small type becomes more evident when it is enlarged to 14 points for comparison with the original.

Horizontal Measurement and Spacing

Point size and horizontal measurement are related, but different. The point size, as noted, is historically determined by the distance from the cap height to the descent line. Horizontal measure, for purposes of spacing, is divided into units based on the width of a typeface's uppercase **M** at a given size. The square of this width, which vertically includes the depth of the descenders, is called the set-em or em. Unlike the pica-em, which is a constant measure of 12 points, the set-em changes as the size of the type changes. When type was still set in lead, the em (set-em) was the source for measurements with which the typesetter could alter spacing within words and between them in sentences. Until the advent of photo and then digital typesetting, there were only five proportional slugs available to the typesetter for this purpose: the **en** (or **nut**), measuring half an em; the **thick space,** one-third of the em; the **mid space,** or one-quarter of the em; the **thin space,** or one-sixth of an em; and **the hair,** one-twelfth of an em. The em is still used as the basis for horizontal spacing, but through the precision allowed by the computer, digital spacing has become extremely refined. The em in page layout software such as Quark XPress and Adobe InDesign is divided into 1,000 units, which is shown in the measurement palette as 0.001 of an em.

M Proportion

M Proportion

M Proportion

The proportional horizontal measure "set-em" is determined by the width of a capital M at a given size. The size of the em as a measurement base changes as type size changes.

Prior to digital typesetting, the limited spacing options available to typesetters consisted of five increments based on the set-em, shown at the bottom.

Em En Thick Mid Thin Hair

The Finer Points of Text Setting

Very little attention is paid to the spacing of punctuation, symbols, and diacritical marks in text. It is often assumed, as with letter- and wordspacing, that software adequately addresses the spacing of these characters and, therefore, their spacing need not be evaluated. Unfortunately, this is not the case. The default spacing of punctuation marks tends to be excessive, creating accidental holes in text. The problem is accentuated by designers and editors who are ill-informed about the conventions of typesetting punctuation and who either space punctuation poorly or use punctuation marks incorrectly. In both instances the clarity and the visual quality of the text are compromised.

1

A single wordspace, never two, follows a period before the initial cap of the next sentence.

latitude. Westerly
latitude. Westerly

2

Numerals within running text always need spacing adjustments, especially within groups. Lining numerals, which extend from baseline to cap height, usually require a bit of extra letterspace, but they tend to be more condensed and more varied in form than uppercase letters. Numerals in tables are generally arranged flush right or around a decimal point in vertical arrangements of figures.

the year 1045 brou
the year 1045 brou

3

The spaces before and after a comma or quotation mark should be reduced; these marks carry additional space above or below them, respectively. Colons and semicolons need additional space preceding them and less space following.

yes, she did
yes, she did

was "horrid"
was "horrid"

4

Content within parentheses and brackets will usually benefit from additional space to separate it from these marks, especially italic forms with ascenders that are likely to crash into the marks if left at the default spacing. In particular, lowercase italic f, l, k, h, and many of the uppercase letters, will need adjustment. In some instances, shifting these marks below the baseline will help them align optically with the line of text.

(smile) (smile)
(factor) (factor)
[factor] [factor]

5

There are three different horizontal punctuation marks. Use the correct one for its intended function, and adjust the spaces around them so that they flow optically within text. A full wordspace on either side is too much. The default lengths and baseline shift of each mark may need to be altered to improve their relationship to surrounding text—the hyphen often sits low, and the em-dash is sometimes too long.

Hyphen Combines words or breaks them
in-depth look

En-Dash Separates ranges or times
100–200 pages

Em-Dash Separates phrases or evolutionary thoughts
beware—it is

did you?

did you ?

7

Exclamation and question marks often benefit from being separated from their sentences by an extra bit of space. A full wordspace is too much, as is half a wordspace; but 20/100 of an em (set-em), or +20 tracking, is usually sufficient.

Ligatures—specially drawn characters that correct spacing difficulties between letter pairs—provide a clue to optimal spacing. Since ligatures are drawn with a fixed space between characters (for example, an fi), assume this *space for the pair is the optimal spacing for the entire face. If the ligatures within text appear more tightly or loosely spaced than the nonfixed characters around them, the text needs to be respaced accordingly.*

difficulty is clear

difficulty is clear

Typography: Designing Words

Typography
DESIGNING WORDS

8

Punctuation can be altered or removed entirely if the text treatment creates the equivalent meaning. For example, a colon separating a title and subtitle must remain if they follow each other on the same line; remove the colon if the subtitle is treated differently enough from the title to visually imply the same grammatical separation.

Most punctuation marks—especially quotations—should be hung outside the aligned text if it occurs at the beginning of a line. This rule sometimes applies to bullets 8as well; a designer may opt to maintain the alignment of bulleted text and hang the bullets in the margin.

of listening to the sea calling
determined, and thought it h
"Think carefully," he said, agai
foremost a kind of singular wi
responds with a word in kind

· **Optional leather seats**
· **Five-speed transmission**
· **ABS breaking system**
· **Power steering**

9

Small caps within text, for acronyms, need additional space around them. The small caps of many fonts appear lighter in weight than the upper- and even the lowercase letters. A designer may adjust the point size of small caps up by as much as two points to achieve uniform weight without confusing them with the uppercase.

10

The appearance of analphabetic symbols, like the @, #, $, and %, and some linear punctuation marks, like the forward slash (/) are improved by slight spatial adjustments. The @ usually appears too high on the line; a *slight shift below the baseline optically centers it on the text. The # and % display a diagonal thrust akin to italic forms, and decreasing the space preceding them—but increasing the space following them—helps improve* *their overall rhythm in text. The / tends to benefit from added space on either side, although a full wordspace is far too much; +20 to +30 tracking is adequate.*

address@domain.com

address@domain.com

as does #25

as does #25

from the AIGA. The figure

from the AIGA. The figure

The Spatial Mechanics of Paragraphs

As more and more sentences are strung together, they cluster to form a basic component of typographic design: the paragraph. Paragraphs can be set in all manner of ways—wide, narrow, aligned or nonaligned, singly or in groups. The paragraph is the archetypal building block of a text; as such, its structure, spacing, and optical qualities warrant a focus of attention by the designer.

Wordspace within Lines of Text
The space between words is derived from the rhythm of strokes and counters established by the letterspacing itself. Typically, the wordspace can be defined by the width taken up by a lowercase **i** as though it has been spaced continuously with the last letter of a word and the first letter of the word that follows. The space between words is, therefore, smaller when the text is set more tightly and larger when the text is set more loosely. The space between words should be the minimum needed to separate them. When the wordspace becomes too great, the lines of type begin to fracture. If large wordspaces appear over and over again, they tend to align from one line to the next, creating white channels of space called rivers. The problem with rivers is that they appear to connect words between lines, interfering with sequential understanding in sentences. If the eye can not hold the line of type, comprehension is effectively destroyed.

Regardless of the nature of the content in a particular paragraph, it must first be considered independently to a certain degree to find an optimal width and depth for comfortable reading. The width of a paragraph depends on a few features: type size, wordspace, and interline space, or leading.

one i hopes i the i words i are i spaced i evenly

one hopes the words are spaced evenly

Normal, uniform wordspacing can be conceived of as the space determined by setting an invisible lowercase i between words as though being letterspaced as continuous text. The effect of uneven wordspacing is evident in the appearance of rivers.

one hopes the words are spaced evenly so that

one hopes the words are spaced evenly so

one hopes the words are spaced

As overall spacing within text changes, wordspace must be altered accordingly.

spacing
leading,
the heig

Many factors affect the interline spacing, or leading, of a text, including the height of the lowercase letters and the respective height and depth of the ascenders and descenders.

spacing
leading,
the heig

Many factors affect the interline spacing, or leading, of a text, including the height of the lowercase letters and the respective height and depth of the ascenders and descenders.

Examples of leading set solid (top) and correcting for the large x-height of the lowercase (bottom). The added leading improves readability and keeps the ascenders and descenders from creating dark spots.

Space between Lines of Text

Leading (pronounced "ledding") is the vertical measure from the baseline of one line to the baseline of the line below it in a paragraph. This term, like so many in modern typography, is another holdover from the days of lead type, when metal letters were set individually by hand. The typesetter had the option of setting the next line solid—butting it up directly to the preceding line—or of introducing additional space between the lines with a thin strip of metal, also of lead. By adding these strips of lead between lines, a typesetter could change the overall depth of a paragraph (and its color) as needed. Leading greatly influences the legibility of a paragraph as well as changes its visual texture.

The first considerations affecting the leading of text are the height of the lowercase letters and the height and depth of their ascenders and descenders, respectively. Clearly, these strokes can not interfere with each other between lines—joined or overlapped strokes diminish character recognition and create dark spots that stop the eye. Typefaces with tall ascenders and deep descenders need added space between lines to avoid this problem. Likewise, a typeface with a large x-height fills the line depth considerably, and more leading is required to offset its increased density. The next consideration affecting leading is the line length of the paragraph, and this can be complicated. A mature reader grabs a snapshot of several words simultaneously; the more advanced the reader, the more the eye grabs. Over time, a reader is able to process several snapshots together in rapid succession—but only to a point. Without a slight break in the process, the reader begins to jumble the snapshots and becomes confused. That break is the return: the end of a line and the backtrack across the paragraph in reverse to find the next line. The reader must keep track of the sequence of snapshots and locate the beginning of the next line. The designer's goal is to find the optimal relationship between these factors so that the paragraph is as easy to negotiate as possible, and interferes minimally with reading comprehension.

A desirable paragraph setting is one in which a constellation of variables—width, leading, wordspace—achieves a harmonic balance.

The mature reader's visual snapshot of word groups may conflict with a narrow paragraph that is leaded too tightly. In the first example, the snapshot takes in not just a full line of type on the narrow column but portions of the lines below. The second example shows a reduced snapshot that aids comprehension; the reader is forced to assimilate the word groups in sequence because the lines have been leaded far enough apart to prevent subsequent lines from interfering.

Text from
The Finer Points of Spacing and Arranging Type
by Geoffrey Dowding. Wace & Company, 1954.

In the finest bookwork the pages of text are printed in such a manner that the lines on a recto page backup exactly those printed on the reverse, or verso, side. This care in setting and printing, nullified when extra space is inserted between paragraphs (for there is some show-through even on reasonably good paper), adds to the beauty and clarity of the pages by heightening the contrast between lines and their interlinear whiting.

In the finest bookwork

the pages of text are printed

in such a manner that the

lines on a recto page backup

exactly those printed on

the reverse, or verso, side.

This care in setting and

printing, nullified when extra

space is inserted between

paragraphs (for there is some

spacing

alignment

leading

character fit

Start Off Right
Finding the "ultimate" paragraph configuration for text at the beginning of a project can be a helpful place to start developing the rest of the layouts.

The Ultimate Paragraph

The width of a paragraph depends heavily on the size of type being used and, therefore, how many characters can be fit onto a single line. Regardless of a reader's maturity or the type size, between fifty and eighty characters (including spaces) can be processed before a return—with words averaging between five and ten letters, that means approximately eight and twelve words per line. Achieving this character count determines the width of a paragraph. That width may be affected by the proportions of the page format and how much text must be made to fit overall, as well as subjective factors, but this method is the best way of finding an optimal paragraph width as a starting point. The leading of the lines, as noted earlier, is somewhat dependent on the width of the paragraph, the type size, and its spacing. The space between lines should be noticeably larger than the optical height of the lines, but not so much that it becomes pronounced. Similarly, the leading must not be so tight that the reader locates the beginning of the same line after the return and begins reading it again. As paragraph width increases, so too must the leading, so that the beginnings of the lines are more easily distinguished. Oddly, as the width of a paragraph narrows, the leading must also be increased; otherwise, the reader may grab several lines together because the snapshots he or she takes while scanning encompass the full paragraph width.

1 Initial setting: solid leading, larger type size

Whenever we speak or write, we communicate. Language, whether spoken or written, is part of what makes us unique as humans. Spoken language is ephemeral and intangible, it disappears as soon as it is uttered. When written, language is captured in a visual and spatial form, permanent and concrete. As the art of visual language, typography is inherently communicative.

2 Solid leading, smaller type size—column wider than optimal

Whenever we speak or write, we communicate. Language, whether spoken or written, is part of what makes us unique as humans. Spoken language is ephemeral and intangible, it disappears as soon as it is uttered. When written, language is captured in a visual and spatial form, permanent and concrete. As the art of visual language, typography is inherently communicative.

3 Increased leading; rag is indecisive, paragraph still too wide

Whenever we speak or write, we communicate. Language, whether spoken or written, is part of what makes us unique as humans. Spoken language is ephemeral and intangible, it disappears as soon as it is uttered. When written, language is captured in a visual and spatial form, permanent and concrete. As the art of visual language, typography is inherently communicative.

4 Optimal paragraph width

Whenever we speak or write, we communicate. Language, whether spoken or written, is part of what makes us unique as humans. Spoken language is ephemeral and intangible, it disappears as soon as it is uttered. When written, language is captured in a visual and spatial form, permanent and concrete. As the art of visual language, typography is inherently communicative.

A sequence of paragraph studies, each changing a specific variable, culminates in the "ultimate" paragraph, above. The initial setting (1) produces a paragraph that is too narrow for the type size, and the solid leading is too tight. Adjusting the size of the type downward (2) on the same width creates a paragraph with lines that are too long to read comfortably. Adding interline space, or leading, (3) mitigates the line length, but the line endings seem indecisive. Making the paragraph narrower (4) finally achieves a harmonic relationship between the variables: a readable type size, comfortable line length, and enough leading to ensure proper reading sequence.

Text from
Typography: Micro- + Macro-aesthetics
by Willi Kunz. Verlag Niggli AG, 1998.

Aligning Text within Paragraphs

No matter how wide or deep, a paragraph may be set in several different configurations called **alignments.** It may be set so that every line begins at the same left-hand starting point (aligned left), at the same right-hand starting point (aligned right), or with an axis centered on the paragraph width. In this case, there are two options: in centered type, the lines are different lengths and are centered over each other on the width's vertical axis; in justified type, the lines are the same length, aligning on both left and right sides. Justified text is the only setting in which the lines are the same length.

In text set to align left, right, or centered, the uneven lengths of the lines create a soft shape that is called the **rag.** The relationship of the paragraph's alignment and rag is yet another factor in determining a desirable text setting. First, the alignment of text in a paragraph has

an effect on the spacing within it. In a paragraph set with a left alignment (flush-left, ragged-right or FLRR), the wordspaces are uniform. This is also true in a paragraph set flush-right, ragged-left (FRRL) and in a centered paragraph. The wordspace in a justified paragraph, however, varies because the width of the paragraph is mathematically fixed, and the words on any given line must align on both sides—no matter how many words or how long they are. In justified text, wordspacing variation is the single most difficult issue to overcome. The result of poorly justified text in which the wordspace constantly changes is a preponderance of rivers. In particularly bad justified setting, the rivers are even more apparent than the interline space, causing the paragraph to become a jumble of strange word clusters. One method of minimizing this problem is to find the optimal flush-left paragraph width

for the size of the type before justifying—and then to widen the paragraph slightly or shrink the type size by a half-point or point. This adjustment can result in an optimal number of characters and words that comfortably fit upon justification and will often compensate for the potential of long words to create undesirable spacing. A slightly wider paragraph also allows some flexibility in how words are broken from line to line, and gives the designer more options for rebreaking text to make it fit with good spacing.

Think of the blank page as alpine meadow, or as the purity of undifferentiated being. The typographer enters this space and must change it. The reader will enter it later, to see what the typographer has done. The underlying truth of the blank page must be infringed, but it must never altogether disappear—and whatever displaces it might well aim to be as lively and peaceful as it is.

Think of the blank page as alpine meadow, or as the purity of undifferentiated being. The typographer enters this space and must change it. The reader will enter it later, to see what the typographer has done. The underlying truth of the blank page must be infringed, but it must never altogether disappear—and whatever displaces it might well aim to be as lively and peaceful as it is.

Think of the blank page as alpine meadow, or as the purity of undifferentiated being. The typographer enters this space and must change it. The reader will enter it later, to see what the typographer has done. The underlying truth of the blank page must be infringed, but it must never altogether disappear—and whatever displaces it might well aim to be as lively and peaceful as it is.

FLUSH-LEFT / RAGGED-RIGHT

CENTERED AXIS

FLUSH-RIGHT / RAGGED-LEFT

Examples of the three ragged alignment structures.

Text from
The Elements of Typographic Style [version 2.4]
by Robert Bringhurst. Hartley & Marks, 2001.

Think of the blank page as alpine meadow, or as the purity of undifferentiated being. The typographer enters this space and must change it. The reader will enter it later, to see what the typographer has done. The underlying truth of the blank page must be infringed, but it must never altogether disappear—and whatever displaces it might well aim to be as lively and peaceful as it is. It is not enough, when building a title

A poorly justified text (right) displays varied wordspaces and rivers, as well as extensive hyphenation. Adjusting the width of the paragraph, using the same point size, may help alleviate such problems (far right).

Think of the blank page as alpine meadow, or as the purity of undifferentiated being. The typographer enters this space and must change it. The reader will enter it later, to see what the typographer has done. The underlying truth of the blank page must be infringed, but it must never altogether disappear—and whatever displaces it might well aim to be as lively and peaceful as it is. It is not enough, when building a title page, merely to unload some big, prefabricated letters into the center of the space, nor to dig a few holes in the silence with typographic heavy machinery and move on. Big type, even huge type, can be beautiful and useful.

Our strategic mix of product development and diversification in the areas of Ig-TheraSorb, Hospital Solutions and device development, as well as the enhancement of distribution structures through the acquisition of DeltaSelect, will help us achieve optimal market placing and provide positive profit development in the short to medium term.

The Financial Year 00_01

From Marketing to Trust

Ig-TheraSorb®

A further clinical use for RheoSorb® was identified in the complaint known as venous stasis ulcer. The increasing problems associated with incurable venous ulcers are proving a strain on health systems as more and more patients are receiving ineffective and expensive treatment for weeks at a time in hospital. The preparation of a multifaceted study into stasis ulcers in comparison to the standard treatment with compresses is nearly complete.

Completing the search for economically attractive areas of use for RheoSorb®, clinical experts are currently exploring rational attachment sites for fibrinogen adsorption in patients with impaired arterial circulation. As a next step, their endeavors will result in a concrete international study concept.

A successful pilot study on the claim for sudden deafness at the University of Regensburg, which enjoyed convincing clinical advantages in comparison with previous therapeutic standards, confirmed the theory that a reduction in blood viscosity in patients with this complaint is beneficial.

The claim for dilatative cardiomyopathy made for Ig-TheraSorb® received much attention following the publication in several highly regarded scientific journals (Circulation, JAMA) of quality clinical pilot trials. Growing agreement among international experts and health professionals on the correctness of the claim and its treatment with Ig-TheraSorb® has led to the decision to confirm the drug's therapeutic benefits and specific advantages in an international clinical trial subject to clearly defined parameters.

New findings regarding the treatment of rheumatoid arthritis, now in the project stage, have resulted in contradictory statements in the national arena. This means that current research into international markets must be concluded, in particular those that reflect the licensing procedures in those individual markets and their influence on this indication.

28 PlasmaSelect AG Business Report 2000/2001 Business Report 2000/2001 PlasmaSelect AG 29

The designers' attention to detail is evident in the various examples of justified setting shown in the pages of this annual report.

Two typefaces, each set at a different size, exhibit uniform spacing characteristics. This is the result of finding each face's optimal size-to-width relationship.
First Rabbit GmbH | Germany

Investigating the Ragged Edge

A paragraph rag may exhibit desirable or undesirable characteristics. As with letter- and wordspacing, uniformity is key to developing a good ragged edge. A rag can range from deep to shallow, active to subtle, but its uniformity and consistency overall are what make it desirable. Ragged line endings are considered optimal if they create an organic, unforced "ripple" down the edge of the paragraph, without pronounced indents or bulges. In an optimally ragged paragraph, the rag becomes invisible: the reader is never aware that the lines are ending at their natural conclusion. If the alternating lines end short and very long, the rag becomes active and calls attention to itself, distracting the reader from following the content of the text. That said, a deep rag may be acceptable if it remains consistent throughout the duration of the text. The uniformity of an active rag will also render it invisible as a result of its consistency. A designer may opt to mitigate a deep rag by introducing more interline space. What is never desirable, however, is a rag that begins at the outset of a paragraph guided by one kind of logic and transforms into another kind of logic as the paragraph progresses in depth; or a rag with excessive indenting from the right; or sharp, angular inclusions of space created by lines that become sequentially shorter. The overall unity of a rag can be easily compromised by the single occurrence of two short lines that create a boxy hole. In optimal rags, the depth is between one-fifth and one-seventh of the paragraph's width.

The rag of a paragraph may exhibit desirable and undesirable characteristics, like every other aspect of typographic structure. And as with letterspacing and wordspacing, uniformity is key to developing a good ragged edge. A rag may be deep or shallow, active or subtle, but its uniformity and consistency, from the top of a paragraph down to the bottom, is what makes it desirable. Of course, there is a range within what constitutes an acceptable rag. The ragged line endings are considered optimal if they create an organic, unforced 'ripple' down the edge of the paragraph, without noticeable indents of white space or pronounced shapes. In an optimally ragged paragraph, the rag becomes invisible: the reader never becomes aware that the lines are ending at their natural conclusion. If the alternating lines end short and very long, the rag becomes active, calling attention to itself, distracting the reader from following the content of the text. That said, it's still acceptable to set a deep rag if the rag will remain consistently deep throughout the duration of the text. The uniformity of the active rag achieves a kind of stasis, its specific logic becoming appraised and assimilated by the eye, and understood to constitute a specific logic for that particular text. In the case of a deep, or active, rag, the designer may mitigate its activity by introducing more interline space, and may focus attention on the interior shape created by the shorter lines in relation to the exterior shape created by the longer lines. What's never desirable, however, is a rag that begins at the outset of a paragraph guided by one kind of logic and transforms into another kind of logic as the paragraph progresses in depth; or a rag that shows excessive indenting from the right, or sharp angular inclusions of space created by lines that become sequentially shorter. The overall unity of a rag can be easily compromised by the single occurrence of two short lines that create a boxy hole. In optimal rags, the depth of the rag hovers between 1/5 and 1/7 of the width of the paragraph.

The optimal rag, above, shows a very even, unforced edge with steady alternation of long and short lines. The width of the paragraph is constant from top to bottom.

The rag of a paragraph may exhibit desirable and undesirable characteristics, like every other aspect of typographic structure. And as with letterspacing and wordspacing, uniformity is key to developing a good ragged edge. A rag may be deep or shallow, active or subtle, but its uniformity and consistency, from the top of a paragraph down to the bottom, is what makes it desirable. Of course, there is a range within what constitutes an acceptable rag. The ragged line endings are considered optimal if they create an organic, unforced 'ripple' down the edge of the paragraph, without noticeable indents of white space or pronounced shapes. In an optimally ragged paragraph, the rag becomes invisible: the reader never becomes aware that the lines are ending at their natural conclusion. If the alternating lines end short and very long, the rag becomes active, calling attention to itself, distracting the reader from following the content of the text. That said, it's still acceptable to set a deep rag if the rag will remain consistently deep throughout the duration of the text. The uniformity of the active rag achieves a kind of stasis, its specific logic becoming appraised and assimilated by the eye, and understood to constitute a specific logic for that particular text. In the case of a deep, or active, rag, the designer may mitigate its activity by introducing more interline space, and may focus attention on the interior shape created by the shorter lines in relation to the exterior shape created by the longer lines. What's never desirable, however, is a rag that begins at the outset of a paragraph guided by one kind of logic and transforms into another kind of logic as the paragraph progresses in depth; or a rag that shows excessive indenting from the right, or sharp angular inclusions of space created by lines that become sequentially shorter. The overall unity of a rag can be easily compromised by the single occurrence of two short lines that create a boxy hole. In an optimal rag, the depth of the rag hovers between 1/5 and 1/7 of the width of the paragraph.

The rag of this paragraph is very deep for its width. The changes in line length make the rag more active; the deep spaces between long lines are distracting.

The rag of a paragraph may exhibit desirable and undesirable characteristics, like every other aspect of typographic structure. And as with letterspacing and wordspacing, uniformity is key to developing a good ragged edge. A rag may be deep or shallow, active or subtle, but its uniformity and consistency, from the top of a paragraph down to the bottom, is what makes it desirable. Of course, there is a range within what constitutes an acceptable rag. The ragged line endings are considered optimal if they create an organic, unforced 'ripple' down the edge of the paragraph, without noticeable indents of white space or pronounced shapes. In an optimally ragged paragraph, the rag becomes invisible: the reader never becomes aware that the lines are ending at their natural conclusion. If the alternating lines end short and very long, the rag becomes active, calling attention to itself, distracting the reader from following the content of the text. That said, it's still acceptable to set a deep rag if the rag will remain consistently deep throughout the duration of the text. The uniformity of the active rag achieves a kind of stasis, its specific logic becoming ap-praised and assimilated by the eye, and understood to constitute a specific logic for that particular text. In the case of a deep, or active, rag, the designer may mitigate its activity by introducing more interline space, and may focus attention on the interior shape created by the shorter lines in relation to the exterior shape created by the longer lines. What's never desirable, however, is a rag that begins at the outset of a paragraph guided by one kind of logic as the paragraph progresses in depth; or a rag that shows excessive indenting from the right, or sharp angular inclusions of space created by lines that become sequentially shorter. The overall unity of a rag can be easily compromised

The rag in this column changes logic from top to bottom, starting out with even alternation, but becoming very irregular toward the bottom. Worse, the column gets progressively wider as it gets deeper, and the shapes in the rag are angular and pronounced.

Too many hyphenated words in a row create a distraction. From an editorial perspective, two successive lines ending in hyphenated word breaks is undesirable. If a text seems to be hyphenating excessively—more than once every 10 lines or so—the problem lies in the relationship between the text's point size and the width of the paragraph; one or the other must be adjusted to correct the hyphenation problem. Although a text free of hyphens would be best, this state of perfection is rarely possible; and indeed, some designers will argue that hyphenating words here and there helps contribute to the uniformity of the rag by allowing lines to remain similar in length, regardless of long words.

Hyphenated word breaks are a constant source of frustration for a designer. Too many hyphens in a row are undesirable, and a slight adjustment in text size or paragraph width may correct the problem. The two paragraphs shown here are set in the same size text, with subtle differences. The first paragraph shows a very active rag but no hyphens— a toss-up between desired goals. The second shows a slightly wider paragraph and a more even rag; the only hyphen appears at the end of the second line. One hyphen every ten lines or more is optimal.

Too many hyphenated words in a row create a distraction. From an editorial perspective, two successive lines ending in hyphenated word breaks is undesirable. If a text seems to be hyphenating excessively—more than once every 10 lines or so—the problem lies in the relationship between the text's point size and the width of the paragraph; one or the other must be adjusted to correct the hyphenation problem. Although a text free of hyphens would be best, this state of perfection is rarely possible; and indeed, some designers will argue that hyphenating words here and there helps contribute to the uniformity of the rag by allowing lines to remain similar in length, regardless of long words.

The depth of the rag is variable, and may be explored to find one that suits the texture of the type and the width of the column.

A rag range between one-fifth (top) and one-seventh (bottom) the width of the paragraph tends to be optimal for most text.

Word order and word breaks across lines also affect the rag. Problems in ragged-right setting commonly arise when series of short words—**of, at, it, to, we, us,** and many others—are broken to align at the left edge, creating a vertical river running parallel to the aligned edge; and when short words appear at the end of a long line between two shorter lines, appearing to break off and float. In such cases, the designer must weigh the consequences of rebreaking the lines to prevent these problems against their effect on the rag as whole. Similarly, the breaking of words across lines—using a hyphen—can also be problematic if left untreated. From an editorial perspective, more than two successive lines ending in hyphens is undesirable. If a text is hyphenating excessively— more than once every 10 lines or so—the problem lies in the relationship between the text's point size and the width of the paragraph; one or the other must be adjusted to correct the problem. Although a text that is free of hyphens would be best, this state of perfection is rarely possible; indeed, some designers argue that hyphenating words here and there helps contribute to the uniformity of the rag by allowing lines to remain similar in length.

Paragraphs in Sequence

A designer has a number of options for separating paragraphs within columns of text. Each option has its own advantages and drawbacks, all of which are dependent on the nature of the text, the size of the type, and the width of the columns. One approach is to simply insert a hard return—a blank line of the same leading—between one paragraph and the next. In columns set with text showing a large x-height, or with a smaller x-height and tighter leading, this treatment may look fine. It may otherwise seem excessive; the return could appear to separate the column, disturbing the column's vertical mass. The return's sharp line negative space may visually interfere with other elements. Although a designer may find this effect useful or appropriate for a particular text, it can be a bit jarring. In traditional typesetting, the columns of books were set without space between paragraphs to save on paper use (and therefore cost); instead, the beginning of a new paragraph was indicated by an indent—where the first line of a new paragraph starts a few character widths in from the left alignment. This treatment works particularly well in justified setting. The depth of the indent is subjective, with the caveat that it must be noticeable. An em (set-em) indent is noticeable, but is often not enough of an indent. The indent must be deeper if the leading is loose; more interline space normalizes the perception of the column's width (this is why adding leading smooths out irregular rags) and a bigger "hole" must be cut into the paragraph. Sometimes, a designer will exaggerate the indent for visual effect. With longer paragraphs set in relatively wide columns, this treatment

As a paragraph lengthens to become deeper than it is wide, it takes on a vertical stress and becomes a column. Within the column, paragraphs that follow each other must somehow be differentiated so that the reader is aware that one has ended and another one has begun.

Paragraphs running continuously in a column, without being differentiated, make it difficult for readers to separate distinct thoughts and to maintain their place in the sequence. Visually, this treatment also creates an overwhelming wall of text.

will break up the wall of text by introducing a rhythm of cuts into the columns. Indents are usually not a good idea if the text is set ragged right. Since the rag is already changing the line lengths on the right edge of the column, the indent on the left side loses some of its visual power, causing the top lines of the columns to appear as though they are changing alignment.

Architects build perfectly proportioned kitchens, living rooms and bedrooms in which their clients will make, among other things, a mess. Typographers likewise build perfectly proportioned pages, then distort them on demand. The text takes precedence over the purity of the design, and the typographic texture of the text takes precedence over the absolute proportions of the individual page. If, for instance, three lines remain at the end of a chapter, looking forlorn on a page of their own, the design must flex to accommodate them. The obvious choices are: (1) running two of the previous spreads a line long (that is, adding one line to the depth of two pairs of facing pages), which will leave the final page one line short; (2) running half a dozen of the previous spreads a line short, thereby bumping a dozen lines along to the final page; or (3) reproportioning some non-textual element — perhaps an illustration or the sinkage, if any, at the head of the chapter.

Spacious chapter heads stand out in a book, as they are meant to. Reproportioning the sinkage is therefore a poor option unless all chapter heads can be reproportioned to match. And running six spreads short is, on the face of it, clearly a greater evil than running two spreads long. If there are only a few pages to the document, the whole thing can, and probably should, be redesigned to fit the text. But in a book of many pages, widow lines, orphaned subheads, and the runt ends of chapters or sections are certain to require reproportioning some spreads. A rigid design that demands an invariant page depth is therefore inappropriate for a work of any length. Altering the leading on short pages to preserve a standard depth (vertical justification, as it is sometimes called) is not a solution. Neither is stuffing extra space between the paragraphs. These antics destroy the fabric of the text and thus strike at the heart of the book.

Architects build perfectly proportioned kitchens, living rooms and bedrooms in which their clients will make, among other things, a mess. Typographers likewise build perfectly proportioned pages, then distort them on demand. The text takes precedence over the purity of the design, and the typographic texture of the text takes precedence over the absolute proportions of the individual page.

If, for instance, three lines remain at the end of a chapter, looking forlorn on a page of their own, the design must flex to accommodate them. The obvious choices are: (1) running two of the previous spreads a line long (that is, adding one line to the depth of two pairs of facing pages), which will leave the final page one line short; (2) running half a dozen of the previous spreads a line short, thereby bumping a dozen lines along to the final page; or (3) reproportioning some non-textual element — perhaps an illustration or the sinkage, if any, at the head of the chapter.

Spacious chapter heads stand out in a book, as they are meant to. Reproportioning the sinkage is therefore a poor option unless all chapter heads can be reproportioned to match. And running six spreads short is, on the face of it, clearly a greater evil than running two spreads long. If there are only a few pages to the document, the whole thing can, and probably should, be redesigned to fit the text. But in a book of many pages, widow lines, orphaned subheads, and the runt ends of chapters or sections are certain to require reproportioning some spreads. A rigid design that demands an invariant page depth is therefore inappropriate for a work of any length. Altering the leading on short pages to preserve a standard depth (vertical justification, as it is sometimes called) is not a solution. Neither is stuffing extra space between the paragraphs. These antics destroy the fabric of the text and thus strike at the heart of the book.

Architects build perfectly proportioned kitchens, living rooms and bedrooms in which their clients will make, among other things, a mess. Typographers likewise build perfectly proportioned pages, then distort them on demand. The text takes precedence over the purity of the design, and the typographic texture of the text takes precedence over the absolute proportions of the individual page. If, for instance, three lines remain at the end of a chapter, looking forlorn on a page of their own, the design must flex to accommodate them. The obvious choices are: (1) running two of the previous spreads a line long (that is, adding one line to the depth of two pairs of facing pages), which will leave the final page one line short; (2) running half a dozen of the previous spreads a line short, thereby

Hard returns between paragraphs are effective… maybe too effective. Pronounced negative spaces produced by the full return may work to separate the columns into parts that interfere with the reading direction.

PaperLogix Because paper is both visual and tactile, a blank sheet is not truly blank. It communicates even without ink. How it looks and feels can say: classy or hip or happy. A blank computer screen is truly blank, but blank paper has personality. Touching is believing.

Paper can set the tone and raise our expectations for any printed piece. This is true for a letterhead or business card, an annual report, or a direct-mail insert. Paper with little or no printing on it can do a great job: as an envelope, a report cover with a window in it, a flysheet or an endpaper. In this sense, paper speaks for itself — and for you or your client.

The large-type introduction paragraphs in this handbook (above) use a proportional return that is only a few points greater than the text leading. At such a large text size, the minimal difference in the return appears adequate.
AND Partners | USA

The paragraphs running within columns on this spread detail (right) are separated by a proportional return that is roughly one and a half times the text leading—open enough to mark each paragraph, but not so open as a full hard return.
Paone Design Associates | USA

Harvard's Richard Elmore Discusses School Improvement

Richard Elmore (center) talks with Penn GSE's Harris Sokoloff and Deanna Burney.

"Schools are the most powerful engines of inequality in our society," said Richard Elmore during a recent visit to Penn GSE. Dr. Elmore, who is the Gregory R. Anrig Professor of Educational Leadership at Harvard University and a member of the management committee at the Consortium for Policy Research in Education (CPRE), talked to Penn GSE faculty and staff about the challenges of school reform. During his visit, he also met with Delaware Valley superintendents who are members of Penn GSE's School Study Councils.

Early in his research career, Dr. Elmore learned that schools cannot be changed from the top down. A study of urban schools conducted when he was at the University of Michigan showed that, despite changes in the structure of the schools' organizations, the schools themselves showed no consistent change. He realized then that school improvement cannot be imposed—that it must spring from classroom improvements in teaching and learning.

Dr. Elmore now looks for examples of great teaching and learning, and uses them as a place from which to study the organizational environment. His renowned observations of systemic change in New York City's District #2

reveal an important link between professional development and improved classroom performance. In District #2, the creation of a support system for teachers, which included intensive adult learning, led to improvements in teaching and learning. District #2 was able to sustain these improvements by creating an internal accountability system to ensure that high standards are continually met.

In speaking about District #2, Dr. Elmore cautioned that "you cannot force accountability on schools unless they have internal accountability in place." The improvement in District #2 points to a predicament that the country's new education law creates for many schools, said Dr. Elmore, citing the recent CPRE study "Assessment and Accountability Across the 50 States" by Penn GSE faculty member and CPRE co-director Margaret Goertz. With requirements for testing students in science, reading, and math in grades 3–8, the new education law holds schools accountable for improved teaching and learning without a commensurate investment in their internal capacity to improve.

According to Dr. Elmore, school improvement can be brought about by a committed nucleus of school leaders—teachers, principals, and superintendents—who can engage in the culture of improvement. He pointed to the difficulties of bringing about a cultural shift, describing the gulf between District #2 and other school districts in New York City. "This gulf is very difficult to bridge," he said.

Six-Nation Project Concludes with Conference

Penn GSE International hosted the final conference of the Six-Nation Education Research Project on October 7–10, 2001. The project, designed and initiated by Cheng Davis in 1993, involved research teams from China, Germany, Japan, Singapore, Switzerland, and the United States. Each team chose a research topic of particular relevance to its own country but also to the nations as a whole. Topics included vocational education and training, pedagogical process in language education, education evaluation and indicators, higher education, and mathematics and science education. The final conference provided the forum in which the teams reported their research findings to an invited audience.

Unique to the Six-Nation Project was the involvement of policymakers as well as researchers and educators. Policymakers' involvement was expected to facilitate the dissemination of the research findings and make them more acceptable to other policymakers. Keynote speaker at the final conference was U.S. Secretary of Education Roderick Paige.

Although the Six-Nation Education Research Project is technically concluded, discussion is under way concerning future collaboration. Thus far, Thailand and France have expressed interest in joining the project. A planning conference is scheduled for later this year in Thailand.

Penn GSE Pe— in Urban Edu

PENN GSE PERSPECTIVES IN URBAN EDUCATION

Penn GSE Perspectives Education is a new onli explores the complexiti cation. Produced by Pen and faculty, the journal education research and materials A dynamic fo viewers to comment on and provides a forum f debating issues and art rial board are Judy Buc National Writing Projec graduate students Ann and Susan Goerlich Zie Professor Kathy Schultz issue features guest edi Slaughter-Defoe, the Ce Professor of Urban Edu GSE, as well as the pres annual Constance Clayt the past four years.

<http://www.urbanedjou

U.S. Secretary of Education Roderick Paige delivers the keynote address at the Six-Nation Education Research Conference.

06

Examples of various indenting approaches. The em (set-em) used as an indent measure can be an effective paragraph separation in justified setting. An unusually deep indent (right) creates an interesting structural element within the text.

Architects build perfectly proportioned kitchens, living rooms and bedrooms in which their clients will make, among other things, a mess. Typographers likewise build perfectly proportioned pages, then distort them on demand. The text takes precedence over the purity of the design, and the typographic texture of the text takes precedence over the absolute proportions of the individual page. If, for instance, three lines remain at the end of a chapter, looking forlorn on a page of their own, the design must flex to accommodate them. The obvious choices are: (1) running two of the previous spreads a line long (that is, adding one line to the depth of two pairs of facing pages), which will leave the final page one line short; (2) running half a dozen of the previous spreads a line short, thereby bumping a dozen lines along to the final page; or (3) reproportioning some non-textual element — perhaps an illustration or the sinkage, if any, at the head of the chapter.

Spacious chapter heads stand out in a book, as they are meant to. Reproportioning the sinkage is therefore a poor option unless all chapter heads can be reproportioned to match. And running six spreads short is, on the face of it, clearly a greater evil than running two spreads long. If there are only a few pages to the document, the whole thing can, and probably should, be redesigned to fit the text. But in a book of many pages, widow lines, orphaned subheads, and the runt ends of chapters or sections are certain to require reproportioning some spreads. A rigid design that demands an invariant page depth is therefore inappropriate for a work of any length. Altering the leading on short pages to preserve a standard depth (vertical justification, as it is sometimes called) is not a solution. Neither is stuffing extra space between the paragraphs. These antics destroy the fabric of the text and thus strike at the heart of the book.

Architects build perfectly proportioned kitchens, living rooms and bedrooms in which their clients will make, among other things, a mess. Typographers likewise build perfectly proportioned pages, then distort them on demand. The text takes precedence over the purity of the design, and the typographic texture of the text takes precedence over the absolute proportions of the individual page. If, for instance, three lines remain at the end of a chapter, looking forlorn on a page of their own, the design must flex to

accommodate them. The obvious choices are: (1) running two of the previous spreads a line long (that is, adding one line to the depth of two pairs of facing pages), which will leave the final page one line short; (2) running half a dozen of the previous spreads a line short, thereby bumping a dozen lines along to the final page; or (3) reproportioning some non-textual element — perhaps an illustration or the sinkage, if any, at the head of the chapter.

Spacious chapter heads stand out in a book, as they are meant to. Reproportioning the sinkage is therefore a poor option unless all chapter heads can be reproportioned to match. And running six spreads short is, on the face of it, clearly a greater evil than running two spreads long. If there are only a few pages to the document, the whole thing can, and probably should, be redesigned to fit the text. But in a book of many pages, widow lines, orphaned subheads, and the runt ends of chapters or sections are certain to require reproportioning some spreads.

A rigid design that demands an invariant page depth is therefore inappropriate for a work of any length. Altering the leading on short pages to preserve a standard depth (vertical justification, as it is sometimes called) is not a solution. Neither is stuffing extra space between the paragraphs. These antics destroy the fabric of the text and thus strike at the heart of the book. Architects build perfectly proportioned kitchens, living rooms and bedrooms in which their clients will make, among other things, a mess.

Typographers likewise build perfectly proportioned pages, then distort them on demand. The text takes precedence over the purity of the design, and the typographic texture of the text takes precedence over the absolute proportions of the individual page. If, for instance, three lines remain at the end of a chapter, looking forlorn on a page of their own, the design must flex to accommodate them. The obvious choices are: (1) running two of the previous spreads a line long (that is, adding one line to the depth of two pairs of facing pages), which will leave the final page one line short; (2) running half a dozen of the previous spreads a line short, thereby bumping a dozen lines along to the final page; or (3) reproportioning some non-textual element — perhaps an illustration or the sinkage, if any, at the head of the chapter. Spacious chapter heads stand out in a book, as they are meant to. Reproportioning

Generous indents add distinction to paragraphs within the text columns of this newsletter. The indents are clearly deeper than an em—and deeper, even, than the rag range—but not so much as to throw the rag and the alignment into question.
Interkool | Germany

Another alternative is the "hanging indent"—the first line hangs outside the lines following it. This may be done whether there is additional space between paragraphs or not. Hanging indents very clearly establish the beginnings of paragraphs and may also help a reader count lines as another reference point while scanning text. On the other hand, hanging indents require extra space between columns that appear next to each other in horizontal configurations. The use of a hanging indent is somewhat unconventional and may be distracting.

Finally, a designer has the option of introducing a specific space between paragraphs that is different from both hard return and text leading. This option is as appropriate as any of the others already described and requires some study on the part of the designer to determine the measure of the space. A good place to start is to use a measure of one and a half times the leading within paragraphs. With a text leading of 12 points from baseline to baseline, for instance, the measure between the baseline of one

paragraph's last line and the baseline of the first sentence in the paragraph following could be 18 points. This may be more or less than enough space, or exactly the right amount, depending on the designer's sensibility.

Sometimes, a paragraph begins with a short introductory phrase, usually referred to as a subhead. The designer should first determine the space between the subhead and introductory paragraph, if any. The first line of the paragraph may follow the same leading, baseline to baseline, from the subhead as its subsequent lines do. Or, the subhead may have a distinct space following it. If this is to be the case, the space between the end of a paragraph and the subhead of the paragraph following must be clearly different than the space between the subhead and the text it introduces.

An empty space is undefined except by its shape. As soon as a typographic element is added, the space is changed. If the type element is a single letter or word, the space focuses attention upon it; it is a point or shape within the space. A sequence of words in a sentence becomes a line: a line of thought, but also a visual line. No matter how simple, the intrinsic quality of type is that of thought and image combined into one form. Aside from what the type says or means, it must always be thought of as a visual element with its own distinct formal qualities.

Breaking Space within a Format

A single line of type, therefore, has the qualities of a line: it is directional, it lacks volume or mass, it has a beginning and an end, and it divides the space in which it is placed. A line of type divides a format into two spaces—one space above the type, and one below. If the line is placed in the optical center of the space, it is passive and neutral, as are the spaces around it. Shifting the line to the left or right changes the space: the opening it creates joins the spaces above and below, creating movement. Additionally, the type element comes into close relation with the edge of the format, creating tension that counteracts the openness of the space it has left.

Activating Negative Spaces

The space in the composition has become active. Moving the line of type off the horizontal center breaks the space proportionally; no longer equal, each space has its own quality and a relationship to the other. One is larger, one is smaller, and all the spaces are activated. Subsequently breaking the space with additional elements divides the format into additional zones, and each zone also has a proportional relationship to the others and to the format as a whole. The more even the proportions of these zones, the more neutral and passive the composition. The more varied the proportions, the more dynamic. A dynamic quality is often considered desirable, because it involves the viewer and stimulates the eye. Passive compositions, in which the spatial proportions are very regular, convey a sense of monotony, and they give the impression

An introductory title for a paragraph— a subhead—may often be present. Considering its spacing in relation to that between paragraphs can help to clarify the relationships of these elements to each other, as well as introduce further visual detailing and texture onto the page.

Architects build perfectly proportioned kitchens, living rooms and bedrooms in which their clients will make, among other things, a mess. Typographers likewise build perfectly proportioned pages, then distort them on demand. The text takes precedence over the purity of the design, and the typographic texture of the text takes precedence over the absolute proportions of the individual page.

If, for instance, three lines remain at the end of a chapter, looking forlorn on a page of their own, the design must flex to accommodate them. The obvious choices are: (1) running two of the previous spreads a line long (that is, adding one line to the depth of two pairs of facing pages), which will leave the final page one line short; (2) running half a dozen of the previous spreads a line short, thereby bumping a dozen lines along to the final page; or (3) reproportioning some non-textual element—perhaps an illustration or the sinkage, if any, at the head of the chapter.

Spacious chapter heads stand out in a book, as they are meant to. Reproportioning the sinkage is therefore a poor option unless all chapter heads can be reproportioned to match. And running six spreads short is, on the face of it, clearly a greater evil than running two spreads long. If there are only a few pages to the document, the whole thing can, and probably should, be redesigned to fit the text. But in a book of many pages, widow lines, orphaned subheads, and the runt ends of chapters or sections are certain to require reproportioning some spreads. A rigid design that demands an invariant page depth is there-fore inappropriate for a work of any length. Altering the leading on short pages to preserve a standard depth (vertical justification, as it is sometimes called) is not a solution. Neither is stuffing extra space between the paragraphs. These antics destroy the fabric of the text and thus strike at the heart of the book.

Architects build perfectly proportioned kitchens, living rooms and bedrooms in which their clients will make, among other things, a mess. Typographers likewise build perfectly proportioned pages, then distort them on demand. The text takes precedence over the purity of the design, and the typograph-

ic texture of the text takes precedence over the absolute proportions of the individual page. If, for instance, three lines remain at the end of a chapter, looking forlorn on a page of their own, the design must flex to accommodate them. The obvious choices are: (1) running two of the previous spreads a line long (that is, adding one line to the depth of two pairs of facing pages), which will leave the final page one line short; (2) running half a dozen of the previous spreads a line short, thereby bumping a dozen lines along to the final page; or (3) reproportioning some non-textual element—perhaps an illustration or the sinkage, if any, at the head of the chapter.

Spacious chapter heads stand out in a book, as they are meant to. Reproportioning the sinkage is therefore a poor option unless all chapter heads can be reproportioned to match. And running six spreads short is, on the face of it, clearly a greater evil than running two spreads long. If there are only a few pages to the document, the whole thing can, and probably should, be redesigned to fit the text. But in a book of many pages, widow lines, orphaned subheads, and the runt ends of chapters or sections are certain to require reproportioning some spreads.

A rigid design that demands an invariant page depth is therefore inappropriate for a work of any length. Altering the leading on short pages to preserve a standard depth (vertical justification, as it is sometimes called) is not a solution. Neither is stuffing extra space between the paragraphs. These antics destroy the fabric of the text and thus strike at the heart of the book. Architects build perfectly proportioned kitchens, living rooms and bedrooms in which their clients will make, among other things, a mess.

Typographers likewise build perfectly proportioned pages, then distort them on demand. The text takes precedence over the purity of the design, and the typographic texture of the text takes precedence over the absolute proportions of the individual page. If, for instance, three lines remain at the end of a chapter, looking forlorn on a page of their own, the design must flex to accommodate them. The obvious choices are: (1) running two of the previous spreads a line long (that is,

The hanging indent of starting lines of paragraphs in this example creates a beautiful, as well as informational, detail that influences the structure of the page.

The structure of paragraphs and columns and, more minutely, the detail of letterform construction and spacing that gives rise to it, are the essential components of the typographic designer's toolkit. Understanding how these basic details—the micro-level—affect the composition of text elements within a format is the first step in developing sensitivity for the design of type. The next step is to investigate and understand the macro level.

It's been said that typography has little to do with typefaces and their style, being more about what one does with them. In one sense, the visual qualities of a specific typeface can be ignored while focusing on more interesting things like layout. On the other hand, the very essence of the type form—the letters, and their myriad interconnections and relationships with others, with space, with texture, and with rhythm—is extremely important. Anything a designer does with a typeface is fundamentally predicated on those tiny formal interactions… but on a larger scale. Typography as a visual discipline exhibits an interesting quality of relating the parts to the whole.

The big picture is made up of parts and is very much characterized by how those parts act. The reverse is also evident: the big picture acts on those individual parts, casting them into new roles. It's very much an open natural system, like the swirl of a snail shell or a fractal, and is, therefore, exceedingly organic; despite the mechanized digital veneer of production, the essence of typography is language… and there's not much that's more organic than that.

TYPOGRAPHY FUNDAMENTA

Form and Function

Building the Bigger Picture

Space: The Typographic Frontier

Where does all this typography happen? It happens in space—what designers refer to as typographic space. This vague term describes a conceptual area where the boundaries of speech, sound, vision, and thought are blurred. More simply put, typographic space is a blank page or screen where language has to be transformed into something visual. This space can be something as banal as a train schedule or as visceral as an animation. The function of the typographic space remains the same: it is a format, a page, a dimension that the type will exist on, around, and within.

It is easy to imagine space without other things—such as type—in it. But type can't be considered without regard to space. Type and space interact in a figure/ground relationship that is mutually dependent. Type—the figure, or positive element—defines the qualities of the space that it breaks; space—the ground—defines the qualities of the type that exists within it, focusing the eye and directing it around the type forms. Both are equally important parts of a composition and must be considered simultaneously.

The Nature and Quality of Space

The quality of a space is given meaning by its shape. A space is defined in practical terms as a format—the physical dimensions of a project to be designed. For example, a client who orders a brochure must first select among numerous variations. Selecting a format depends on the nature of the content and on the kind of presence the designer wants to establish for it: whether it should be active, passive, or neutral. The proportions of a format can go a long way in communicating a general feeling to the viewer, and the organization of the type is colored by these proportions from the beginning.

The interdependency of type and space is relative. The presence of the same typographic element can become completely different depending on how it relates to the format. Conversely, the same space can be dramatically altered by changing the size and position of the type within it.

word word word

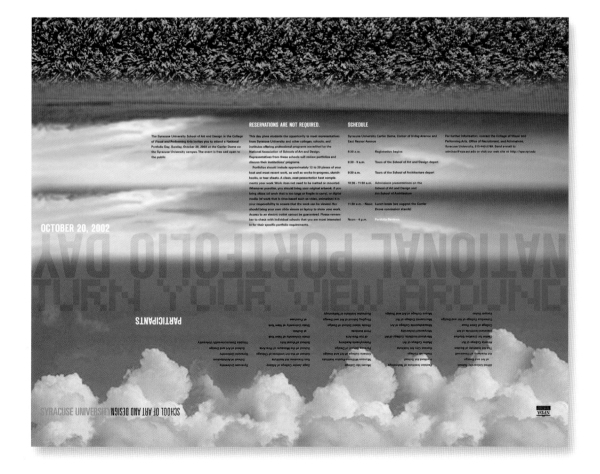

A square format has a neutral quality because of the even stress in all directions created by its equal sides. Vertical formats force the optical thrust upwards, and impart an active feeling; the proportions of a vertical format have a visual relationship with the upright presence of the human body. As the format widens, it becomes more passive and more restful, taking on the quality of a landscape. The stress is shifted outward toward the sides.

Breaking space into zones for informational components not only helps clarify the content, but may also contribute to the concept of a given piece. At left, the information is broken up in relation to the background image, a surreal flop that affects the orientation of the text.
stressdesign | USA

A passive composition of one line of type, centered within a format, is activated by shifting the line off center, either vertically or horizontally. Each change in the type's position alters the spaces that are created in relation to each other.

typographic work

typographic work

typographic work

Breaking Space

Organizing type within a format is both an additive and reductive process. Each element that is brought into the space adds texture and complexity, but it also decreases the amount of space in the format, forcing it into distinct shapes around the type like a puzzle. These spaces are integral to achieving flow through the type and providing a sense of order and unity throughout a composition. The system of spaces broken by the type is extremely important in helping the viewer navigate around various elements—text, callouts, and titles, among others.

An empty space is undefined except by its shape. As soon as a typographic element is added, the space is changed. If the type element is a single letter or word, the space focuses attention upon it; it is a point or shape within the space. A sequence of words in a sentence becomes a line: a line of thought, but also a visual line. A single line of type has the qualities of a drawn line: it is directional, lacks volume or mass, has a beginning and an end, and divides the space in which it is placed. A line of type divides a format into two spaces—one space above the type, and one below. If the line is placed in the optical center of the space, it is passive and neutral, as are the spaces around it. Shifting the line to the left or right changes the space: the opening it creates joins the spaces above and below. Additionally, the type element comes into close relation with the edge of the format, creating tension that counteracts the openness of the space it has left. Moving the line of type off the horizontal center breaks the space proportionally; each space now has its own quality and a relationship to the other. Subsequently breaking the space with additional elements divides the format into additional zones. The more even the proportions of these zones, the more neutral and passive the composition. The more varied the proportions, the more dynamic. A dynamic quality is considered desirable, because it involves the viewer and stimulates the eye. Passive compositions, in which the spatial proportions are very regular, are monotonous, and give the impression that all the elements are of the same value.

The division of space creates structure. Structure is what unifies disparate elements in a composition. The structure in a composition with one line of type is simple, but it's a structure nonetheless. Several lines of type together create a different kind of structural relationship to the format than a single line of type. It is related to the line of type but visually contrasts with it. This mass of texture further defines the space around it into channels that correspond to its height and depth, and between itself and the format in all directions. Separating elements within a grouping maintains a sense of the mass; it also introduces a greater complexity of structure by further subdividing the space. Structure may be improvised or planned. Improvising structure within a format depends on the content of the type; if the arrangement is determined only on a visual level, it may not communicate clearly: the order of the words and the order in which groups of words are read are important. The visual structure must evolve out of the verbal structure of the language.

T Y P O T Y P O

Adding space between letterforms (above) calls attention to their individual identities and transforms them into dots. As they come closer together, the linear aspect of the word dominates.

An unusual arrangement of type in this book spread, at right— running vertically, but canted at a slight angle—creates ambiguity and interest, as well as a sense of deep illusory space.
Brian Jacobson | USA

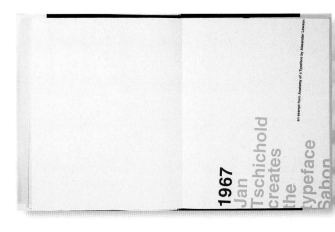

An excerpt from Anatomy of a Typeface by Alexander Lawson

1967
Jan Tschichold creates the typeface Sabon

Spatial relationships based on the messages within the text are the basis for this poster's austere and simple, yet complex, composition. The alignments and proportional areas they define are further enhanced by changing the spatial units' colors to create optical depth.

Philippe Apeloig | France

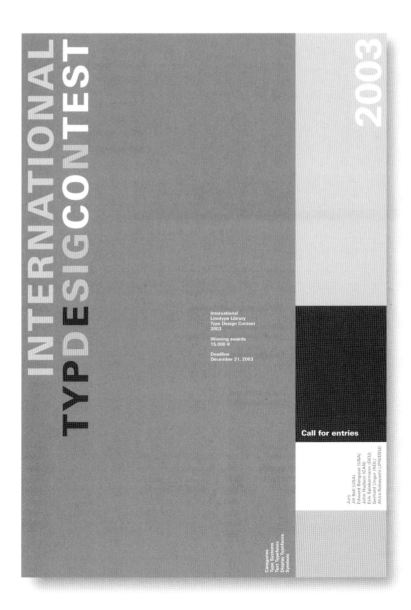

Space is neutral until it is divided. Breaking the space into units of even proportion activates the space, but the space is still relatively passive. Changing the size and proportion of the divisions establishes a sense of the points of alignment and casts each unit of space into a unique relationship with the ones around it. The interaction of these contrasting spaces helps to engage the viewer.

Alignments, Masses, and Voids

The verbal sense helps define what material within it may be mass or line. A continuous sequence of thoughts will likely be clarified if they cluster together; a distinct thought may benefit from being separated from the others. Both elements are positive forms—the figure within the composition. They are in contrast to each other, as well as to the spaces around them. The relationship of typographic mass to these voids within the format is the essential relationship to be defined in typographic space, as it is in defining the rhythm of letterspacing and the space within a paragraph. The considerations are the same, but take place on an expanded scale. Regular intervals between masses and voids—unlike in letter-spacing, wordspacing, and leading—are undesirable, because regularity implies sameness, and not all the type elements are the same: they mean different things. Changing the proportions between masses and voids helps impart meaning to them, as well as engages the viewer on a visual level. Elements that are related may be clustered together. Separations between individual or clustered elements indicate they are different in their meaning. On a visual level, the designer also creates contrast and rhythm within the composition by changing the proportional relationships between solids and voids. As type elements divide space in proximity to one another, their points of alignment become another important consideration, in addition to the relation of solid and void. Aligning elements augments the sense of relationship between them. Further, alignments between elements help create directional movement through them within in the format.

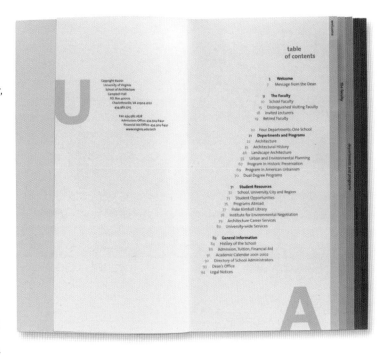

The information listed in this brochure's table of contents is set along a diagonal alignment that crosses the gutter and involves the entire spread. Large tinted letterforms add a spatial transition from the solid type to the white page. The colored banding of the stepped page trim allows for quick reference from content listing to section.
Keith Godard | USA

The Typography Workbook
A Real-World Guide to
Using Type in Graphic Design
Timothy Samara
Rockport Publishers
Gloucester, MA

The Typography Workbook

A Real-World Guide to
Using Type in Graphic Design

Timothy Samara

Rockport Publishers
Gloucester, MA

The Typography Workbook

A Real-World Guide to
Using Type in Graphic Design

Timothy Samara

Rockport Publishers
Gloucester, MA

Creating distinctions between separate thoughts accomplishes two things: first, the opportunity to clarify the parts of the message is greatly increased; second, the increased activity of the space resulting from the separations adds visual interest and helps engage the viewer.

In the first composition, the elements are clustered together in a passive relationship with the space of the format.

In the second, visual structure is created when elements are positioned to subdivide the format. Differentiating the elements in separate parts can clarify the information and create a more active visual structure.

In the third composition, the alignment of particular elements establishes a similarity of meaning among them. Separating an element from the primary alignment distinguishes that element.

Tables contain specific information for clarification and comparison. Well-designed tabular setting allows generous space for its components without disconnecting them. The proportions of the columns and rows, and how the elements align, contribute to the table's clarity.

Jack Design | USA *top*
Ideas on Purpose | USA *bottom*

Breaking Space within Text: Tabular Structure

Space around text elements within the overall format helps direct the eye through the composition and clarifies their shape. Space can also be used to separate material within a text element, such as a table. For example, a table of financial information provides a viewer with groups of numbers that may be added up or compared in terms of specific variables. Each variable to be considered must operate along a particular axis, and the specific values related to each variable must be separated spatially to distinguish them from one another. The tabular paragraph is a matrix of exploded thoughts separated into rows and columns. In using space to break information into a table, consider the number and sizes of elements that must be tabulated and, therefore, the number of alignments that must be introduced to accommodate them. The number of alignments needed in the table—how many times the space must be subdivided—affects how close the values in the table are to each other and, therefore, how large their point size may be. The length of the informational components determines the minimum width for the columns; the complexity of the list determines how much space is needed vertically between the rows. Alignments within the table will depend on the nature of the information. If the table consists of numbers, such as financial data, the components will need to be aligned at the right of each column or aligned around a decimal point so that their numeric values are clear in comparison.

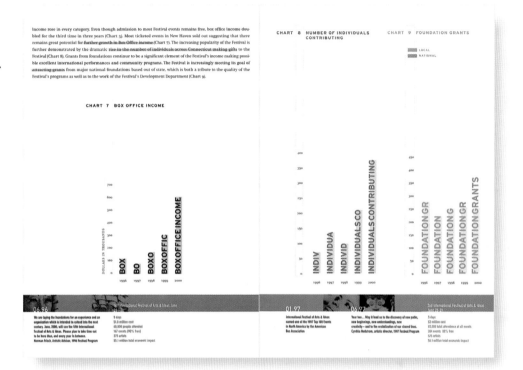

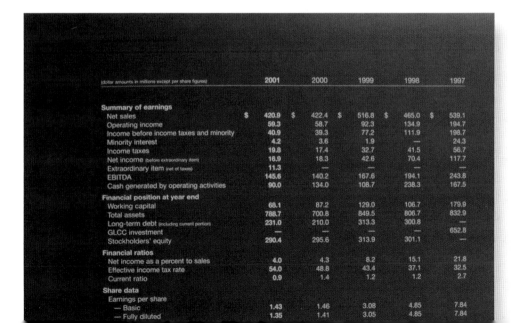

Typographic Color
The Visual Texture of Language

Contrast!
The key to good type layouts is contrast. Use one or two type families for a unified feeling, but make sure they're very different, and that each has a full complement of weights.

Similar-sized elements break a format's space across a single plane at what is perceived to be the surface. Changing the typographic color of the elements—altering their scale relationships or their visual darkness, or weight—separates them from the surface and introduces the illusion of spatial depth.

Typographic color is similar to chromatic color—like red, blue, or orange—but deals only with changes in lightness and darkness, or value, not hue. It is also different from the qualities of chromatic color in that it describes changes in rhythm and texture. Typographic elements may be small or large, dark or light, closed or open, linear or volumetric. These are the changing variables of typographic color that allow the eye to perceive them as occupying different locations in illusory deep space. The perception of depth

is very much keyed to the functioning of the human optical system and how the brain interprets visual stimuli in the world of experience. A larger element, for example, appears closer than a smaller element, because of the way the eye transmits images of objects that are closer or further away. A lighter element appears to recede into the distance for the same reason. A texture appears to flatten out, and its shape and value are more important in determining its spatial depth than its components. A line appears to come forward regardless of its weight, but a heavier line comes further forward than a narrow line. A typographic color change allows a designer to highlight structure and invigorate a page.

A A A **A** ፴ A **A** A A

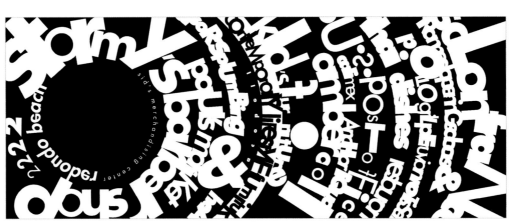

Dramatic scale changes, even using a single typeface, create dynamic typographic color.
Leslie Cheung | USA

Point, Line, and Plane
The Expanded Typographic Repertoire

The archetypal structure of letterforms—configurations of lines and dots—is transformed by their organization: a grouping of letters and words in sequence becomes a line, a grouping of lines of type becomes a plane. Indeed, the individual letter is itself a dot. A random grouping of letters in space emphasizes their individuality. As they come closer together, their individuality is lost and their unity as a word is emphasized. Words separated by space are also points whose individual shapes are dominant; these shapes become secondary as the words are sequenced into a line. Since these formal qualities exist in letters and words themselves, actual drawn lines, dots, and geometric forms can also, by their nature, be typographic elements.

No need for the typographer to restrict him or herself to letters and numbers–dots, lines, and abstract shapes offer a world of additional possibilities.

Dots of different sizes and arrangements can act as points of reference, divide spaces, or become shapes in and of themselves, depending on how they are used.

Dots
The dot defines a location in space and can act as a point of reference, indicating a beginning or calling attention to type that appears next to it. Dots can also indicate structure, referring to the crossing points of imaginary lines or of alignments between type elements. The size of a dot is essential to defining itself as such. At the instant its size increases so that its outer contour becomes noticeable, it becomes a circular mass (as distinguished from a circle, which is a curving line that joins itself without end). A circular mass can be interpreted visually as a plane or as a sphere with weight.

Mixing Typefaces

Choosing a variety of typefaces to use in a single project depends on the functional nature of the content, not just the visual effect of their combination. Using several type families together increases the textural quality of typographic color, but mixing too many different faces may become visually confusing: what do these changes signify for the viewer? Are any of the items related? As a general rule—which may, of course, be broken in the right context—using two type families within a project is sufficient for visual variety. The choice of typefaces to mix must be decisive. There must be enough stylistic contrast between them so that their individual qualities are clearly seen.

Mixing two similar weight oldstyle serifs, for example, will seem an ambiguous decision—their qualities may be somewhat different, but overall they will seem too similar and the choice to mix them arbitrary. Using two serif faces that are radically different—a modern serif and a chunky slab serif, for instance—will make a clear visual statement. The designer can use these differences to differentiate complex information within a layout. By assigning certain styles or weights to captions, text, and headings in a book, for example, the designer gains not only the added visual activity, but helps clarify the information for the viewer.

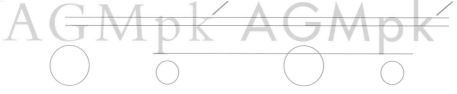

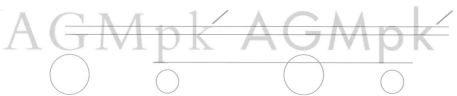

In choosing to mix typefaces, be sure to select counterparts with enough contrast—but be aware of their similarities as well. In this example, the serif and the sans serif are radically different in stroke contrast and detail, but their construction is similarly geometric.

Two type families—an oldstyle serif (Garamond) for text and a sans serif (Futura Condensed) for support information—help separate complex information in this book spread.

The typeface choices become a kind of system the reader can use to navigate through content. Captions are in two weights of Futura; running text is set in Garamond, with special callout text set in the italic. The two families contrast each other, but the designer's attention to their scale and weight relationships unifies them within the layout.

Yoshino Sumiyama | USA
*School of Visual Arts, New York;
Timothy Samara, instructor*

Texture and Rhythm in Typographic Color

Changing the typographic color of elements in relation to one another introduces rhythmic variety into type compositions. It also gives the designer further options for separating information, as well as adding visual interest. Combining various weights and sizes within a single family of type—for example light, regular, and bold weights—will yield an overall unity because the styles are all structurally related, while introducing a rich variety of spatial perceptions. Scale changes affecting a single weight or style will likewise change the presence of the various components: as the scale of a lightweight face increases, it will appear to become bolder than its smaller sized counterparts. These kinds of changes affect not just the boldness and apparent depth of the elements, but also their linear, or textural, qualities. Smaller type running in lines creates texture that contrasts in volume with large-scale letterforms or words. The openness or tightness of leading between such lines will similarly affect the quality of the texture itself. More interline space calls attention to the individual lines of type; less interline space causes the textural gray aspect to dominate, and the overall shape of the text block becomes more apparent than its internal linear structure.

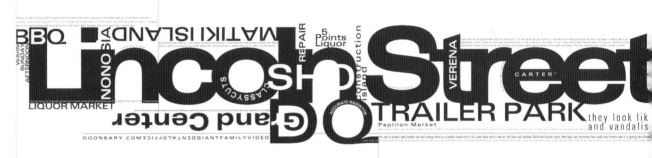

The rich variety of typographic color within this poster (right) relies on a single type family— Univers—in all its weights and widths. Textural elements contrast bold large-scale forms.
Amanda Raymundo | USA
Otis College of Art + Design, Los Angeles: Clane Graves, instructor

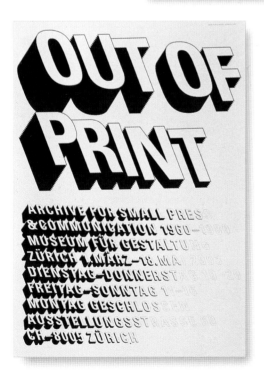

Elements of changing typographic color support the conceptual communication in this poster. Not only do the forms themselves change in weight, but they are also progressively tinted lighter to fade out.
Ralph Schraivogel | Switzerland

Two typefaces combine for an elegant presentation in this wine bottle label. The proportions of the serif used for Paone and the sans serif used for Grappa are similar, helping to visually unify them despite their differences.
Paone Design Associates | USA

A sentence set twice in the same point size and style but in two different weights. The bold sentence appears spatially in front of the lighter sentence. It is also darker and appears tighter, having a more aggressive rhythm.

Typographic color is independent of chroma.

Typographic color is independent of chroma.

the subtlety of form in small-size lines of type

is exaggerated in larger sizes
and more so in bold weight

but ambiguous when tinted

The large type appears to be closer to the surface than the line of smaller type. The scale of the large letterforms reveals the quality of the strokes and emphasizes their linear nature, while this linear quality dominates the individual character of letters in the smaller type. The larger type comes forward when solid, but its depth relationship becomes ambiguous when it is tinted a lighter value.

The designer of this poster achieves dramatic typographic color through the interplay of tightly spaced, condensed forms and smaller, more open lines and negative spaces.
Atelier Varga | Switzerland

Energy and matter are neither destroyed nor ever created.

They only appear to be as they change their forms

Combining lines of different weights creates a sense of spatial depth. The character of lines in groups changes depending on how they interact, whether repeating, slanting, crossing, or breaking; they become a texture when the space between them is reduced. Lines of dots or dashes impart texture and activity.

Angled lines contrast starkly with typographic material, which is primarily vertical and horizontal. Repeating a perpendicular angle in a stepped progression relates to the vertical and horizontal motion of type.

Lines

There are two kinds of lines in typographic design. The first kind is the invisible, or imaginary, line that appears to exist between type forms in space. Two elements that appear in a direct and uninterrupted relationship are connected by an imaginary line, and this line creates a sense of direction and movement between them. The quality and direction of that movement depend entirely on the size and weight relationship of the two elements; movement will be perceived as proceeding from the less dominant element to the more dominant. Alignments among elements in a composition are another example of the imaginary line.

The second kind of line is the concrete line, a line that is real. The nature of a line is defined by the space around it. A single line appears to be a positive element on a background, as does a group of lines with ample space around them. The quality of a line is related to its thickness, or weight. The heavier the line becomes, the more static it becomes, eventually transforming into a solid plane. A line can also be understood as a dot in motion; a sequence of dots in decreasing intervals describes a line that is moving in a particular direction. A line is dynamic and directional, and because of its formal affinity with lines of type, it is structural and spatial as well. Lines can help divide information, emphasize portions of it, enclose it, connect it, or highlight it.

Curved lines show dramatic movement and appear to expand in space, contrasting with the horizontal and vertical motion of type. A line curved into a spiral creates the impression of moving inward and outward simultaneously. Wavy lines are soft, organic, rhythmic, and fluid.

Shapes

Geometric shapes are also an interesting option for the typographic designer to employ in compositions. Their abstract, hard-edged qualities can be visually similar to letterforms and, therefore, integrate easily with them. Their ability to integrate with type forms, yet retain their identity as images, means they can create visual links between type and pictures or serve as images themselves. An abstract shape can act as a housing for type elements or provide transitions between foreground and background in a layout.

Abstract shapes relate to letters in their architectural simplicity. They may act as objects, like the type itself, or fields upon which typographic elements can be arranged.

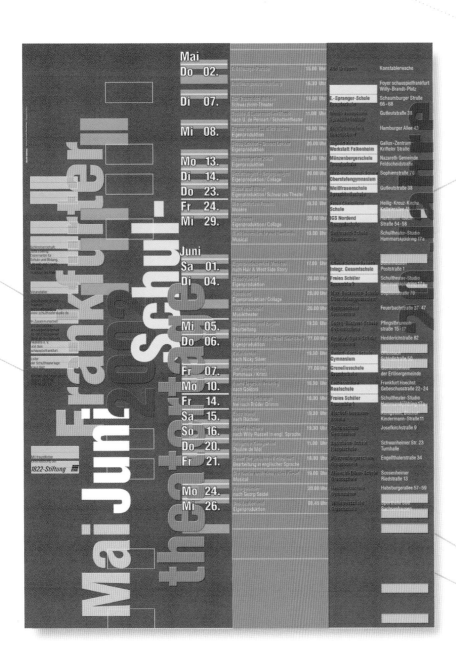

Schultheatertage *poster*
Büro fur Gestaltung | Germany

Delhi *composition study*
Elizabeth O. Hawke | USA

*Dots and lines performing
various functions: as structural
devices; as markers or indicators;
as decorative elements; and
as communicators.*

Oslo *composition study*
Travis Simon │USA

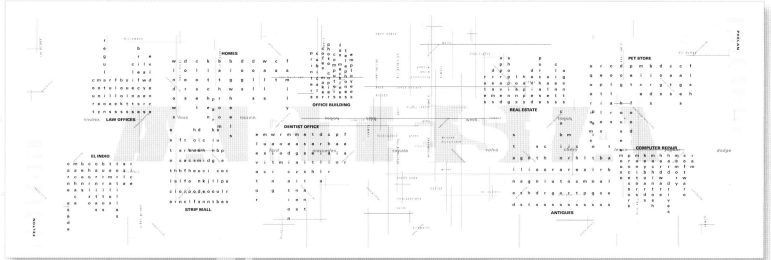

Artesia *mapping study*
Oscar Genel │USA

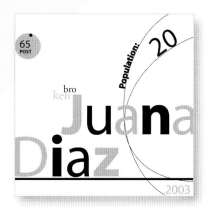

Juana Diaz *composition study*

Developing Hierarchy
Clarifying the Content

One of a designer's most important tasks is helping a viewer understand information in a way that makes sense. Whether a business card, a complex table, or poster, information must be given an order that allows the viewer to enter the typographic space and navigate it. This order, called the hierarchy of the information, is based on the level of importance the designer assigns to each part of the text. Importance ranks the parts that should be read first, second, third, and so on; it also refers to the distinction of function among the parts: running text, for example, as measured against other elements like page folios, titles and subheads, captions, and the like. Determining a hierarchy is the result of reading the text and asking some simple questions:

The answers to these questions are often common sense. In a poster, for example, the poster's subject is most important, so it makes sense that the poster's title should be the first type the viewer sees. In a table of financial information, the viewer needs to understand the context of figures being presented, so the headers, which describe the meaning of the figures, need to be easily located. In the pages of a book, where running text may interact with captions, pull quotes, and other details, the running text needs to occupy a consistent area and be visually noted as different from these other elements. The effect of these decisions is simultaneously verbal as well as visual: treating different parts of a text in different ways changes their color and rhythm in the layout.

Distinctions of Space and Scale

There are a number of ways a designer can differentiate the separate text components within a design. One option is through spatial organization. Grouping related items together, or aligning them along an axis, establishes a sense of regularity to them. By shifting a specific item out of alignment, attention is called to it, and this difference of location alerts the viewer to its importance over the

What are the parts of the information to be designed?

What ought to be the main focus of the reader's attention? Does the viewer need to see a certain grouping of words before focusing on the main part?

How do the parts that are not the main focus relate to the part that is?

SP ARCHITEKTEN AG

Hierarchic concerns play a role in this logo for an architectural practice. The regular geometric rhythm of the letterforms, along with their close wordspace and medium-value gray color, creates a uniform line of strokes.

The initials S and P of the firm's principals are rendered in black, creating a hierarchy between them and the word Architekten—because it places importance on the identifying aspect of the firm's name, not its function.

The plus sign that joins the initials together, although in gray, remains distinct.

The corporate signature AG is distinguished from the remainder of the type lockup by a different

space—an actual wordspace. This separation from the other elements marks this component as less important overall.
Niklaus Troxler | Switzerland

other elements that remain within the grouping. The greater the number of spatial distinctions created, the greater the differences between them must be. More components in a fixed format means that the spaces around them become more even and, by default, these elements will tend to have a similar presence. The result is a flattening out of the hierarchy. In concert with alignment-related spatial differences—distributing material at intervals across the surface—the designer may also use scale change to indicate levels of importance. Larger elements appear to advance in space, calling attention to them. Smaller elements appear to recede. In effect, the optically perceived depth of elements helps to clarify their importance in relation to one another— their apparent nearness or distance signifies their position in the hierarchy. Scale change among elements, unlike alignment distinctions, changes the typographic color of the elements as well, introducing contrast in light and dark, tension and stasis. A single typeface in one weight, for example, will appear bolder if set at a larger size.

This poster sets up a complex hierarchy among its informational components using changes in weight and typeface style to group or distinguish them from each other. The title, for example, is set in a black-weight serif at the upper left; its weight and rhythmic curved forms bring it to the top of the hierarchy. At the next level down, the column of black type at the right organizes more specific information into a recognizable form—a column. Large-scale typographic image material in the background is sent to the lowest part of the hierarchy through the use of color.
Studio di Progettazione Grafica | Switzerland

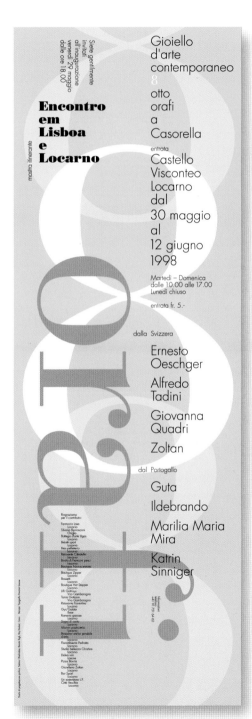

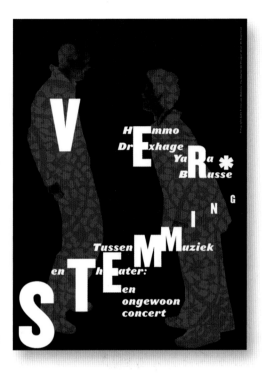

The scale relationships among the typographic elements in this postcard (above) create a simple, but unexpected, hierarchic structure. The individual letters of the title are unified into a strong spatial form that distinguishes it from the surrounding type.

However, the letters of the title are also letters that form part of the hierarchy's secondary level in a single, smaller size so that their complete thoughts are easily read.
Faydherbe/DeWringer | Netherlands

The raw text presents itself in a passive composition, lacking visual interest and informational clarity. The power of minute changes to create hierarchy is demonstrated in the second study: the first line of each major section has been set in bold. In the third study, a column structure groups information of related importance together that plays off a dramatic change in scale for the primary information—the title and subject matter of the poster. The fourth study clarifies the hierarchical levels and allows the type to interact with the negative space in the format. The fifth study adds optical depth to the hierarchic levels by enhancing their spatial separation with chromatic color changes.
Timothy Samara | New York

Walking Skyscrapers
New York City Walking Tours
NYU School of Architecture
Continuing Education Program
Fall 2004

Experience the history and variety of Manhattan's
noteworthy architectural wonders—the skyscrapers
that have given the city its signature skyline and
inspired its residents for nearly one hundred years.

Tour Programs

The Flatiron District September 17
New York's first scyscraper and the industrial
buildings of the early 20th Century

Lower Manhattan September 24
Explore the concrete canyons that rose up on
the site of New Amsterdam

Midtown October 5
The corporate megaliths of the 1970s and 1980s

Sign up now! Space is limited.
$125 per three-hour tour. Purchase the package of
three for $275

Call the office of Continuing Education at NYU:
212.555.2259 or visit us on the Web at
www.nyu.edu/arch/walk.html
One academic credit
Tours are open to the public

Walking Skyscrapers
New York City Walking Tours
*NYU School of Architecture
Continuing Education Program*
Fall 2004

*Experience the history and variety of Manhattan's
noteworthy architectural wonders—the skyscrapers
that have given the city its signature skyline and
inspired its residents for nearly one hundred years.*

Tour Programs

The Flatiron District September 17
New York's first scyscraper and the industrial
buildings of the early 20th Century

Lower Manhattan September 24
Explore the concrete canyons that rose up on
the site of New Amsterdam

Midtown October 5
The corporate megaliths of the 1970s and 1980s

Sign up now! Space is limited.
$125 per three-hour tour. Purchase the package of
three for $275

Call the office of Continuing Education at NYU:
212.555.2259 or visit us on the Web:
www.nyu.edu/arch/walk.html
*One academic credit
Tours are open to the public*

Typographic Color and Hierarchy

Typographic color plays an important role in establishing hierarchy. Changes in weight, texture or value, and rhythm also signify differences between elements, in addition to the differences implied by spatial separation. Those elements that appear to advance forward compete for attention, occupying the top level in the hierarchy. Smaller or lighter elements, which appear to recede, decrease in relative importance because they become less active. Contrast in typographic color between elements must be treated carefully, especially among complex or disparate elements. One might assume that making everything in the space as different as possible would clearly indicate their hierarchy, but the opposite is actually true. If all the elements appear very different, they also appear equally important to each other, and the sense of hierarchy among them is destroyed.

At first appearance, all text looks equally important in raw form. If placed on a page as is, the words form a uniform field of texture. By manipulating the spaces around and between text, the designer creates levels of importance. The uniformity that is usually desirable to keep the reader moving is thereby purposely broken, creating a fixation point. The fixation point is interpreted as deserving attention and is, therefore, more important than the other elements.

In a complex compositional framework, the pages of a book for example, spatial differentiations not only distinguish the importance of elements but also their function. The primary text for reading is located in a prominent, central area of the page—it is the focus of the format, the reason the format exists and exists in a particular shape. The title for a section of text also appears in a specific location. As a result, it is clearly not running text, regardless of size or other treatment. At the top or bottom of the page spread, the title of the book or the title of the chapter may appear in the same place on every spread. This running header (or running footer, respectively) is obviously not a title, because it is not in proximity to the beginning of the running text. Its distance from these elements signifies its function as an element of secondary importance.

scale change

color variation

alignments

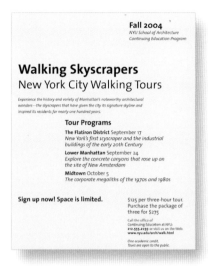

The spatial separation of elements in the layout of a book spread helps define their functions and relative importance.

The proportions of the pages focus attention inward on the text. In this, all the typographic elements are the same size and weight, but clearly the elements outside the text area are less important than the text itself.

Another example of the book page spread, although this time, the typographic color of the elements is also a factor in establishing their hierarchy. The chapter title becomes more important when set in a bold weight. The color of the

other elements acts in concert with their spatial distinction to exaggerate the hierarchy. The subdued value of the running header has made it even more inconspicuous.

Hierarchies within Text Elements

All the typographic elements within a given space exist in a hierarchical relationship with the others, ranging from most important to least important. The need to establish hierarchy within text elements themselves may also be evident. Captions, tables, and lists are examples of complex texts that may benefit from internal hierarchic distinctions.

Complex Captions

A caption is a short text that describes an image appearing on a page with the primary text. A caption is usually of secondary or tertiary importance within a page hierarchy. The content of the caption, however, may need its own internal hierarchy. It may, for example, include a reference number or letter that associates it with the image it describes. This is often true if several captions are located in one area while the images they describe appear elsewhere. Each image and its caption may be numbered or indicated by a letter or other marker—"opposite," "above," and "at right," for example. The body of the caption may include distinct informational components independent of its description: for example, the date a photograph was taken, or the identity of a photographer. The caption may even be a collection of components, rather than sentences describing the image. A caption for a piece of art may consist of a title; an indication of the medium used; physical dimensions; duration of film or video work; the identity of the creator; and the date of creation. The components of such a caption must be distinguished for readability. The viewer will want to locate specific components of the information repeatedly; a designer may choose to separate components with punctuation or visually contrasting indicators.

Tabular Hierarchies

In a table, the separation between columns and rows of information is an important consideration. By establishing a hierarchy among elements within a table, a designer can help clarify the individual variables, the values being tabulated, and the communicative goal of the tabular information as well. Some values in a table of financial data, for instance, may be a focus—perhaps a company's profit for the most recent year in a table that compares profit by year. These numbers are related to the other numbers in the table but are more important because they represent the current year's profit. In addition to the hierarchy the designer establishes for the table overall, he or she may opt to distinguish this specific information through a change in weight or, perhaps, by enclosing them in a block of tone.

Hierarchy in Lists

A list is a complex text form that may categorize listed items or include text that qualifies specific items. There may also be some relationship between items in different categories. Changes in weight, size, and color will help to establish such a list's internal hierarchy. The designer must pay careful attention to the leading between the various parts of the list so that all of its components are easily separated by the reader.

Hierarchic Treatments in List-Based Prose Text

Text that is neither running, a caption, a list, nor a table, is an odd phenomenon. It is not a list per se, but it may list distinct thoughts in a strange middle ground that is similar to running prose. The most common example of this kind of text includes information related to an event, like location, time, and event speakers. Depending on the text's editorial style, it may be more or less listlike, but each portion can be treated to enhance its accessibility.

Anticipated Memory **MEDIUM** Oil on paper with wire and inclusions, objects, scrap metal, and wood **SCALE** 175cm X 72cm X 9cm **DATE** November–December, 2004 **COLLECTION** The Ryan Estate | The sensuous interaction of the painted surfaces, with the tactile quality imparted by the paper and other materials, speaks to the associations we often make between remembered moments and their physical experiences—especially those yet to occur.

The specific values in this table of financial data are distinguished through changes in typographic color.

Hierarchy within a complex caption. A grouping of informational components is separated from a descriptive sentence in the same caption through a change in width and weight. Within these informational components, the indicators are distinguished by a change in weight and case. The title of the work being captioned is set italic, and larger than the text describing the work that follows the specification details.

	2004	2003	2002
New York	1054.97	997.44	9765.85
Caracas	705.20	584.36	512.52
Los Angeles	**1127.35**	995.82	987.22

A page spread from a brochure containing a list shows a clear overall hierarchy among elements in the spread. Within the list itself, attention to hierarchical detail clarifies categories and qualifying information related to the items in the lists.

C. Harvey Graphic Design | USA

Typography Now—An Exposition
Presented by AIGA New York

23 September, 2004·164 Fifth Avenue
Opening Reception 6:00–7:00pm·Room 3A

Curated by Ellen Lupton, author of *Mixed Messages*
Princeton Architectural Press, 2001

Signed copies available at the reception for $45.00

Typography Now

An Exposition presented by **AIGA NEW YORK**

23 September, 2004
164 Fifth Avenue, Room 3A

6:00–7:00pm
Opening Reception

Curated by Ellen Lupton, author of
Mixed Messages
Princeton Architectural Press, 2001

*Signed copies available at the
reception for $45.00*

Two very different versions of the same complex paragraph showcase the role of typographic designers as a managers of information. The order of informational components, how they are separated or grouped, and how typographic color is used to clarify them, are important parts of typographic design.

The Typographic Grid
Creating Architectural Space

All design work involves problem solving on both visual and organizational levels. Pictures, fields of text, headlines, tabular data—all these pieces must come together to communicate a coherent message. A grid is simply one approach to achieving this goal. Grids can be loose and organic, or they can be rigorous and mechanical. To some designers, the grid represents an inherent part of the craft of designing, the same way joinery in furniture making is a part of that particular craft. The history of the grid has been part of an evolution in how graphic designers think about designing, as well as a response to specific communication and production problems that needed to be solved. A corporate literature program, for example, is a late twentieth-century problem with complex requirements. Among other things, a grid is suited to helping solve communication problems of great complexity.

Using a grid permits a designer to lay out enormous amounts of information, such as in a book or a series of catalogs, in substantially less time because many of the design considerations have been addressed in building the grid's structure. The grid also allows many individuals to collaborate on the same project or on series of related projects over time, without compromising established visual qualities from one project to the next.

Building an effective grid for a given project means thoughtfully assessing that project's specific content in terms of the visual and semantic qualities of typographic space. A grid consists of a distinct set of alignment-based relationships that serves as a guide for distributing elements across a format. Every grid contains the same basic parts, no matter how complex the grid becomes. These parts can be combined as needed, or omitted from the overall structure at the designer's discretion.

The benefits of working with a grid are simple: clarity, efficiency, economy, and continuity. Before anything else, a grid introduces systematic order to a layout. A grid helps distinguish specific types of information and eases a user's navigation through them.

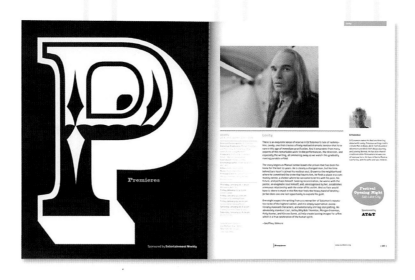

Breaking information— text, pictures, illustrations, and call-outs—across a column grid allowed the designer to quickly lay out many similar pages. At the same time, the grid structure provided flexibility for pictures of different sizes and options for placing illustrations and support information.
AdamsMorioka | USA

The Anatomy of a Grid

Working with a grid depends on two phases of development. In the first phase, the designer attempts to assess the informational characteristics and the production requirements of the content. This phase is extremely important; the grid is a closed system once developed, and in building it the designer must account for the content's idiosyncrasies, such as multiple kinds of information, and the nature and number of images. Additionally, the designer must anticipate potential problems that might occur while laying out the content within the grid, such as unusually long headlines, cropping of images, or dead spots left if the content in one section runs out. The second phase consists of laying out the material according to the guidelines established by the grid. It is important to understand that the grid, although a precise guide, should never subordinate the elements within it. Its job is to provide overall unity without snuffing out the vitality of the composition. A well-planned grid creates endless opportunities for exploration, and a designer should not be afraid to test its limits. Every design problem is different and requires a grid structure that addresses its particular elements. There are several basic kinds of grid, and as a starting point, each is suited to solving certain kinds of problems.

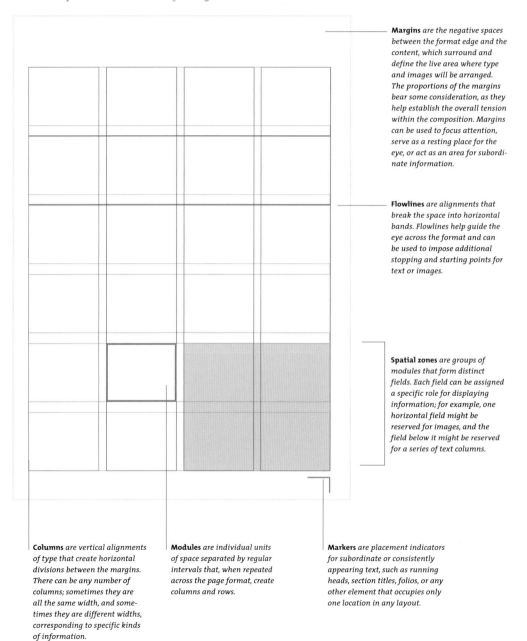

Margins *are the negative spaces between the format edge and the content, which surround and define the live area where type and images will be arranged. The proportions of the margins bear some consideration, as they help establish the overall tension within the composition. Margins can be used to focus attention, serve as a resting place for the eye, or act as an area for subordinate information.*

Flowlines *are alignments that break the space into horizontal bands. Flowlines help guide the eye across the format and can be used to impose additional stopping and starting points for text or images.*

Spatial zones *are groups of modules that form distinct fields. Each field can be assigned a specific role for displaying information; for example, one horizontal field might be reserved for images, and the field below it might be reserved for a series of text columns.*

Columns *are vertical alignments of type that create horizontal divisions between the margins. There can be any number of columns; sometimes they are all the same width, and sometimes they are different widths, corresponding to specific kinds of information.*

Modules *are individual units of space separated by regular intervals that, when repeated across the page format, create columns and rows.*

Markers *are placement indicators for subordinate or consistently appearing text, such as running heads, section titles, folios, or any other element that occupies only one location in any layout.*

The Manuscript Grid

The block, or manuscript, grid is structurally the simplest kind of grid. As the name implies, its base structure is a rectangular text area that takes up most of the page. Its job is to accommodate extensive continuous text, such as a book or long essay, and it developed from the tradition of written manuscript that eventually led to book printing. It has a primary structure—the dimensions and location of the text block and margins—as well as a secondary structure—the locations and size relationships of the running header or footer, chapter title, and page numbers, along with an area for footnotes, if appropriate.

Even within such a simple structure, care must be taken so the continuous type texture can be read comfortably page after page. Creating visual interest, comfort, and stimulation is important to continuously engage the reader during long reading sessions. Adjusting the proportions of the margins is one way of introducing visual interest. Classical grids mirror the text blocks left and right around a wider gutter margin. Some designers use a mathematical ratio to determine a harmonic balance between the margins and the weight of the text block. Generally, wider margins help focus the eye and create a sense of calm or stability. Narrow lateral margins increase tension because the live matter is closer to the format edge. Although many manuscript grids use margins that are symmetrical in width, it is just as acceptable to create an asymmetrical structure, wherein the margin intervals are different. An asymmetrical structure introduces more white space for the eye to use as an area of rest; it may also provide a place for notes, spot illustrations, or other editorial features that do not occur regularly or warrant the articulation of a true column.

The size of the text type in the block—as well as the space between lines, words, and treatments of subordinate material—is of incredible importance. Remember that tiny shifts in typographic color, emphasis, or alignment create enormous differences in how they are perceived in the overall hierarchy of the page; in this case, less is usually more effective.

A standard manuscript structure for a book. Technically, this structure is not really a grid in the full sense, because it lacks multiple intervals for alignments. But it is an orthogonal structure whose alignments and proportions are considered in terms of a system. The structure of a manuscript grid is defined by the arrangement of the primary text blocks on the page.

Flowlines define major vertical increments from the top of the pages. In this layout, the text blocks are arranged symmetrically—their placement mirrors each other's across the gutter.

The text blocks in a manuscript grid may also be arranged asymmetrically, essentially repeating the structure of the left page on the right page.

The straightforward manuscript structure of this book (left) conveys an appropriate sense of historical context; the open leading and mix of typefaces creates a more modern texture.
Eggers+Diaper | Germany

The manuscript grid in this book (below) fills the page to narrow margins just within the format edge. In some spreads, text extends across both text blocks, violating the gutter of the book.
Interkool | Germany

Running heads if required, single line only

Jacques Derrida

Numbers/Signs/Religion – a collision of multiple worlds within a collective chaos

L'acte même de lire – Italo Calvino

... and repeated > Abramović Class

Im Rahmen von A LITTLE BIT OF HISTORY REPEATED werden StudentInnen der Performanceklasse von Marina Abramović am dritten Abend Performances zeigen. Diese Arbeiten schließen sich dem Konzept von A LITTLE BIT OF HISTORY REPEATED an und werden von folgenden StudentInnen präsentiert: Ivan Civic, Frank Werner, Viola Yesiltac, Melati Suryodarmo, Daniel Müller-Friedrichsen, Irina Thormann, Iris Selke, Herma Wittstock.

In the framework of A LITTLE BIT OF HISTORY REPEATED students of the Performanceclass of Marina Abramović at the Hochschule für Bildende Künste in Braunschweig will present performances which are conceptually based on the ideas around A LITTLE BIT OF HISTORY REPEATED. These performances will be shown on the third evening and will include work of: Ivan Civic, Frank Werner, Viola Yesiltac, Melati Suryodarmo, Daniel Müller-Friedrichsen, Irina Thormann, Iris Selke, Herma Wittstock.

Vorwort / Foreword
Klaus Biesenbach

Column Grid

Information that is discontinuous benefits from being organized into an arrangement of vertical columns. Because the columns can be dependent on each other for running text, independent for small blocks of text, or crossed over to make wider columns, the column grid is very flexible. For example, some columns may be reserved for running text and large images, while captions may be placed in an adjacent column. This arrangement clearly separates the captions from the primary material but maintains them in a direct relationship.

The width of the columns depends, as noted, on the size of the running text type. If the column is too narrow, excessive hyphenation is likely, and a uniform rag will be difficult to achieve. At the other extreme, a column that is too wide will make it difficult for the reader to find the beginnings of sequential lines. By studying the effects of changing the type size, leading, and spacing, the designer will be able to find a comfortable column width. Traditionally, the gutter between columns is given a measure, *X*, and the margins are usually assigned a width of twice the gutter measure, or *2X*. Margins wider than the column gutters focus the eye inward, easing tension between the column edge and the edge of the format. This is simply a guide, however, and designers are free to

adjust the column-to-margin ratio as they see fit. In a column grid, there is also a subordinate structure. These are the flowlines: vertical intervals that allow the designer to accommodate unusual breaks in text or image on the page and create horizontal bands across the format. The hangline is one kind of flowline: it defines the vertical distance from the top of the format at which column text will always start. A flowline near the top of the page may establish a position for running headers, the pagination, or section dividers. Additional flowlines may designate areas for images only or for different kinds of concurrent running text—timelines, a subarticles, or a pull quotes.

When several kinds of information in juxtaposition are radically different from each other, one option is to design a distinct column grid for each kind instead of attempting to build a single overall column grid. The nature of the information to be displayed might require one component grid of two columns and a second grid of three columns, both with the same margins. A compound column grid can be made up of two, three, four, or more distinct component grids, each devoted to content of a specific type.

Commonly used column grids: any number of columns may be used, depending on the format size and the complexity of the content. Flowlines define horizontal alignments in increments from the top of the page. Within a column grid, a designer has a great deal of flexibility for arranging type and image material.

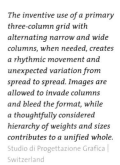

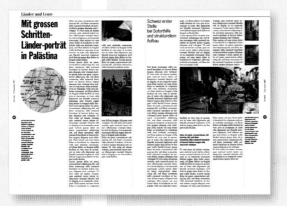

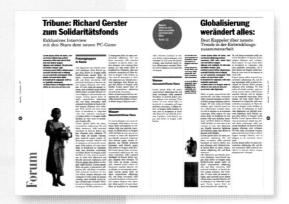

The inventive use of a primary three-column grid with alternating narrow and wide columns, when needed, creates a rhythmic movement and unexpected variation from spread to spread. Images are allowed to invade columns and bleed the format, while a thoughtfully considered hierarchy of weights and sizes contributes to a unified whole.
Studio di Progettazione Grafica | Switzerland

Using a compound grid builds a certain rhythm into a publication. As the grid changes to accommodate different information, the rhythm of each grid's occurrence becomes an integral part of the pacing and style of the work.

Use Wisely!

Column grids work best for editorial projects or other series-based material where the content may change often. Be careful how many columns you use—if there are too many, the layout will become confusing.

Modular Grid

Extremely complex projects require even more precise control, and in this situation, a modular grid may be the most useful choice. A modular grid is essentially a column grid with a large number of horizontal flowlines that subdivide the columns into rows, creating a matrix of cells called modules. Each module defines a small chunk of informational space. Grouped together, these modules define areas called spatial zones to which specific roles may be assigned. The degree of control within the grid depends on the size of the modules. Smaller modules provide more flexibility and greater precision, but too many subdivisions can become confusing or redundant.

How does one determine the module's proportions? The module could be the width and depth of one average paragraph of the primary text at a given size. Modules can be vertical or horizontal in proportion, and this decision can be related to the kinds of images being organized or to the desired stress the designer feels is appropriate. The margin proportions must be considered simultaneously in relation to the modules and the gutters that separate them. Modular grids are often used to coordinate extensive publication systems. If the designer has the opportunity to consider all the materials that are to be produced within a system, the formats can become an outgrowth of the module or vice versa. By regulating the proportions of the formats and the module in relation to each other, the designer may simultaneously be able to harmonize the formats and ensure they are produced most economically.

A modular grid also lends itself to the design of tabular information. The rigorous repetition of the module helps to standardize tables or forms and integrate them with the text and image material. Aside from its practical uses, the modular grid accords a conceptual aesthetic. Between the 1950s and 1980s, the modular grid became associated with ideal social or political order. These ideals have their roots in the rationalist thinking of the Bauhaus and Swiss International Style, which celebrates objectivity, order, and clarity. Designers who embrace these ideals sometimes use modular grids to convey this. Even simple projects or single formats can be structured with a rigid modular grid, adding this additional meaning.

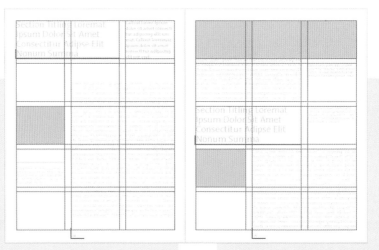

A relatively simple modular grid, defined by three units across and five units down. The greater the number of modules, the more precise the layout may be, but too many increments becomes redundant. Variations on the number and stress of the module achieve different kinds of presence for the typographic and image content.

The enormous potential for arranging images in a modular grid is seen here. Combining modules into zones for images (gray areas) ensures variety as well as a unified relationship with text.

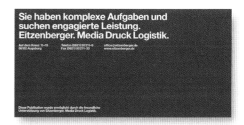

Complex identity programs
may benefit from the use of a
strong grid system. The use
of a single typeface and weight,
along with a precisely articulated
modular grid, clearly identifies
communications for the client
and allows a wide range of
disparate materials to be inte-
grated in a unified way.
Keller Maurer Design | Germany

The modularity of this website
(above) keeps navigation clear
while providing flexibility for
different content. Two columns
at left contain A- and B-level
navigation. Their depth, together
with the depth of the photographs,
gives evidence of the module.
Piscatello Design Centre | USA

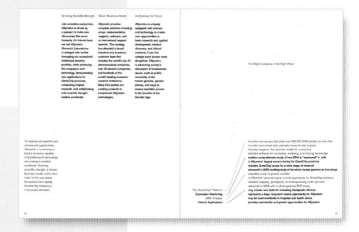

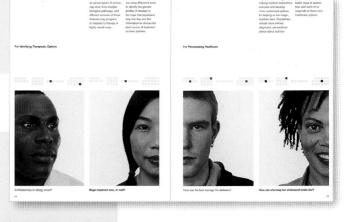

Varying the arrangement of text
elements on a grid introduces
variety and interest. Here (right,
above right), text is allowed to
fill one or several columns in this
4 x 6 modular grid as needed.
Cahan + Associates | USA

Hierarchical Grids

Sometimes, the needs of a project require an odd grid that does not fit into any category. These grids conform to the needs of the information they organize, but they are based more on an intuitive placement of alignments customized to the proportions of the elements, rather than on regular repeated intervals. Column widths, as well as the intervals between them, tend to vary.

Developing a hierarchical grid begins by studying the various elements' optical interaction and then determining a rationalized structure that will coordinate them. Careful attention to the nuances of weight change, size change, and position on the page can yield an armature that is repeatable over multiple pages. Sometimes, a hierarchical grid unifies disparate elements or creates a superstructure that opposes organic elements in a single-instance format like a poster. A hierarchical grid can also be used to unify sides of packages or to create new visual arrangements if they are displayed in groups. Web pages are examples of hierarchical grids. The dynamic content that drives most websites, along with the continued option of resizing the browser window, requires a flexibility of width and depth that precludes a strict modular approach but still requires a standardization, or templating, of alignments and display areas.

This kind of grid, whether used to build books, posters, or Web pages, is an almost organic approach to the way information and elements are ordered that still holds all the parts together architecturally in typographic space. Hierarchical grids lend an appearance of not being grid-structured, although the eye understands the spatial distinctions or hierarchical treatments within the layout to have a specific kind of unity.

A hierarchical, or proportionate grid, creates a system of alignments and zones for text and images that can be varied page by page. The proportions of the columns are related very specifically to the kind of information they will carry.

A Web page is a common example of a hierarchical grid. The proportions between the alignments change, but they are related to each other, and the orthogonal quality of the arrangement is very clear.

The hierarchical grid for this site organizes less important content toward the outer edges of the page; more important content, such as branding and product promotions, occupy the central column area. The schematic below represents the "informational intensity" of the content areas in relation to one another—the hotter or more intense the color, the more important the information within that area.
Korn Design | USA

www.maxwell.syr.edu/ict

ict/news

Technology Training -- Off Site

ICT and New Horizons Learning Center have formed a collaboration to offer off-site computing training to the Maxwell community. Many levels of training are available on a variety of software applications, including Microsoft Word, Excel, Access, Outlook, and PowerPoint. All training is conducted at New Horizon's modern facilities using current technology and equipment. The cost for each class is $100 per day per participant. To arrange training, contact Dave Novak at New Horizons (dnovak@nhsyracuse.com, 449-3290). For additional information, email us at training@maxwell.syr.edu.

ICT Staff Profile: Jeff Young

Jeff Young is ICT's new microcomputer technician. He moved to Syracuse recently after having lived in Albany for 12 years. While in Albany, Jeff worked for seven years as an electrical engineering designer for an architectural and engineering firm. In that position he did electrical, network and cabling systems for new buildings as well as renovations. Much of his work was involved with educational buildings, and he had a key role in designing cabling upgrades for 75% of the dorms at Rochester Institute of Technology. Jeff also worked on electrical design for facilities at SUNY Health Science Library in Syracuse.

Although he started out in the electrical engineering department in his position in Albany, when technology started to "kick in," he became intrigued and basically learned much of what he knows about computers on his own. That allowed him to transition into the IT department at his job. He was not only responsible for desktop support, dealing with over 70 users in his own building, but he also coordinated the IT desktop support at four other offices, in Albany, DC, Boston, and NYC.

Jeff has an associate's degree in design and drafting from SUNY-Alfred. He is married and has four children, and he enjoys cooking, gardening and spending time with his family. He and his wife are active in father's rights organizations and are lobbying for change related to father's rights in New York family courts.

Jeff Young

Remote Access and VPNs

ICT offers a variety of methods to access network resources from home or when traveling. One of the most versatile options is through a Virtual Private Network or VPN. A VPN is essentially a secure connection within a connection that allows a laptop or desktop computer to exchange data with computers at Maxwell over a secure link. This allows users to access network drives, printers, and their desktop computers remotely. The simplest way to use a VPN is to utilize ICT's Connection Utility (described in this issue). VPN services are available to Maxwell faculty, staff, and graduate students.

... the **simplest** way to use a VPN is to use ICT's Connection Utility...

Varying column widths in this page detail from a newsletter accommodate primary text information (left column) and support information or images (right column). Narrow rules help define major hanglines and alignments within the page.
stressdesign | USA

Breaking the Grid
Alternative Organizational Approaches

— *Is a grid the only way to organize information?*
When is it OK not to use a grid?

— *How many ways are there to organize type in a format?*
What are they? How do they work?

— *What happens to readability when type is organized*
in an organic way?

Grid structure in typography and design has become part of the status quo of designing, but as recent history has shown, there are numerous other ways to organize information and images. The decision whether to use a grid always comes down to the nature of the content in a given project.

Sometimes, the content has its own internal structure, which a grid will not necessarily clarify. Sometimes, the content needs to ignore structure altogether to create specific kinds of emotional reactions in the intended audience. Sometimes, a designer simply expects the audience to have a more complex intellectual involvement with the piece. The public's ability to apprehend and digest information has become more sophisticated over time as well. One has only to look at television news broadcasting, where several kinds of presentation—oral delivery, video, still images and icons, and moving typography—occupy the same space, to understand that people have become accustomed to more complex experiences. In an effort to create a meaningful impression that competes within this visual environment, designers have pursued various new ways of organizing visual experience.

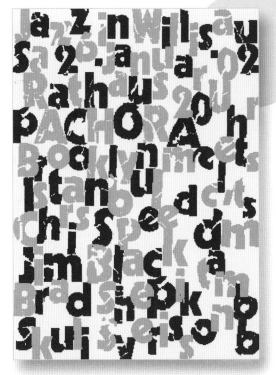

The letterforms and words in this poster have been masterfully fitted together in a painterly texture that seems composed of torn and pasted chunks of paper. Simply alternating the color of the letters in sequence allows the reading of the poster: from disorder, to order.
Niklaus Troxler | Switzerland

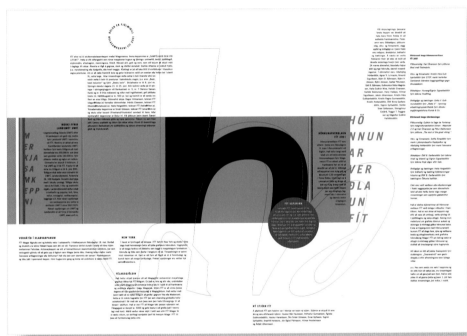

A basic modular grid (left) can be deconstructed in a number of ways, including pushing the modules around (middle) or stretching the modules (right). The more complex the deconstruction, the more ambiguous the spatial relationships of the typography that adheres to the new structure will be.

Evidence of a column grid, although greatly deconstructed in this layout, is visible in the remnants of a regular rhythm of columnlike intervals. Reversals of alignment, half-columns with small-scale paragraphs shifted into leftover spaces, and a sense of fracture are all characteristic of grid deconstruction.
Einar Gylfason | Iceland

Grid Deconstruction

As the word implies, the purpose of deconstructing is to deform a rationally structured space so that the elements within that space are forced into new relationships. There is not one set of rules that can be applied to the process of deconstructing. But if the goal is to find new spatial or visual relationships by breaking down a structure, it's helpful to at least begin thinking about that process in a methodical way. An initial possibility is to think about splitting apart a conventional grid. The options here are varied. First, a designer might investigate cutting apart major zones and shifting them around. It's important to watch what happens when information that would

normally mark a juncture in the grid is moved to another place. The shifted information may wind up behind or on top of some other information if a change in size or density accompanies the shift in placement. This causes an optical confusion that can be perceived as a surreal kind of space where foreground and background swap places. Shifting grid modules or columns can create overlaps and a perception of layers within the compositional space. These overlapping columns create a sense of transparency where the viewer perceives the columns of text, or other elements, to be floating in front of each other. A conventional grid structure repeated in different

orientations could be used to explore a more dynamic architectural space by creating different axes and new spatial zones that interlock. Similarly, overlapping grids with modules of different proportions, or that run at different angles in relation to each other, can introduce a kind of order to the spatial and directional ambiguity that layering creates, especially if elements are oriented on both layers simultaneously.

Linguistic Deconstruction

Verbal or conceptual cues within the content can also be used to break structure. The natural rhythm of spoken language, for example, is often used as a guide for changing weight, size, color, or alignment among lines of type; louder or faster words may be set in larger or bolder type or in italics, corresponding to stresses and lulls in actual speech. Giving a voice to visual language can help alter the structure of a text by pushing words out of paragraphs or forcing modules or columns into relationships where the natural logic of the writing creates the order. Breaking phrases and words apart in a running text calls attention to the individual parts of speech. As the space between them increases, the text takes on a matrixlike appearance and the presumed reading order may be changed. Although generally this would interfere with reading, in some cases the resulting ambiguity may be appropriate to the text, yielding associations between words or images that can be used to augment its literal meaning.

The elements of syntax— punctuation and line elements— are used to create texture and tension in the composition. The question and exclamation marks suggest this kind of speech and affect the calmness of the open spaces.
Qwer Design | Germany

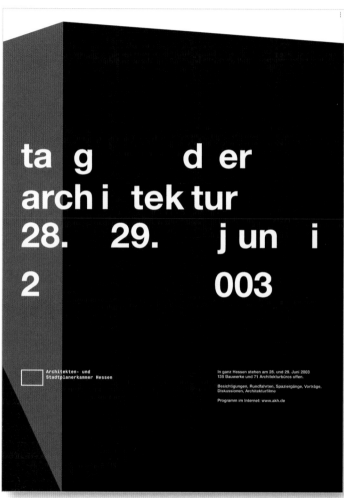

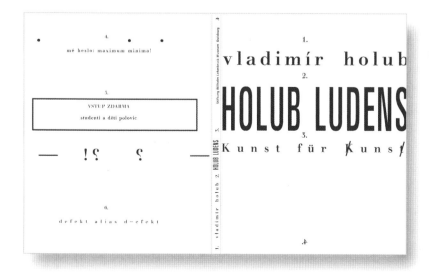

Linguistic deconstruction uses the syntax of language as a basis for dismantling the regular order of the typography. Above, syllables and initial letters split from their words; careful attention to the spacing allows an intelligible reading while new alignments are formed. Exploring the architecture of the words appropriately reflects the content of the poster.
U9 Visuelle Allianz | Germany

Spontaneous Optical Composition

Far from being random, this compositional method can be described as purposeful intuitive placement of material based on its formal aspects and making connections for the viewer based solely on those relationships. Designers may use this method as a step in the process of building a grid, but using this as an organizational idea is just as valid. The designer approaches the material much like a painter does, making quick decisions as the material is combined and the relationships first seen. As the optical qualities of the elements begin to interact, the designer can determine how those initial decisions affect the communication and make adjustments to enhance or negate the qualities in whatever way is most appropriate. One way of exaggerating the spontaneity of a composition is to perform a chance operation. The use of chance as an organizing principle seems counterintuitive. The unpredictable results, however, can often aid in communication from a conceptual standpoint by bringing out juxtapositions of material that might otherwise have escaped notice.

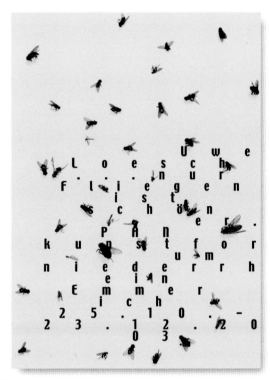

In this poster (left), the seemingly random arrangement of flies and letterforms integrates type and image. The composition is so random, it's possible the designer used chance operation— a purposely arbitrary method of composing, perhaps scattering— to help find an unstructured layout that doesn't feel forced. Careful attention is paid to type placement for readability.
Uwe Loesch | Germany

The designer finds a balance between intuitive composition and a rigid structure in this poster (below). A symmetrical dual-column structure is hinted at in the alignment of the type below the gyroscope with the gyro's axis; but the type shifts around and through the machine, never really aligning with anything. The type elements are placed to create tension and counterpoint to the arcing lines of the gyroscope, giving a deceptively unstudied appearance.
Qwer Design | Germany

Intuitive layout approaches result in aggressive, unforced solutions with a painterly or collagelike presence. The elements exist in direct, unstudied relation to each other, imparting a kind of honest freshness, and the connections between informational elements are organic and nonspecific. The typography in this study for what could become a CD sleeve is amorphous and translucent, reacting to the expressive forms that surround it.
Creuna Design | Norway

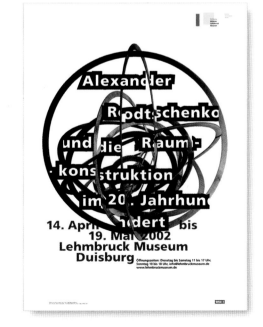

A primary typeface is used for
major branding in this identity.
A secondary sans serif face adds
visual suppport for promotional
items, such as the moving
announcement, and a system
of rule elements provides detail.
Paone Design Associates | USA

Typographic Systems

The vast majority of typographic design occurs in series-based projects. Most often, the visual logic of a typographic idea must be extended from one format into another: books, brochures, newspapers, reports, websites, packaging, animation sequences, film titles, exhibition spaces, print advertising campaigns, television commercials—so many projects contain multiple parts or happen over time. Series-based typographic applications force the designer to consider variables beyond the basics of composition. The number of items in the system, differing format sizes or media, informational similarities among components

versus informational disparities, the potential for undecided components, and the economic factors of production are all initial considerations. A typographic system shares many of the benefits provided by a grid, although a typographic system need not necessarily make use of a grid. A system relies on establishing type styles, colors, and supporting elements that will mark its components as speaking in a single voice. The most obvious example of such a system is that of a corporate identity. But books, newsletters, and websites are also typographic systems.

Typographic Systems

Books
Each book is a single object, but is made up of a sequence of formats; each spread must be unified typographically yet change so the experience is constantly refreshed.

Publications
Newsletters or other publications are serial. Each issue is a single object, but the visual logic of the publication must be consistently recognizable to its readership.

Websites
Web pages are similar to books, with the caveat that their flow is nonlinear, and they are likely to be updated with different content over time.

Motion Graphics
Film titles and TV commercials with a typographic emphasis are peculiar systems in themselves; their format remains fixed as the content changes over time.

The first step in the process of conceptualizing a system is to evaluate the entire group of components to determine whether there will be subgroups within the system. For example, a series of brochures may be formatted in a similar way, but each edition may carry specific information. If any of the components already exist (but will be redesigned to work with the new system), they are an invaluable source for developing the criteria that will define the system; some variables can already be accounted for by evaluating these examples. Important questions that must be posed at this stage include:

Color and the typographic mast-head define the system for this newsletter.
Korn Design | USA

The answers to these questions will have a profound effect on the typography. If the materials, for example, arrive together at once, that implies that each element relies on the others to complete an overall story. This might mean that at least two typographic tags must appear on all the pieces: one unchanging element that establishes the overall concept; and a second element that distinguishes it from the others. Or perhaps the elements will be displayed within a stacked holder, so that only their top thirds are visible. If time-based applications are part of the mix, the motion or interactivity in these media must be considered—how their own logic is referenced in static media and vice versa. Consider what additional materials may need to be created—and by whom—as the system evolves or grows. Accounting for contingencies such as undecided formats or production by nondesigners is an important function of the system that must be addressed up front.

Who uses these materials? Which materials do they use most often, and which do they use together? Is there a sequence to how these materials get used: does the audience receive one first, or all at once?

After the designer has developed a list of limitations, the actual design process can begin. As in other typographic designing, the search will be for a visual logic that will convey the meaning and emotion of the content, yet work within the limitations so that no one component feels out of place or becomes problematic on a functional or production level. If the designer reaches this goal, the result is an organic system of parts that reaches the audience in a consistently recognizable way and allows for variation and flexibility in design as the system expands.

Promotional cards in a series use alphabetical sequences as a context for the initial letter of the given event related to each card. Within the cards, a system of typographic structures and typeface selection unifies them from printing to printing.
Büro Schels | Germany

Words that are given visual form become images as well as continue to carry verbal meaning. This dual nature of typography is a powerful force for communication. Within a single letterform, word, or phrase exists the potential to simultaneously convey a clear verbal message along with symbolic or emotional messages that mutually enrich each other. In this exploration of typography, the discussion of how type works focuses on the integral mechanics of the letters themselves. Building on that fundamental understanding of type's functional aspects, the discussion turns to transcending mechanics to build communications of great power—transforming words into images and integrating them with the overall visual experience.

Expressing the Unspoken

Image and Emotion in Typography

Integrating Type and Image

Getting type to interact with other elements in a composition—especially imagery—poses a serious problem for many designers. The difficulty of resolving this problem stems from typography's inescapable functionality. Yet, similar to elements of a painting or sculpture interacting to create a coherent whole—linear elements in opposition to masses of dark and light, curves reacting to geometric angles—the elements of typography must form unifying visual relationships with nontypographic material around it. The content of the communication—both pictures and text—helps the designer weave a unified expression in which the typography and the images are equal players.

The results of poorly integrated type and image fall into two categories. In the first category, the typography is separated from the image areas, while the second category is typography that has been reduced to mere shape and texture and devoid of its function. Between these two extremes lies a magical intersection of reading and seeing, and the typographer who is sensitive to the word as image and as idea is the one who finds this intersection.

Bringing words and pictures together means finding a visual harmony between them that best augments the reading of the text, while also adding conceptual dimension to the image. This connection can be textural (as in seeing an element within a photograph that a word or sentence can mimic in rhythm) or structural (as in using vertical rectangles of text columns arranged against horizontal rectangles of photographs).

Sometimes, the typography itself is the primary image, meaning there are no photographs or illustrations accompanying it. In these instances, the formal interaction of the primary type/image and the secondary information is also important.

Type and image are cleverly integrated in this brochure cover for Anni Kuan, a New York–based fashion designer. The primary type has illustrative qualities that relate to the subject—they are drawn of linear elements that remind one of threads—and they appear to have been heated by an iron. The letterforms darken and bleed as they come into contact with the image, creating density and texture whose overall shape corresponds to the image. Informational type has been arranged in four shallow columns that restate the symmetry of the image, but vary in depth. Threadlike rules further carry the primary typographic concept of the main image area.
Sagmeister, Inc. | USA

HAPPILY
INVITES YOU
TO THE
FASHION COTERIE
TO PREVIEW THE
FALL AND WINTER
2003
COLLECTION

Sunday, Feb/23/2003	Tuesday, Feb/25/2003	New York Showroom	Atlanta Showroom
The Piers		Anni Kuan Design	Leib Associates Inc.
New York City			

Think About It!
Type works best with images when the two kinds of materials are considered equally important. Always work with type and images together when starting a project.

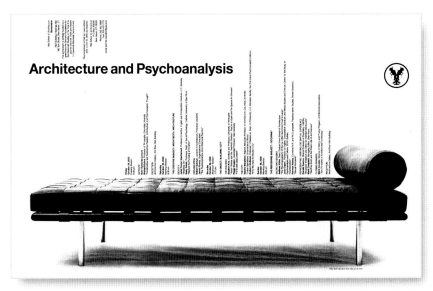

Architecture and Psychoanalysis

In this poster for a lecture, the primary image of the chaise acts as a conceptual and visual cue for the arrangement of the type. The image, reduced to its essential character, is a long horizontal line that is heavy in overall weight. The poster title corresponds to this heavy line as a lighter line. Secondary type is arranged in a rotated column that appears to be resting on the chaise—conceptually related to psychoanalysis, as well as visually contrasting the movement of the chaise. Supporting type at the upper right reverses the alignment but relates in logic to the type on the chaise.
Pentagram (Michael Bierut) | USA

The elements in this cover (above) for a restaurant menu demonstrate a sensitive allocation of space, weight, and color. The restaurant's name in English appears at the lower right, quiet and stately in a light sans serif, set all uppercase. The muted gray flower creates a marker for the type. The white type and the organic form of the flower correspond to the fluid cascade of white flowers in the upper right of the background.

The interior of the menu is a study in contrasts. The organic quality of the background images is contrasted by the repetition of vertical columns; the geometry of their alignment helps set the type apart from the background, but interacts with the up-and-down movement of the imagery.
Sean Ryan | USA

DINNER

APPETIZERS

SOUPS

KUSHI YAKI GRILL

SALADS

SUSHI

OKONOMI - SUSHI À LA CARTE

SUSHI ROLLS

MAKI SUSHI ROLLS

SUSHI CHEF SPECIALS

HAMACHI SPECIAL SUSHI

OMAKASE HOUSE SPECIAL

Visual Relationships between Words and Pictures

Interaction between words and pictures happens as a
result of their similar abstract, pictorial qualities. Images
are composed of lights and darks, linear motion and
volume, contours, and open or closed spaces, arranged in
a particular order. Type shares these same attributes.
It is composed of lights and darks, linear and volumetric
forms, contours and rhythms of open and closed spaces,
also arranged in a particular order. The task is to find
where the specific attributes of both come together.
Laying type across an image is a quick way of finding visual
relationships. Their immediate juxtaposition will reveal
similarities in the shape or size of elements in each. The
rag of a short paragraph may have a similar shape as a
background element in a photograph. An image of a land-
scape with trees has a horizon line that may correspond
to a horizontal line of type, and the rhythm and location
of trees on the horizon may share some qualities with
the type's ascenders. At the opposite end of the spectrum,
the image and the typographic forms may be completely
unrelated—in opposition to each other. Opposition is a
form of contrast that can be equally viable for integrating
the two materials. A textural and moody image with great
variation in tone, but no linear qualities, may work well
with typography that is exceptionally linear. The contrast in
presentation helps enhance the distinct qualities of each.

*A schematic diagram, left,
shows the tonal composition of
the photograph in the page
spread above. The angles and
proportions created by the tonal
areas give rise to a network of
alignments that the designer
has used as a guide in arranging
the text on the right page of*
*the spread. Note that the typog-
raphy doesn't simply mimic the
composition of the image but
expands on it by introducing
additional divisions and tonalities
that relate to those found within
the image.*
Gunter Bose | Switzerland

#1_SZENE

nte

NI MI DIVORA IL DESIDERIO / DI TORNARE NELLA MIA TERRA. / SONO STANCO DI

Un paese di Minatori In einer Bergarbeitersiedlung

A VITA GRIGIA, / DI QUESTO LAVORO NELLE TENEBRE. / PENDO COM'UN FAN

O SVUOTATO / SENZA TOCCARE LA TERRA. / LA MIA VITA è SOSPESA ALL'UNCINO DEL

NO.

Gastarbeiter

SEIT JAHREN VERZEHRT MICH DIE SEHNSUCHT
ZURÜCKZUKEHREN IN MEINE HEIMAT.
ICH BIN MÜDE DIESES GRAUEN LEBENS,
UND DIESER ARBEIT UNTER DEN SCHATTEN.
GLEICH EINEM LEEREN BALG BAUMLE ICH
WEIT ÜBER DER ERDE.
MEIN LEBEN IST AUFGEHÄNGT
AM HAKEN DER NOT.

Chor der Bergarbeiter

ERHER KAMST DU

Coro di Minatori

TU GIUNGESTI QUI
EMIGRANTE
STARBEITER CON QUALCHE SPERANZA.
I GIOVANI DEL TUO PAESE
FFNUNGSVOLL. SONO COSTRETTI A LASCIARLO:
LÀ NON C'È LAVORO.
E JUNGEN DEINES LANDES DAL FONDO DEI POZZI
SALIAMO ALLA LUCE
ESSEN DIE HEIMAT VERLASSEN, MASCHERE NERE
CON LUNGHE CRINIERE DI FUMO.

NN ES GIBT KEINE ARBEIT.

M GRUND DER SCHAECHTE STEIGEN WIR ANS LICHT

HWARZE MASKEN

T LANGEN MAEHNEN AUS RAUCH.

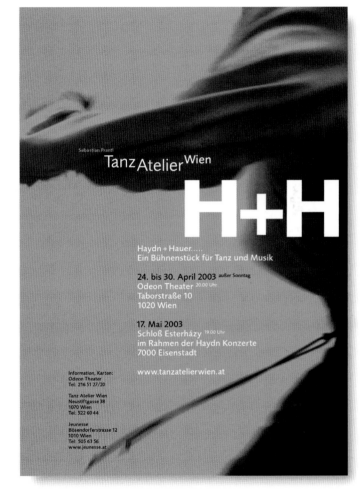

Sebastian Prantl

Tanz Atelier Wien

H+H

Haydn + Hauer.....
Ein Bühnenstück für Tanz und Musik

24. bis 30. April 2003 außer Sonntag
Odeon Theater 20.00 Uhr
Taborstraße 10
1020 Wien

17. Mai 2003 19.00 Uhr
Schloß Esterházy
im Rahmen der Haydn Konzerte
7000 Eisenstadt

Information, Karten:
Odeon Theater
Tel: 216 51 27/20

Tanz Atelier Wien
Neustiftgasse 38
1070 Wien
Tel: 522 60 44

Jeunesse
Bösendorferstrasse 12
1010 Wien
Tel: 505 63 56
www.jeunesse.at

www.tanzatelierwien.at

Placing the type directly onto the image permits a quick comparison of the shapes within both elements. This poster treats the type so that it repeats both the scale changes of forms in the photograph and the directional movements between the forms.
Bohatsch Visual Communication |
Austria

The type within the image becomes a part of the image (top). The same type, placed adjacent to the image (middle), retains its identity as a separate element, but its shape may be related to shapes within the image. By crossing the image, the type occupies an ambiguous space (bottom). It appears to flatten out against the page surrounding the image, but appears to float over the image as it crosses it.

Consider the location of the type relative to the image and the attributes of the image's outer shape in relation to the format. An image cropped into a rectangle presents three options: the type may be enclosed within the image; the type may be outside or adjacent to the image; or the type may cross the image and connect the space around it to its interior. Type that is placed within the field of a rectangular image becomes part of it. Type adjacent to the same image remains a separate entity. Its relationship to the image is dependent on its positioning and any correspondence between its compositional elements and those in the image. The type may align with the top edge of the image rectangle, or it may rest elsewhere, perhaps in line with a division between light and dark inside the rectangle. Type that crosses over an image and into the format space becomes both part of the image in the rectangle and part of the elements on the page. Its location in space becomes ambiguous.

The geometric alignment in a block of text will naturally counter the organic, irregular forms within a silhouetted image if the image precedes the alignment in position

The relationship between the image shape and the rag becomes dominant if the rag enters into the image's contour.

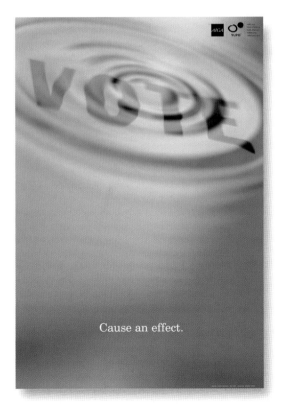

Cause an effect.

The arrangement of the word VOTE follows the diagonal axis of the water ripples and shows the effect of them on its strokes. Its location also draws the darker blue of the lower right area upward into the lighter portion of the format.
Doyle Partners | USA

Silhouetted images—whose contours are free from enclosure in a rectangle—share a visual relationship with the rag of paragraphs or columns, but also share an opposing relationship with their alignments. Type adjacent to a silhouetted image offers more or less contrast or similarity depending on its location relative to the image. If the rag leads into the image contours, the two elements flow together, and the type may seem to share the spatial context of the image. Bringing the vertical alignment of a column into proximity with an image's irregular contour produces the opposite effect: the type advances in space and disconnects itself from the spatial context of the image, appearing to float in front of it. The strong contrast between the aligned edge of the type and the contour of the image may then be countered by the irregular contour of the column's rag.

*The texture and arrangement of
the word* April *in the poster (right)
transforms the typography into
an image of rain.*
Leonardo Sonnoli │ Italy

Philadelphia Youth Orchestra

Joseph Primavera, Conductor

an american sampler

Symphony No. 2	Charles Ives
Salute to George M. Cohan	arr. Aldo Provenzano
An American Sampler	arr. Aldo Provenzano
The Stars and Stripes Forever	John Philip Sousa

*The typographic elements
on the CD respond to the linear
weights and diagonal
orientation of the graphic
images and rules.*
Paone Design Associates │ USA

Formal Congruence

Similarities between type elements and pictorial elements make a strong connection between the two. Every image portrays clear relationships between figure and ground, light and dark, and has movement within it. Objects depicted in photographs have a scale relationship with each other and proportional relationships with the edge of the image. When typographic configurations display similar attributes to an adjacent image, or expand on those attributes, the type and the image are said to be **formally congruent.** There are an unlimited number of ways for type to become congruent with an image. The selection of a particular face for the type may relate to tonal or textural qualities in the image. A bold-weight face, for example, may have a similar visual texture to the shadows cast by small stones in a beach scene. Or, two paragraphs, one above the other, could be set in different

The type in this series of studies is related to the image alternately by position, by repetition of linear movement, by alternation of weights, and by the angle of its alignment.

**rhythmic linear progression
rigor, repetition and reflection
the summary of planning**

strength of glass and steel

mathematical poetry

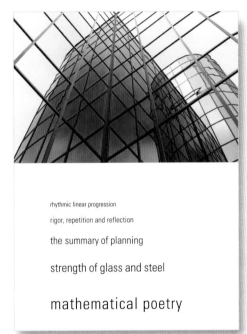

rhythmic linear progression

rigor, repetition and reflection

the summary of planning

strength of glass and steel

mathematical poetry

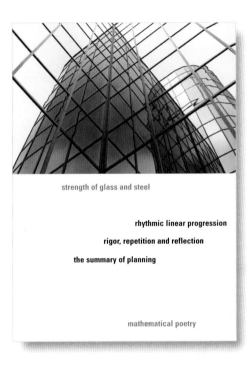

strength of glass and steel

rhythmic linear progression

rigor, repetition and reflection

the summary of planning

mathematical poetry

weights to mimic the lightness of the sky and the darkness of the ocean. These paragraphs may evolve the logic of the beach scene as well, not just imitating it but adding another conceptual relationship: if the two paragraphs—a light one above and a heavier one below—are set staggered, with dramatically uneven rags, they may suggest the ebb and flow of the ocean and the motion of wind. These ideas do not visually exist in the image, but their truth is brought out through the treatment of the typography. Instances in which type extrapolates the formal qualities in an image create powerful emotional and intellectual responses in the viewer. Type that is adjacent to an image can also be formally congruent in terms of its position relative to the image. In this kind of formal congruence, the image exerts an influence on the composition of the page as a whole. Even if the type retains its

natural architecture, it may still react to the compositional architecture within the image. For example, a rectangular photograph of a building that has been shot with extreme perspective offers opportunities for typographic composition within and outside of its picture box. The linear rhythm of windows, advancing into space, may be repeated by lines of type that are separated by more and more space, continuing the perspective outside the picture box. The space between a regular column of type and the image may correspond to progressively increasing intervals elements in the photograph, and the sense of space established in the picture will intrude into the format that surrounds it. The type connects optically to this space, and so all three elements—image, format, and type—appear to share the same physical space.

From a visual perspective, the Roman alphabet that Western typography uses can be understood as a system of line drawings. The drawing of individual letters is archetypal; each form comes out of a long history of cultural development and has a recognizable structure that has been steadily codified and passed along over the generations. The archetypal form of a particular letter is what distinguishes it from other letters, and distinguishes it as itself. That is, no other form has a shape quite like a letter. At first, this seems like a silly statement to make—we encounter shapes that remind us of letters all the time. But it's important to recognize the clue to the letterform's power over our cultural mindset in that statement: shapes remind us of letters, rather than the other way around. Letterforms are iconic symbols that are so ingrained into our consciousness that their visual form holds sway over the perception of other images. This is an interesting proposition, because the letters of our alphabet were originally derived from pictographic drawings—like the hieroglyphs of the ancient Egyptians—that represented real-world objects. Since that time, however, Western culture has evolved to the point where the image of the letter as a symbol has become preeminent over its pictorial origin. Its visual qualities and how those qualities interact with each other—individually and in groups—are what drive modern approaches to typography at every level.

From a visual perspective, the Roman alphabet that Western typography uses can be understood as a system of line drawings. The drawing of individual letters is archetypal; each form comes out of a long history of cultural development and has a recognizable structure that has been steadily codified and passed along over the generations. The archetypal form of a particular letter is what distinguishes it from other letters, and distinguishes it as itself. That is, no other form has a shape quite like a letter. At first, this seems like a silly statement to make—we encounter

From a visual perspective, the Roman alphabet that Western typography uses can be understood as a system of line drawings. The drawing of individual letters is archetypal; each form comes out of a long history of cultural development and has a recognizable structure that has been steadily codified and passed along over the generations. The archetypal form of a particular letter is what distinguishes it from other letters, and distinguishes it as itself. That is, no other form has a shape quite like a letter. At first, this seems like a silly statement to make—we encounter shapes that remind us of letters all the time. But it's important to recognize the clue to the letterform's power over our cultural mindset in that statement: shapes remind us of letters, rather than the other way around. Letterforms are iconic symbols that are so ingrained into our consciousness that their visual form holds sway over the perception of other images. This is an interesting proposition, because the letters of our alphabet were originally derived from pictographic drawings—like the hieroglyphs of the ancient Egyptians—that represented real-world objects. Since that time, however, Western culture has evolved to the point where the image of the letter as a symbol has become preeminent over its pictorial origin. Its visual qualities and how those qualities interact with each other—individually and in groups—are what drive modern

From a visual perspective, the Roman alphabet that Western typography uses can be understood as a system of line drawings. The drawing of individual letters is archetypal; each form comes out of a long history of cultural development and has a recognizable structure that has been steadily codified and passed along over the generations. The archetypal form of a particular letter is what distinguishes it from other letters, and distinguishes it as itself. That is, no other form has a shape quite like a letter. At first, this seems like a silly statement to make—we encounter From a visual perspective, the Roman alphabet that Western typography uses can be understood as a system of line drawings. The drawing of individual letters is archetypal; each form comes out of a long history of cultural development and has a recognizable structure that has been steadily codified and passed along over the generations. The archetypal form of a particular letter is what distinguishes it from other letters, and distinguishes it as itself. That is, no other form has a shape quite like a letter. At first, this seems like a silly statement to make—we encounter shapes that remind us of letters all the time. But it's important to recognize the clue to the letterform's power over our cultural mindset in that statement: shapes remind us of letters, rather than the other way around. Letterforms are iconic symbols that are so ingrained into our consciousness that their visual form holds sway over the perception of other images. This is an interesting proposition, because the letters of our alphabet were originally derived from pictographic drawings—like the hieroglyphs of the ancient Egyptians—that represented real-world objects. Since that time, however, Western culture has evolved to the point where the image of the letter as a symbol has become preeminent over its pictorial origin. Its visual qualities and how those qualities interact with each other—individually and in groups—are what drive modern approaches to typography at every level. The archetypal form of a partic-

From a visual perspective, the Roman alphabet that Western typography uses can be understood as a system of line drawings. The drawing of individual letters is archetypal; each form comes out of a long history of cultural development and has a recognizable structure that has been steadily codified and passed along over the generations. The archetypal form of a particular letter is what distinguishes it from other letters, and distinguishes it as itself. That is, no other form has a shape quite like a letter. At first, this seems like a silly statement to make—we encounter shapes that remind us of letters all the time. But it's important to recognize the clue to the letterform's power over our cultural mindset in that statement: shapes remind us of letters, rather than the other way around. Letterforms are iconic symbols that are so ingrained into our consciousness that their visual form holds sway over the perception of other images. This is an interesting proposition, because the letters of our alphabet were originally derived from pictographic drawings—like the hieroglyphs of the ancient Egyptians—that represented real-world objects. Since that time, however, Western culture has evolved to the point where the image of the letter as a symbol has become preeminent over its pictorial origin. Its visual qualities and how those qualities interact with each other—individually and in groups—are what drive modern

That is, no other form has a shape quite like a letter. At first, this seems like a silly statement to make—we encounter shapes that remind us of letters all the time. But it's important to recognize the clue to the letterform's power over our cultural mindset in that statement: shapes remind us of letters, rather than the other way around. Letterforms are iconic symbols that are so ingrained into our consciousness that their visual form holds sway over the perception of other images. This is an interesting proposition, because the letters of our alphabet were originally derived from pictographic drawings—like the hieroglyphs of the ancient Egyptians—that represented real-world objects. Since that time, however, Western culture has evolved to the point where the image of the letter as a symbol has become preeminent over its pictorial origin. Its visual qualities and how those qualities interact with each other—individually and in groups—are what drive modern approaches to typography at every level. The archetypal form of a particular letter is what distinguishes it from other letters, and distinguishes it as itself. That is, no other form has a shape quite like a letter. At first, this seems like a silly statement to make—From a visual perspective, the Roman alphabet that Western typography, remind us of letters, rather than the other way around. Letterforms are remind us of letters, rather than the

Integrating Images with a Grid

Using a grid structure to organize pictures and text produces the opposite effect of altering the typography; it alters the images so that they become formally congruent with the type. The horizontal and vertical axes of type are an intrinsic, formal attribute of typography. By organizing images into a grid that repeats these attributes, their internal visual qualities are subordinated to the structural expression of the page. As the modules permit the images to increase in size, the images' internal logic becomes more pronounced, and the structural quality of the type begins to contrast the image. This fluctuation between formal congruence and opposition is another attribute of composition imparted by the grid.

The grid used to structure this layout defines the possible proportions of images; pictures may occupy the space created by one, two, three, or four grid modules across and up to six modules deep. A smaller image relates visually to the structure and to the type itself. As the image becomes bigger, its internal visual qualities come to dominate, creating contrast between itself and the type.

Formal Opposition

Alternatively, relating typographic elements to images by contrasting their visual characteristics is also a viable way of integrating them. Although seemingly counterintuitive, creating formal opposition between the two kinds of material can actually help clarify their individual characteristics. Contrast is one of the most powerful qualities that a designer can use to integrate material— by their very difference, two opposing visual elements become more clearly identified and understood. Within a letterform combination of an **M** and an **O**, for instance, the fact of the **M**'s angularity is reinforced by the curved strokes of the **O**. The movement within each form is made more pronounced, and the two elements fight for visual dominance. The caveat is that some congruence between the elements must also exist so that the opposing characteristics are clearly brought into focus. In the

same way that a hierarchy is destroyed if all the elements are completely different, so too is the strength of the contrast in opposing forms weakened if all their characteristics are different. In the example of the **M** and the **O**, a designer might choose to keep the two characters the same size and weight. To enhance the opposition of their geometry—angle against curve—a very circular **O** may be selected to oppose a condensed italic **M**. The shift in the **M**'s posture and width augments its angular quality; the rounder **O** more powerfully opposes the angled **M**.

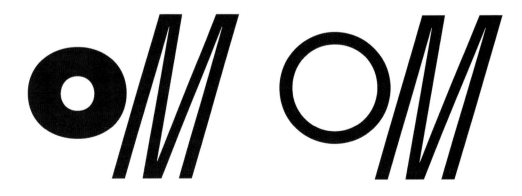

Contrasting the visual qualities of different type elements is just as valid a way of integrating them as making them similar. When the qualities of two type elements, or type and an image, are formally opposed, they each become more recognizable and distinct.

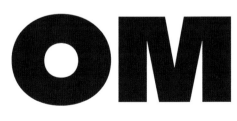

*A study of the two letterforms, **O** and **M**, interacting, reveals both congruence and opposition. Their inherent differences are made more pronounced by changing the posture, weights, and positions of the letters.*

The same abstract pictorial qualities of image and type are the source for creating opposition, as they are for creating congruence. A soft-focus photograph with muted detail and light tonal values overall may suggest a bold-weight sans serif typeface; another option may be a regular-weight modern serif face with a great deal of contrast in the strokes—the opposite of the photograph's lack of contrast. Yet another option may be a light-weight text with very active details, so that the passive, neutral character of the image is counteracted by the stylized quality of the typeface. In all three cases, some quality of the type is congruent with the image, but its primary quality is formally opposed to it.

The number of options for relating type to image are virtually endless. In these two studies, the selection of typeface and weight create formal opposition between the type and the image.

Total clarity of relationship—created by the complete difference in color, arrangement, and visual thrust between the corn cob image and the type—is demonstrated in this spread.
Felix Estrada | USA

The two spreads from this annual report show two grids opposing each other. The type is structured on a grid of narrow columns with a more vertical emphasis; the images are aligned on a second grid with more horizontal emphasis. Where the two layers of information interact, a great deal of tension is created, but the layout is very clear because of the decisive spatial distinction between the two layers.
First Rabbit GmbH | Germany

Opposition can be created between elements through spatial or structural means. If all the typography is aligned on a grid and set justified, its geometric quality may be clearly opposed by organically shaped images. Opposition could also be created by positioning rectangular photos randomly or on a second grid that interferes with the type grid. Although a grid most often is used to create a system of proportional options for text that is spatially congruent with the structure, it can also be used to impose structure in a mannered way to create unexpected interactions between text and image. The opposition between type and images creates an indisputable sense of order because they are dramatically different. Spatial or grid-based opposition offers a directness and immediacy that is augmented by the opposing structural logic. Seen another way, the aggressive presentation of elements in opposition can be jarring, but this may have value. Optical disturbance is as valid a communication as is optical harmony; it may be entirely appropriate to make the viewer uncomfortable, nervous, or tense.

Type as Image
Transforming Words into Pictures

Letters and words are very strong forms. Their simplicity allows them to be dramatically manipulated without fear of losing their identities. When a letter or word takes on pictorial qualities beyond those that define their form, they become images in their own right, and the potential for impact is enormous. Words that are also pictures fuse several kinds of understanding together. As their meaning is assimilated through each perceptual filter—visual, emotional, intellectual—they assume the iconic stature of a symbol. Understanding on each level is immediate, and a viewer's capacity to recall images explains why corporate identity exists in the way that it does. The business community learned that identification and memory were key to building market share and brand loyalty, and the surest way of triggering memory in consumers was to identify their businesses with strong word images: the logo and its variants, the wordmark and letter symbol.

Like so many aspects of strong typographic design, making type into an image means defining a simple relationship between the intrinsic form of the letters and some other visual idea. It is easy to get lost in the endless possibilities of type manipulation and obscure the visual message or dilute it. A viewer is likely to perceive and easily remember one strong message over five weaker ones—complexity is desirable, whereas complication is not.

Making type into a picture creates enormous opportunity for the designer. When typography becomes something more than just what it says, its communicative power is dramatically increased.

How can type become an image?

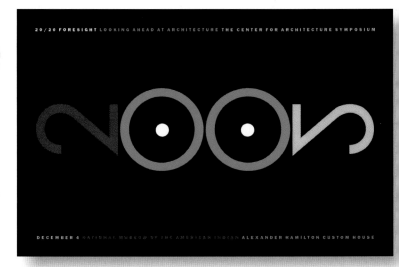

By pictorializing the numerals of the year in this poster, the designer not only creates an image but communicates the theme of the lecture being promoted in a clear, direct, and humorous way.
Pentagram (Michael Gericke) | USA

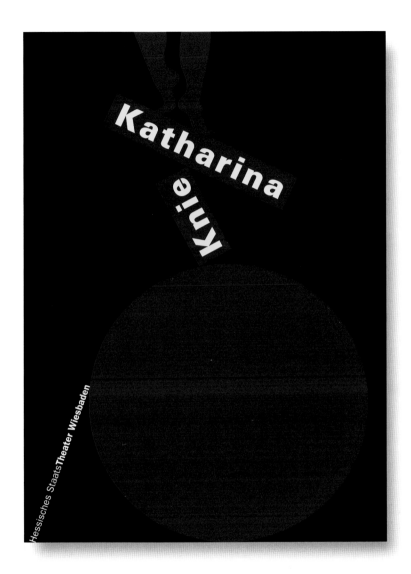

The type in these two theater posters from a series acts in different ways as images. In the Katharina Knie poster (left), the type becomes graphic objects that interact with the other images in the same space.

In the Godot poster (right), the title is transformed into an environment that acts as a context for the small figures at the top.
Günter Rambow | Germany

Type may be transformed into an image using a variety of approaches. Each provides a different avenue of exploration and several may be appropriate both to the desired communication and to the formal aspects of the type itself.

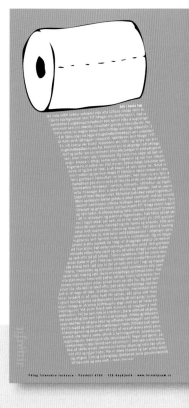

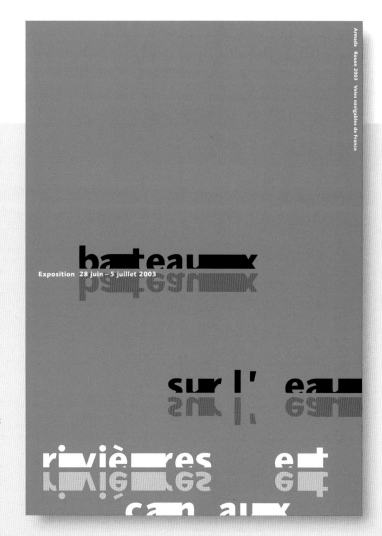

Fitréttir *newsletter page*
Einar Gylfason | Iceland *far right*

Bateaux Sur L'Eau, Rivières et Canaux *poster*
Philippe Apeloig | France *right*

Pictorialization

When type becomes a representation of a real-world object, it has been pictorialized. It may interact with other real-world elements, such as figures or environments, as though the type and the figures, for example, may be existing in the same space; the figures interact with the type element as though it is the thing it represents. Alternately, the type may exist independently of other images but begin to look like a real-world object. For example, the forms are drawn to appear to be made out of a recognizable material or form part of a recognizable object. Or, the type forms may affect elements or the space around them in a naturalistic way, such as by casting shadows or rippling water in an adjacent image.

Pictorial Inclusion

Illustrative elements brought into the type forms so that they interact with its strokes or counterforms are said to be included. The type retains its essential form, but the pictorial matter is integrated by reversing out of the type or by replacing the counterforms within or between the letters. Pictorial inclusion is an effective strategy when the designer wants to achieve scale impact within a limited format; since the inclusions occur within the type, it can fill as much of the format as possible without sacrificing space for pictures. Further, the pictorial inclusion fuses with the type and transforms it into image, despite the fact that it is not an actual part of the type forms.

Form Alteration

Changing the structural characteristics of type elements is a strategy for aiding in comprehension and recall. Altering the form of an adjective—a word that describes something—so that the alteration performs the quality of the description is one example. Form alteration can be illustrative or not—the word "heat" could be illustrated by drawing the letters as though they're literally on fire; or the forms could be altered so that the letters appear to be melting. Altering type elements may have a syntactic component as well. If the word "growth" is set so that the letter **O** is larger than the other words, it involves the word's vowel, exploiting the syntactic quality of the vowel's sound by exaggerating its visual presence as it relates to the word's meaning.

Living Stereo *CD packaging*
344 Design, LLC | USA *above left*

Asahi Television *identity*
Taku Satoh Design Office | Japan *below left*

B&G Sawin *logotype*
What!Design | USA *top*

STIM *logotype*
Timothy Samara | USA *middle*

Taipei *wordmark*
Wongi Ryu | USA *bottom*

Form Substitution

Replacing a type form with a recognizable object or another symbol is referred to as a substitution. Substituting one form for another is a kind of pictorial inclusion, but because the image is substituted for a letter, a very different visual relationship has been achieved. Many real-world objects resemble letterforms. Circular objects are often substituted for a letter O, or a tree substituted for a letter Y. Careful attention must be given to legibility. The closer the resemblance of the image to the letter it has substituted, the more legible it will be.

GLUT *performance poster*
Atelier Bundi | Switzerland *right*

Fort Tryon Park logotype
STIM Visual Communication | USA *below*

FORT TRYON PARK

Form Combination

One kind of form alteration mixes several strategies together, and is itself called a combination. When a letter or word is combined with another form—representational or abstract—so that the two images exist as one, it is referred to as a form combination. This strategy combines the ideas of substitution, alteration, and pictorialization. The clearest example is that of a logo or wordmark in which one of the letters is clearly itself and something else at the same time. If the image combined with the letterform is that of a recognizable object, the alteration takes on the quality of a substitution. If the letterform is combined with abstract shapes the combination becomes more of a form alteration.

Syntactic Deconstruction

Changing the visual relationships between the parts of a word or phrase is a deconstruction—and the fact that it is related to the nature of meaning makes it syntactic. The cadence of the spoken word can be used as a clue for deconstructing it. Another catalyst for deconstruction can be found in a word's syllables. Changing the scale, weight, or spacing of the root word, the prefix, the suffix, or the individual letters to impart meaning are all ways of deconstructing the word. Changing the spacing of a word like "staccato"—a musical term meaning a stilted separation between notes—so that the letters become a rhythm of dots is a clear example.

bécoming
american

Crosswalks *identity*
Timothy Samara | USA *left, middle*

Becoming American *identity*
Lynn Fylak | USA *near right*

Objectification

Creating type elements out of actual objects reverses the logic of pictorialization—rather than transforming the type into an image that refers to the real world, naturally occuring materials are used to make letterforms. Because words treated this way have the credibility of hard objects, they take on a solidity and symbolic power that is hard to match. The choice of material with which to make the type forms is profoundly significant; the same word formed in glass and then in dung will take on dramatically different meaning. Added to the symbolic potential is the opportunity to incorporate unusual photographic images that are all the more striking.

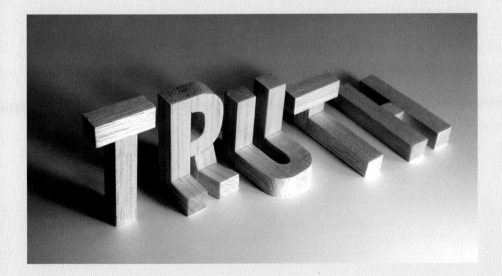

URANIUM

L'ÉTAT SAUVAGE
IMPRIMATEURS

Ornamentation

Lastly, typographic elements may be transformed into images by adding ornamentation: borders, outlines, dots, dingbats, lines, geometric shapes, to name a few. The ornament may be structurally related to the typography, or it may be purely decorative. The scale and nature of the ornamentation will have an impact on the type. If the ornaments have some kind of symbolic or representational quality, they may take on the aspect of an inclusion and therefore be more strongly connected to the meaning of the word. If the ornament occurs between word parts, it may have syntactic qualities. The style of the ornament may affect the viewer's sense of the historical context of the type; for example, a flourish or antique dingbat from a particular period. Ornamentation that is representational may also take on the aspect of a form alteration or a pictorialization; a double outline of three weights around the word *Uranium* logotype (top) is an example of orna-mentation becoming pictorial.

Uranium *wordmark*
STIM Visual Communication | USA *top, right*

L'État Sauvage *identity*
STIM Visual Communication | USA *middle, right*

Truth *photo illustration*
Doyle Partners | USA *above*

Color in Typographic Expression

Typographic color in a composition refers to the textural qualities, as well as the relative darkness or lightness, of the type elements. But chromatic color—the perceptual difference among colors like red, blue, or orange—can also play a dramatic role in typography. A composition in black and white, for example, may exhibit very dynamic typographic color—contrast in scale, gray value, and spacing—even though the type appears only in black. The same composition may be enhanced by coloring these elements or background to add dimension, expression, and informational clarity.

The intrinsic attributes of color are hue, saturation, value, and temperature. Each attribute affects the same color in different ways. Darkening the color tends to decrease its intensity, as does making it lighter. Changing the color's temperature affects its relative hue—as it gets cooler, it becomes more of a burgundy; as it gets warmer, it appears yellow-orange.

Hue	*Saturation*	*Value*	*Temperature*
The identity of a color	*Brightness or dullness; intensity*	*Darkness or lightness of a color*	*Warmth or coolness of a color*
Yellow	Less saturated	Deeper value	Cooler (shift toward blue)
Red *Used for comparison* >	Red	Red	Red
Blue	More saturated	Lighter value	Warmer (shift toward yellow)

Understanding how colors work optically is an important step in understanding how they will affect typography.

The contextual relationship of color is evident in this study of a violet interacting with other colors. Value, temperature, hue, and saturation—as well as the amount of each color interacting—all contribute to how the colors appear when they come in contact.

Il faut voire combien d'une couleur existe dans les mots.

les mots

The color in the line of small type appears darker (and less colorful) than that in the line of larger type, even though the color of the type is the same in both examples. Neither appears as colorful, nor as light, as the field of the same color shown at right.

Formal Aspects of Color

A single color is defined by four essential qualities: hue, saturation, value, and temperature. **Hue** refers to the essential identity of a color—red, violet, orange, yellow. The color's **saturation** describes its intensity. A saturated color is very intense or vibrant. Colors that are dull are said to be **desaturated.** A color's **value** is the aspect most closely related to typographic color—its darkness or lightness. Yellow is perceived as being light; violet, as dark. The **temperature** of a color is a subjective quality that is related to experiences. A warm color, like red or orange, reminds us of heat; a cool color, like green or blue, reminds us of cold objects, like plants or water.

The perception of these color characteristics is relative, changing as different colors come in contact. The perception of hue is the most absolute: a color is either seen as blue or green. However, if two similar blues are placed next to each other, one will be perceived as having more red in it, and the other will be perceived as having more green in it. This perceptual change can only happen when two colors are close enough to be compared. A color's value, temperature, and saturation will also appear to change

when brought into context with another color. A blue may appear dark against a white field but may appear light against a black field. The same red may appear warm next to a violet but cool next to a yellow or orange. A pale violet may appear intense against a warm gray background or desaturated against a cool gray background; it may appear neutral (completely desaturated) if placed against a vibrant orange background.

Colors that are similar in value enhance each other's intensity, but their optical separation becomes less distinct. Two colors of a similar value that are complementary—opposites on a color wheel—create a severe optical buzz when brought together; their similar values decrease their optical distinction, but their opposing hues mutually increase their intensity to the extreme.

Color and Space

Color exhibits a number of spatial properties. Cool colors appear to recede while warm colors appear to advance. Of the primary colors, blue appears to recede and yellow to advance, but red appears to sit statically at a middle depth within space. A color will appear darker the less there is of it. A large rectangle and a narrow line of the same color will appear to have different values if set against a white background—the color in the rectangle will appear lighter than it does in the line, because the line is surrounded by much brighter white space.

Chromatic color can have extraordinary impact on the typographic color of the elements to which it is applied. The relative value of colors is an aspect that demands great care in regard to how it affects legibility, especially in instances where a colored background interacts with colored type. As their values approach each other, the contrast between type and background diminishes, and the type becomes less legible. The effect of color on hierarchy within a composition is pronounced, especially in terms of value, as this aspect of color corresponds directly to typographic color.

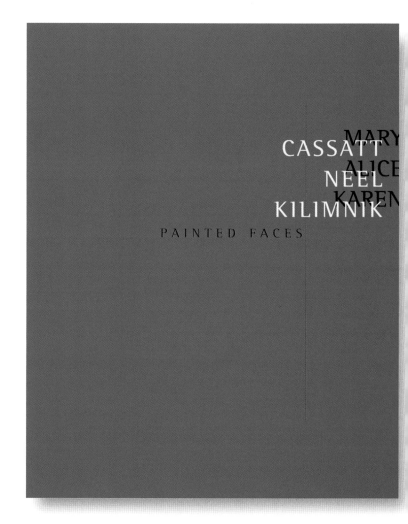

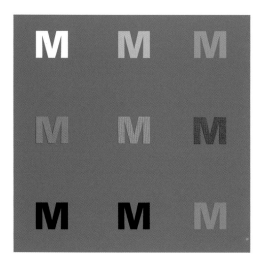

As the relative values, temperatures, and saturation of type and background change, so do their apparent spatial relationships—along with legibility.

Value, hue, and saturation play definitive roles in the typography of this catalog cover. A similarity in intensity and value—but not in hue—brings the background and the title, Painted Faces, into a close spatial relationship; the colors are nearly complementary and appear to buzz, but their closeness in value sends the type into the background. Dramatic value changes in the artists' names at upper right puts them at the top of the hierarchy. The white type is more different in value from the background than is the black, and so it comes forward in space.
Paone Design Associates | USA

Hierarchic Distinction through Color

Applying color to a typographic composition will have an immediate effect on hierarchy. The intrinsic value relationships of typographic color may be exaggerated through the application of chromatic color, and therefore clarified. Color distinctions can greatly enhance the perception of spatial depth and force greater separation between the hierarchic levels. For example, if the information at the top of a hierarchy is set in a deep, vibrant orange-red, while the secondary information is set in a cool gray, the two levels of the hierarchy will be visually separated to a much greater degree. Although the values of the colors are similar, the saturated orange type will advance in space, and the cool gray type will recede. The application of color to the ground within a composition can further enhance the hierarchy. Type in one color, set on a field of another color, will join closely with it or separate aggressively,

depending on their color relationship. If the colors of type and background are related, the two elements will occupy a similar spatial depth. If they are complementary in nature, the two will occupy very different spatial depths. It is important to maintain considerable contrast between the type color and the background color so that the type remains visible. Color may also be used to link related informational components within the hierarchy of the composition. In an event poster, for example, all the information related to the time and place of the event may be assigned a particular color, which may relate to the color assigned to the title of the event. The color relationship of the two informational components creates a meaningful link for the viewer and serves to clarify the information.

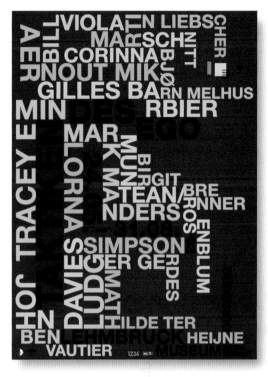

An overall color establishes a hierarchical base against which color changes help distinguish the importance and relationship between typographic elements. In areas where the color change from the background pink becomes more extreme, the information they carry becomes more important.
Qwer Design | Germany

By arranging the contents listing in this page spread on a gray background, the designer decreases the contrast between background and text. At the same time, reversing the list headings out white from the gray background increases their contrast. The headings are, therefore, more noticeable— higher in the hierarchy. Color saturation can enhance the dominance of the word Innhold ("Contents"): its scale helps, but the vivid red against the neutral background really distinguishes its importance.
Creuna Design | Norway

Keep It Simple
Fewer colors with rich relationships between them will help clarify hierarchy, as well as introduce an overall visual harmony.

Psychology of Color

With color comes a variety of psychological messages that can be used to influence the verbal meaning of typography. This emotional component of color is deeply connected to human experience at an instinctual level, as well as being influenced by the socialization process. Many of the psychological properties of color are dependent on the reader's culture. Many cultures equate red with feelings of hunger, anger, or energy because red is closely associated with meat, blood, and violence. Vegetarians, by contrast, may associate the color green with hunger. In Western cultures, which are predominantly Christian, black is associated with death and mourning, but Hindus associate death with the color white. Christians associate white with purity or cleanliness. Because of the history of Western civilization, violet conveys authority and luxury to members of that culture. Most cultures respond to blue with an association of water or life. Blue is also often perceived as deeply spiritual or contemplative, perhaps because of this particular association. Clearly, selecting a color for specific words in a composition can add meaning by linking its associations to the verbal message. A headline or title set in one color may take on additional, or completely different, meaning when set in another. Comparing color options for type simultaneously helps determine which color is most appropriate for the communication.

Color conveys a strong mood, whether specifically applied to typographic elements or the overall composition, as in this event invitation. The controlled palette of neutral colors with similar values supports the serene, elegant communication already transmitted by the selection of classical serif and sans serif forms.
Poulin+Morris | USA

STOP

STOP

STOP

STOP

The word stop is transformed by color, sometimes supported in meaning and sometimes opposed. Curiously, the idea of stopping is very clearly conveyed by the version set in a very loud, vibrant color.

Caroline Weiß
Sascha Török
Ruedi Ruegg
Bruno Margreth
Sabine Jahlen
Susan Holler
Willem Baumann
designalltag@access.ch
Fax 01 262 06 63
Telefon 01 261 02 00
CH-8030 Zürich
Merkurstrasse 51
Kommunikation
Büro für visuelle
Ruedi Ruegg
Designalltag Zürich

Designalltag Basel
Peter Vögtle
Büro für visuelle
Kommunikation

Münchensteinerstr. 69
CH-4052 Basel
Telefon 061 373 17 17
Fax 061 373 17 18
designalltag@magnet.ch

Peter Vögtle
Igor Schmutz
Katrin Ginggen

For Westerners, the use of red and green together immediately marks this card as pertaining to the winter holidays.
Ruedi Rüegg | Switzerland

Color Coding in Systems

Within a complex system, such as a corporate identity or a series of brochures, color can help distinguish different kinds of information. In addition, color coding may be able to expand the color vocabulary within a brand, creating a rich and evolutionary experience that helps clarify the brand in the minds of its audience, while creating flexibility for the designer. If a company's identity relies on a specific deep blue, a secondary palette of lighter blues, a violet, and a green-blue might be used to expand the system's color vocabulary and for coding the company's literature. A secondary palette may include very different colors— in this hypothetical example, perhaps a vibrant golden orange or a deep fuchsia—as accents that can be used to add contrast or distinguish certain types of information.

For a company that produces software and manufactures equipment, for example, color may be used to brand the components of the overall system as related to the company, but a secondary palette may distinguish software brochures from equipment brochures. Within each of those categories, additional color coding may help distinguish brochures that are overviews from those that are more specific or technical. To be effective, color coding must be relatively simple and must be easily identifiable. Conversely, using more colors for coding creates confusion, as the viewer is forced to try to remember which color relates to which information. Color coding within a related set of hues—a deep blue, an aqua blue, and a green— can help distinguish subcategories of information within

an overall grouping, but care must be taken to ensure that the viewer is able to perceive the differences between the colors. Pushing the colors farther apart in relation to each other may help—the deep blue may be skewed toward the violet while yellow is added to the green, for example.

A consistent typographic treatment works with a changing palette of complementary colors to create an overall color system for the packaging. Although not typographic color-coding per se, the link created between the specific typographic forms and the sophisticated combinations of colors chosen for each product takes on systematic qualities.
Taku Satoh Design Office | Japan

The powerful mnemonic effect of color makes it ideal for clarifying verbal information within complex systems, such as extensive product literature.

Within this manufacturer's overall branding color palette of fuschia and orange, a secondary palette distinguishes product offerings—a neutral brown for Instruments, and a smoky blue for Informatics. The amount of color applied to type and elements decreases within the Instruments subsystem as the collateral becomes more technical. By limiting the palette and keeping the code colors as distinct as possible, the designer ensures the difference between product groups is never confused.

STIM Visual Communication | USA

TYPOGRAPHY
IN PRACTICE

Historically, the province of letterform design was restricted to a scarce few typographers with a scholarly background. With the development of computers and graphical user interfaces, typeface design has been democratized, and in recent years the number of new faces available has proliferated. The ease with which designers can build their own alphabets is unparalleled. Interestingly, the result has been two sided. On one hand, the ability to investigate type design so easily has encouraged some designers to pursue training in traditional methods; on the other, it has encouraged experimentation with radically altered and inventive letterform designs that speak to the complicated visual tastes of the age. Typeface designs of this kind, while not necessarily adhering to accepted notions of good form or legibility, nevertheless help evolve the visual language of the culture. Regardless of training or intent, designing typefaces requires an acute sensitivity to formal details—the letters in a character set must visually feel related through their internal logic.

TYPOGRAPHY

Typeface Design

Creuna Design, located in Norway, is headed by Stein Øvre and Frode Slotnes, who regularly create custom typefaces for their personal, as well as professional, use. Their roster of clients in the publishing and entertainment industries benefits from their combined devotion to creating new type forms, often as part of a branding program—the custom nature of a project's typeface becomes an important aspect in differentiating their clients' brands. Here, Stein and Frode discuss their approaches to designing typefaces.

What interests you about designing typefaces, and what training did you have for drawing letterforms?

Stein Øvre: I've had no courses. Designing letterforms is really a pure expression of certain individual styles. When using my own letterforms in a design, I just feel the whole design becomes more personal. It's more free, like a painting, as opposed to placing templates in a certain order on a page. I've been interested in type—and the effect of typestyles—since I was a child. An early key inspiration for me was the record sleeve for the Dire Straits album *Making Movies*. I believe this single piece of work really got me interested in typography.

Frode Slotnes: I have no formal training in type design. When I went to primary school, I was interested in drawing, and made "decorative" fonts—headings for school papers and cassette covers and things like that. In the late 1980s, I liked the punk typography of fanzines; I used photocopiers, rubdown letters, and old typewriters, and I made potato and rubber stamps. My interest in type grew when I started designing on a Macintosh. My sources of inspiration became *Emigre* magazine, T-26, P. Scott Makela, Barry Deck, and Suzanna Licko.

Talk a little bit about a couple of favorite typefaces that you've designed. How did you approach designing them? What did you think about?

Stein: One of my favorites is Jersey Girl Electroclash. I had a basic idea for a font that somehow should express my interest in the edge and simplicity of the musical style "electroclash"—both glamorous and militant. Instead of making a font from scratch I transformed the free font T-Series by Territory to fit my idea… the challenge was to make it as different from T-Series as possible.

Frode: I'm partial to GCE. I surfed the 'Net for propaganda posters from the 1930s and '40s, and found a site with posters from the Spanish Civil War. GCE is an abbreviation for Guerra Civil Española. One of the posters had a nice letter g, which inspired the font—but I modernized it with sharp corners instead of the round curves of the original. Another is Cleanfax. I started working on this font in 1994, based on the clean pixellike font in fax headings (where the receiving information is printed automatically).

Do you draw your letters by hand first and then digitize, or do you work directly on the computer?

Stein: I do rough idea sketches by hand—to get the right feel—then the rest of the process is done on a computer.

Frode: Usually, I draw them directly on the computer, but I've made some hand drawn fonts and rough stencil or typewriter fonts where I trace, print, and scan to get the right feeling.

What are your favorite typefaces and why?

Stein: I like Berthold Akzidenz Grotesk for its neutrality. It's my default text typeface. I use it in the same way many people use Helvetica. To me, Helvetica is a typeface with certain flaws that I'm fond of. The individual letters don't necessarily have to be perfect; flaws can create a different kind of text picture. Telenor, by Magnus Renking, is one of my favorite typefaces from this century! It's an extremely good text face—it's really "now." Unfortunately, this is the corporate typeface for Norwegian telephone company, Telenor, which means it's proprietary. I'd love to set a brochure for Telenor because it would mean being able to use the font.

Jersey Girl Electroclash

A B C D E F G H I J K L M N O P
Q R S T U V W X Y Z Æ Ø Å

Cleanfax Rounded

A B C D E F G H I J K L M N O P Q R S T U V W X Y Z
1 2 3 4 5 6 7 8 9 0 ! ?

GCE

A B C D E F G H I J K L M N O P Q R S T U V W X Y Z
1 2 3 4 5 6 7 8 9 0 ! ? + −

B-Dot

The strokes of the B-Dot letterforms are drawn from dots but do not use a grid as the basis for their arrangement. The strokes appear created by a dot-matrix printer; the dots are evenly spaced apart from each other, but they are positioned where needed to create smooth curves and more regular, traditionally derived proportions for the forms. The full character set was created in the light weight first, to establish the relationships of the dots in the letters; additional weights simply enlarge the dots, which remain in the same orientation to each other, increasing the density of the letters until the dots begin to overlap.

André Baldinger Conception Visuelle | *Zürich, Switzerland*

Aa Bb Cc Dd Ee Ff Gg Hh Ii
Jj Kk Ll Mm Nn Oo Pp Qq Rr
Ss Tt Uu Vv Ww Xx Yy Zz

1234567890 ¬%‰ .,;:/?!.()[]{}

The quick brown fox jumps over the lazy dog
The quick brown fox jumps over the lazy dog
The quick brown fox jumps over the lazy dog
The quick brown fox jumps over the lazy dog

Green Rounded Mono

This particular dot-based font family is constructed on a grid and uses a double-line configuration to add mass to the strokes for additional character sets. The rounded versions in the family are softer, but the squared version is more legible, owing to the pronounced angular junctions in the forms. A comparison of the B-Dot font shows how enforcing the grid as a structural conceit creates a font that is much more stylized; the B-Dot font is more naturalistic.

Design Machine Alexander Gelman |
New York City (NY), USA

ABCDEFGHIJKLM
abcdefghijklm
NOPQRSTUVWXYZ
nopqrstuvwxyz
1234567890
!@#$%^&*()-_+=
{}[]:;,.<>?/

Cube / Six-Shooter / Parallelogram

Three graphic typefaces created for various applications by an Australian design studio explore the possibilities of geometric construction of letters. Each alphabet has its own internal formal logic—linear, point based, or planar—and defines the structures of its letters on a grid. In the case of Cube and Parallelogram, the grid is three-dimensional, although the next result of the articulation of the grid structure in Cube is strictly linear. Six-shooter is a dot-based typeface (see B-Dot and Green Rounded Mono, opposite) that defines points on a grid; the grid in this typeface, uncharacteristically, is a 45°/90° grid.

Gollings+Pidgeon | *St. Kilda, Australia*

Newut

Newut is a new sans serif font—a grotesk—in which the uppercase and lowercase letters have been designed to be the same height. Based on the idea of a universal font explored by Herbert Bayer at the Bauhaus during the 1920s, it is an idea that goes even further back in history for its source—the uncial forms that developed in the third and fourth centuries after the fall of the Roman Empire. Uncials are a debased form of capitals, developed accidentally over time by scribes copying the capitals more and more casually. At a certain point, the uncial forms split into two types—majuscules and miniscules—the basis for our uppercase and lowercase letters.

Each uppercase letter in Newut has a corresponding lowercase letter, as in any roman typeface, but here, both are the same size and weight; the uppercase letters are at the x-height. The ascenders and descenders of the lowercase still extend above and below the body of the type. In text setting, the interchange of uppercase and lowercase is barely noticeable, and the lines of type hold their linearity very aggressively. The alternate characters give a designer several options for setting text; he or she can mix the characters at will without creating an optical disturbance. The family includes three weights and an extended character set.

André Baldinger Conception Visuelle | *Zürich, Switzerland*

Aa Bb Ċc Dd Ee Ff Gg
Hh Ii Jj Kk Ll Mm Nn
Ȯo Pp Qq Rr Ṡs Tt U̇u
V̇v Ẇw Ẋx Ẏy Żz ẞ & et

Ȧà Ȧà Ȧà Ȧà Ȧà Ȧà Çç
Ėė Ėė Ėė Ėė Iì Iì Iì Iì
Ṅṅ Ȯò Ȯò Ȯò Ȯò Ȯò U̇ù
U̇ù U̇ù U̇ù Ẏÿ ™ ⓘ →

The quick brown fox jumps over the lazy dog 1234567890 @ ↖↗↙↘←→
The quick brown fox jumps over the lazy dog 1234567890 @ ↖↗↙↘←→
The quick brown fox jumps over the lazy dog 1234567890 @ ↖↗↙↘←→

All signes of amb+ Newut shown in classic-medium

Aa Bb Cc Dd Ee Ff Gg Hh Ii Jj Kk Ll Mm Nn Oo Pp Qq Rr Ss Tt Uu Vv Ww Xx Yy Zz 1234567890 ¼ ½ ⅓ ⅔ ¾ % ‰ .,:;-–—·''‚'""„<>«»*/?!¿¡()[]{}
†‡§¶•£ƒ¢$flfiβ æ Æ œ Œ ø Ø & et & á â à ä ã å ç é ê è ë í î ì ï ñ ó ô ò ö õ ú û ù ü ÿ Á Â À Ä Ã Å Ç É Ê È Ë Í Î Ì Ï Ñ Ó Ô Ò Ö Õ Ú Û Ù Ü Ÿ © ® ™ @ • ... # ª º + - = ≠ ± µ | ⓘ ↖ ↗ ↘ ↙ ←→

VESTONS vestons

VESTONS vestons

VESTONS VESTONS

V̇EṠTȮNŚ VEŚTONŚ

V̇EṠTȮNŚ V̇EṠTȮNŚ

VEŚTȮNS V̇estonŚ

L'élève → L'élėve

öl → œl → ȯl

Häuser → Hȧuser

Eine kleine ȯde an
ȯderland... ööȯȯderland

smith & sons & ṡons et ...

The promotional poster
introducing Newut shows
the regularity of the text
setting despite mixing upper-
and lowercase characters.
The linearity of the lines is
also pronounced.

Combining upper- and lowercase
characters provides a number of
options that alter the character,
but neither flow nor legibility, of
the setting.

Variations in punctuation and
special characters add to a
designer's options for setting;
note the different ampersands
included in the character set.

PYO Proprietary Typeface

This typeface for a youth orchestra uses strong forms that derive their shapes from geometric base components: a horizontal line, a circle, a diagonal line, and a vertical line. The strokes are mathematically the same thickness, not compensated for optically. The circular shoulders of the **R** and **P** are literally half circles. The **A** is an isosceles triangle, as is the **V**, and both share the same angles—unlike the same forms in any other alphabet. The cross strokes along the midline have been removed from relevant letters—the **H, F, A, E**—and replaced with a dot, optically the same weight as the strokes but mathematically centered on the vertical height of the body—again, not optically compensated. Unlike the proportions of the Lever Sans alphabet (opposite), these are not based on the square of the **M,** which is composed of two triangles. The proportions are, instead, more naturalistic, aiming for an intuitively even pacing of strokes and an optically related width among the letters. The forms are open and very musical; in setting, the alphabet evokes musical notation. Oddly, despite the lack of compensation for optical aberrations like midpoint drop, the alphabet appears formally harmonious.

Paone Design Associates Gregory Paone |
Philadelphia (PA), USA

PI·IILADELPI·IIA YOUTI·I ORCI·IESTRA

ANNUAL FESTIVAL CONCERT

Jersey Girl

This sans serif typeface is reminiscent of the kind of industrially templated type that might be punched into license-plates or stamped onto machine parts for identification. It is an all uppercase font of a slightly bolder weight than a true regular is. Its curved and angled junctures have been replaced by segments, although these are not based on a hexagonal system of proportions. The counters in the **O, Q, A,** and **U** are squared, rather than following the exterior contour of the strokes. A second version of the typeface incorporates negative lines through some of the strokes, enhancing the machined stencillike quality of the alphabet.

Creuna Design Stein Øvre | *Oslo, Norway*

ABCDEFGHIJKLMNOP
QRSTUVWXYZÆØÅ

ABCDEFGHIJKLMNOP
QRSTUVWXYZÆØÅ

Lever Sans

The Lever House is an icon of modern architecture located in New York City's midtown business district, on Park Avenue just north of Grand Central Station. Designed in 1950 by Gordon Bunshaft for Skidmore Owings Merrill, its pioneering structure is the first glass and steel curtain wall built in the United States.

For an identity and signage representing the building, Pentagram and the Hoefler Type Foundry created a custom alphabet based on Modernist sans serif models popular around the time of the building's design and the building's original signage. The proportions owe a lot to Paul Renner's Futura of the 1930s, using Roman geometric proportions; the **O** is a circle, the **M** based on a square, the **E** a half-square. Elegantly curved stem details—the leg of the **R** and the tail of the **Q**—and slightly uneven top-to-bottom counters in characters like the **E, H,** and **K** bring a lightness and cool austerity to the strokes. The **G** is particularly beautiful, an almost full circle sliced into by a crossbar—without the potentially disturbing upcut into the vertical off the lower part of the bowl. The thinness of the strokes is dangerously light, but the archetypal construction of the forms seems to give the strokes an unnatural tensile strength.

Pentagram Michael Bierut | *New York City (NY), USA*
Hoefler Type Foundry Jonathan Hoefler |
New York City (NY), USA

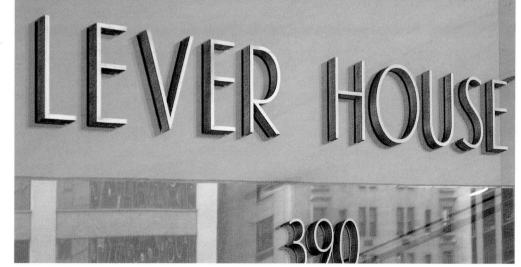

Photo: Peter Mauss / Esto

Willke Farr & Gallagher Logotype

Logotypes evolve in subtle ways. They get adjusted, retypeset, "fixed" by well-meaning but unskilled employees. This is true of many logotypes created in the earlier part of the twentieth century that are still in use and especially of those related to the older, more conservative professions such as law, where revision is always based on precedent—even if it's poorly drawn. Evaluating the details of letterform construction in a logotype with the aim of cleaning it up is no small task. Aside from the act of analyzing the minutiae of the existing forms, the designer must also bring a skillful knowledge of letterform drawing and sensitivity to bear in adjusting the forms—even drawing new ones—so that the result is not another bastardization. In this redrawing of a law firm's logotype, the attention to detail and sensitivity is evident. The existing lockup was fraught with formal inconsistencies that most designers would overlook, let alone a corporate executive. Careful study and a masterful reworking of the logotype resulted in the firm retaining its brand equity and a newly refurbished mark of integrity. A thoughtful presentation guides the client through the analytical process, presents options for evolution, and compares the final mark to its antecedent. The designer has succeeded in achieving a timeless visual structure that joins past to present and future.

AND Partners David Schimmel | *New York City (NY), USA*

This client presentation details the analysis of the original logotype, describing the formal inconsistencies in a language that is understandable to nondesigners and supporting the finds with diagrams.

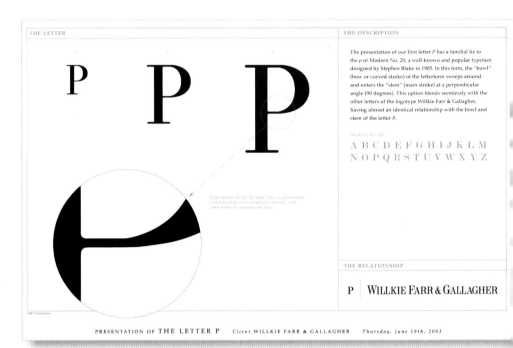

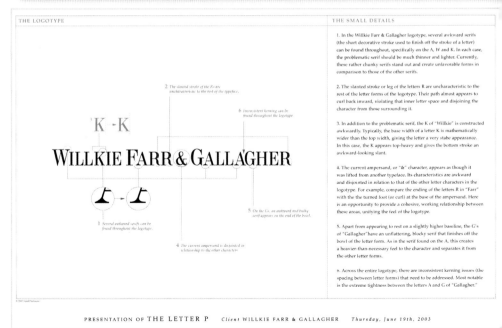

THE COMPARISON

ORIGINAL WILLKIE FARR & GALLAGHER

PREVIOUS WILLKIE FARR & GALLAGHER LLP

CURRENT WILLKIE FARR & GALLAGHER LLP

The differences between the original and revised logotypes appear minute, but the final mark reveals a state of overall grace the original lacks.

WILLKIE FARR & GALLAGHER LLP

The final, refurbished mark in its corporate color. Corrections to the spacing between letters, unbalanced forms, and inconsistently drawn terminals in several of the letters have yielded a well-crafted mark that will continue to build the client's brand for years to come. The gently condensed serif letters are marked by a great deal of contrast in the strokes and fully filleted brackets that elegantly taper outward to the serifs. The emphasis in the bowls of the round forms are slightly higher than conventional, giving the letters a distinct lift and energy, and the initial caps are just taller than the capline of the remaining letters, weighted the same, and spaced evenly. Overall, the spacing is tighter than normal, adding a distinctly vigorous rhythm to the line.

Designing books and jackets is a very intense process. The typographic interiors of books, by their nature, must be carefully considered to enhance their content—and to make the reading process comfortable and accessible. The nuances between text sizes, weights, and their distribution require a sensitivity to detail and pacing that more immediate typographic communications do not. Book jackets, on the other hand, often require the opposite kind of presentation—one that is almost posterlike—so that they'll attract readers in a crowded sales environment and communicate the book's content in a visceral way. Balancing these two typographic extremes simultaneously draws on a designer's skill with the subtleties of textual typographic color and contrast, as well as his or her conceptual approaches to investing typography with imagelike power.

TYPOGRAPHY

Book Design

IN PRACTICE

Texts and Covers

Describe your personal approach to designing with type—what characterizes your typographic sensibility from that of other designers? I got involved with typography because I fell into a bowl of alphabet soup as a child. But I find other disciplines, like photography, philosophy, film, and music just as important. I'm passionate about design, but I'd love to have been an astronaut or professional soccer player. Perhaps the most important thing is to simply love your own work. What you actually do isn't that important.

What is your feeling about rules in typographic design? Are there any rules you feel should never be broken? The only rule is: there are no rules! And that rule can also be broken.

Do your concerns about type change when you're designing a book cover as opposed to a poster or a brochure? The medium dictates the design. The viewing range for a book is not the same as for a poster. And books are three dimensional—that's a fundamental difference between books and posters. Books even have a fourth dimension if you count their overlapping pages. A book

is also a riddle, and the cover alone can't reveal the contents—they are revealed by opening it, leafing through it page by page and reading. I don't want to spoil the secret of a book on the front cover. But I do want to provide an interpretation of the contents. A poster can contain different layers of information too, but I'm more fascinated by posters that convey a clear message and communicate that message with power.

From where do you draw inspiration for your design work, in particular, your typographic work? I find inspiration in calmness, in the void, in a state of complete nonstimulation, in the shelter of the soul. But I also find inspiration in loudness, in the flood of information, in music and film, in the city. These contradictions are perhaps what define my work. I don't have a particular style; in fact, I reject style. I tend to swing from one extreme to the other. There's a table tennis table in our Berlin studio. Whenever we're totally exasperated by some project or we're looking for an idea, we play table tennis excessively. Sometimes, there are ten people all playing "round the table" simultaneously. It's great for getting rid of aggression and clearing the head. Then the ideas just come on their own.

What is your favorite typeface and why? When I was nine, I was in love with Tippi Hedren (star of Alfred Hitcock's thriller, *The Birds*). At twelve, it was with Nastassja Kinski *(Tatort)*, at fifteen with Catherine Deneuve *(Belle de Jour)*, at seventeen with Julie Christie *(Fahrenheit 451)*, at nineteen with Beatrice Dalle *(Betty Blue)*, at twenty-two with Monika Vitti *(The Eclipse)*, at twenty-seven with Isabella Rossellini *(Blue Velvet)*, at thirty-one with Uma Thurman *(Pulp Fiction)* and at thirty-six with Nicole Kidman *(Dogville)*. The same is true of typefaces, except that I can never remember their names.

The Influence Machine

This book about the image-projection work of Tony Oursler is simply laid out, focusing primarily on images of the artist's works that are accompanied by single-line captions. The interesting typography occurs in the essay section, where a dot-matrix face is used in a large size for the essay text, extending across the gutter and overlaying images in the background; and in a historical section that follows the development of image projection technology, where simultaneous events are distributed among congruent timelines color-coded by subject. The dot-matrix typeface calls to mind the technological nature of the artist's work, while the ethereal background images refer to ghosts and dreams, which figure prominently in the context of the work itself. The typography in the historical section is set in a neutral sans serif face in a grid of variable column widths determined by the length of the information being presented in a particular entry.

Eggers+Diaper Mark Diaper | *Berlin, Germany*

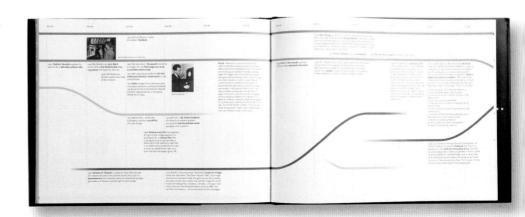

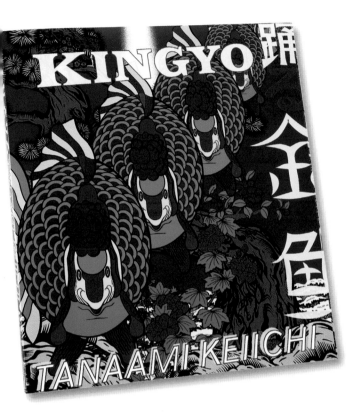

The Druid King Book Cover

Remarkably well-drawn letterforms constructed from twigs form the title and author typography of this book. The designer has brought great sensitivity to bear in building the letterforms, paying careful attention to the widths of the twigs so that the rhythm of their weights and irregularities fluidly interconnect the forms and remain essentially true to the archetypal drawing of letters. Smaller sprouts from the primary twig strokes become serifs or swashes—notice the **E** on the word "The"—and an acorn becomes a terminal detail in the **R** of Druid. Independent twigs are used as rules to fill out spaces in between lines of type. The twigs are photographed lit from the side to enhance the dimensions against the dark black cover.

Doyle Partners Stephen Doyle | *New York City (NY), USA*

Kingyo Book Cover

This vibrantly colored book cover features the illustrative work of Tanaami Keiichi, a Japanese artist, the subject of the book. The linear and decorative quality of the illustration, along with bold coloration, contains similarities both to comic book drawing and Japanese woodblock prints. The forms are echoed by the English typography, which is set in heavily outlined uppercase letters to help separate it from the activity of the art in the background. The Japanese title appears vertically at the right edge of the book, set into the artwork in white characters that, although bright, seem to integrate formally with the artwork and so become visually secondary to the English titles. For a native Japanese speaker, the reverse is likely to occur—the English integrates into the artwork while the Japanese title separates out into the foreground.

Graph Co., Ltd. Issay Kitagawa | *Tokyo, Japan*

Yoshio Hayakawa Catalog Jacket

Japanese typography has an inherent abstract simplicity resulting from complete ideas or words being expressed in a single form, unlike Western writing, where sequences of letters must work to convey a single idea. The visual power of this simplicity is dramatically conveyed in this catalog cover for an exhibition. The single characters, printed on different surfaces, interact by overlapping one another. The individual characters essentially fill the format from edge to edge. They are complex enough, however, in their drawing to have enough detail to sustain interest in the composition; even if the overlap were not part of the finished image, the character by itself on the cover would be sufficiently strong to hold the viewer's attention. The translucent vellum wrap with the second imprint interacts with the print on the cover board itself, creating another dimension to the surface of the book.

Shinnoske, Inc. Shinnoske Sugisaki | *Tokyo, Japan*

Make It Bigger Book Cover

For the cover of her monograph, Paula Scher uses dramatically large type extending outside the format—in fact, wrapping around the book literally, being silk-screened across the edge of the book block itself.

The title, *Make It Bigger,* is a reference to insensitive client suggestions about type that Ms. Scher, as have most designers, had to endure at one point early in her career. In her particular irreverent style, she has made the type so big that it will not fit on the cover. The impact of the enormous type is augmented by the selection of bold sans serif italic, set in uppercase; the diagonal motion provided by the italic slant adds compositional interest. The counterforms of the letters become giant abstract shapes boldly covering the format, but are still recognizable as letters. The full title and author name are repeated at a much smaller size in one line, distinguished from each other through a color change.

Pentagram Paula Scher, Partner | *New York City (NY), USA*

Delugan Meissl: 2

This book about an architectural firm is composed of two independently bound, yet interactive, sections. A reader may flip through both sets of pages simultaneously, in random or sequential order. The juxtapositions of text and image elements, therefore, change, along with the overall layout of the double-spread configuration, as the pages are turned independently (small photos, below).

An overall text structure of one wide column, set with asymmetrical margins left and right, may be divided into two columns when necessary. The wide left margin is used as a place for small inset photographs. The typographic styling is spare and elegant, with one geometric sans serif family used throughout the book. The scale of the type is generally small, allowing the sense of scale of the architecture being portrayed to dominate. Simple coding systems for the folios and project navigation lend a clear, systematic sensibility to the information. An alternate coding system connects materials between the two separate book sequences, referring the reader to other page spreads to investigate related information.

Bohatsch Visual Communication Walter Bohatsch, Wolfgang Homola | *Vienna, Austria*

Bei Delugan_Meissl sind Wege niemals nur die kürzeste Verbindung zwischen zwei Orten. Knotenarchitektur, Verkehrsarchitektur sind ihre Projekte gemünzte Begriffe, die beide den Weg, die Bewegung, die Verbindung ins Zentrum der Betrachtung stellen, ob es sich nun um Straßen, Gänge, Stiegen, Rampen oder Schwellen zwischen Nutzungszonen handelt. Wege sind fließende Übergänge, keine Linien, die Punkte verbinden.

With Delugan_Meissl, paths are never simply the shortest route between two points. 'Node architecture' and 'transportation architecture' are expressions that seem custom-made for their projects, both focusing on the path, the movement and the connection, whether it be streets, hallways, stairways, ramps, or thresholds between different utility zones. Paths are fluid transitions, not lines that connect the dots.

Wege

Paths

Schließlich, an der Seite Richtung Donau: die gläserne Membran der Loggien mit ihrem aufgedruckten Strichcode, eine transparente Haut von innen nach außen, eine Geste der Vereinheitlichung von außen nach innen, Sichtschutz für auch noch so individuelle Nutzungsvarianten.

Der »Balken« war ursprünglich Teil eines städtebaulichen Gesamtkonzeptes für die Donau-City, von dem so gut wie nichts übrig geblieben ist. Trotz eines Ex-aequo-Sieges im Wettbewerb wurde letztlich ein städtebaulicher Versatz aus widersprüchlichen Konzepten realisiert. Das ist tragisch, denn es zeigt, wie schwierig es heutzutage ist, weitsichtigen Städtebau in größeren Dimensionen nicht nur zu denken, sondern auch umzusetzen. Der Balken ist das Fragment einer weitaus komplexer angelegten Stadt- und Architekturvision.

Finally, in the direction of the Danube: the glass membrane of the balconies with its bar code pattern, a skin that is transparent from the inside to the outside, providing a visual screen for all variations of use, no matter how individual.

Originally, the 'Beam' was part of a greater urban concept for the Donau-City development, of which hardly anything remains. Despite the result of the competition – a draw – what was ultimately realized is an urban set piece composed of contradicting concepts. This is unfortunate, for it demonstrates how difficult it is today not only to conceive far-sighted urban planning on a large scale but to translate such a vision into reality. The Beam is but a fragment of a much more complex urban and architectural vision.

Die bedruckte Glashaut der Loggienschicht als semitransparenter Paravent zur Stadt, Schutzschicht für den Einblick von draußen, Durchblicksmembran für den Ausblick nach draußen. Und vereinheitlichende Schicht für eine gewollte Gebäudemasse.

The patterned glass skin of the loggie surround as a semi-transparent screen between building and Danube, in the direction of the city. A layer that protects the privacy of residents, but also a membrane that allows a view of the outside. A unifying layer for a powerful building mass.

Two languages, German and English, run simultaneously in the same typeface, distinguished only by weight (top). Whether running across the full single column or divided into two columns, the text in one language mimics the structure of the other.

The detailing of the folios and cross-book reference is minimal but effective (above). The folio lists the book (1 of 2); the project and its location in German in bold; and repeats the project and location in English in the regular

weight. The reference code at the top of the page runs vertically, distinguishing itself from all the other type on the page, and is marked with a numeral reversing out of a black dot.

The Bridesmaid Guide

This amusing book is full of tips and suggestions for women who will serve as a bridesmaid in a wedding party. In an age where such information is generally thought of as old-fashioned and silly, the visual presentation of this book plays with these ideas in a tongue-in-cheek way, bringing the subject up to date and giving it some fun.

The typography interacts throughout the book with illustrations that, in their style and coloration, hark back to 1950s homemaking magazines. The primary typeface for headings, callouts, and introductory text follows suit, an updated version of those magazines' display faces; the contrast of the strokes within the type is formally congruent to the quality of the strokes in the illustrations, helping to integrate the two kinds of elements. A second typeface, more neutral than the primary but still somewhat detailed for a sans serif, is used for running text, its bold weight for subtitles.

Aside from these stylistic plays, the typography is informationally very clear and accessible. A two-column grid structure allows for continuous text and caption- or diagram-oriented texts to run together. Each level of information in the hierarchy has its own recognizable treatment that helps the reader navigate the content. Informational cues, like a bar of color for certain kinds of headings, alerts the reader to particularly important points. Paragraphs and notations in blue type that contrasts the brown running text are understood as introductory paragraphs.

Red Canoe Deb Koch, Caroline Kavanagh (design); Neryl Walker (illustration); Vivien Sung/Chronicle Books (creative direction) | *Deer Lodge (TN), USA*

For all its stylistic whimsy, the typographic detailing is thoughtfully considered. In the table of contents, for instance, the page numbers precede the chapter listings so that they are more easily connected to the listing, and their bold weight makes them easy to find on the page.

Clear changes in typographic color, along with informational cues, help the reader locate information. Tip headers, call-outs, freeform list arrangements and support text all are treated consistently in their own styles that code this information in a recognizable way.

The tip at left is set in the bold weight of the sans serif text face. Narrow rules running alongside bulleted information separate it from running text, and the bullets draw attention to the entry point of each item.

10 x 10: 10 Critics, 100 Architects Book Cover

A minimalist typographic approach to the title of this book on architecture results in a visually arresting texture. The primary title, **10 x 10,** appears centered in the format of the cover, in a mechanically drawn sans serif face that is bold and stark in appearance. The first **10** of the title relates to the **10** critics whose writing is the content of the book. The second **10,** set in orange, completes a mathematical equation that results in the number **100,** the number of architects whose work is also part of the book's contents. The names of all the contributors appear on the cover but are printed on two different layers of a thick casing so that they appear to float on two levels in front of and behind the large numbers of the title. The subtitle, *10 critics, 100 Architects,* is split in two, the first located in the upper-left corner, and the second in the lower-right corner.

Phaidon Press Julia Hasting | *New York City (NY), USA and London, United Kingdom*

Three Book Covers

These three book jackets present titles in bold typographic treatments that integrate directly with their imagery. In all three covers, the typography of the titles joins the surface plane of the book and the imagery, whether photographic or illustrative, so that both elements are perceived simultaneously as a unit. The scale of the type in all three is large, relative to the format of the cover, and is literally connected to the imagery in each instance.

From left: **Shane Keaney, Gary Fogelson, Houman Pourmand**
Pratt Institute: Scott Santoro, instructor |
New York City (NY), USA

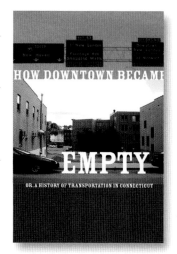

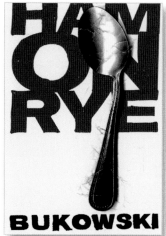

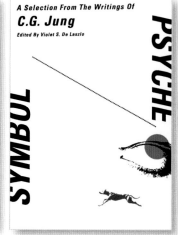

Mühlrad, Schulbank und Carrière

A historical documentary, this book has a layout that is restrained, informationally direct, and unembellished. The manuscript structure—one column for the body, set mirrored in the spread with wide outer margins— is stately and well proportioned. It is divided into two narrow columns for footnote listings and captions. The manuscript's classical structure is countered through the use of Scala in the serif and sans serif forms to differentiate particular sections of the book. The two forms are very similar in structure but offer a slight textural change that is subtle, yet noticeable. Indentation and paragraph breaks are well considered, proportionally related to the column width. The type size-to-column width ratio has been carefully explored, resulting in a justified setting that shows neither excessive hyphenation nor pronounced rivers.

Büro fur Gestaltung Christoph Burkardt, Albrecht Hotz |
Offenbach, Germany

Schiffbau

This book documents the transition of an industrial building in Zürich, Switzerland, into a theater and the impact of this transition on local cultural life. A two-column structure, asymmetrically arranged with a left-side emphasis on the pages, carries running text, while the right-hand margin is used for captioning and inset images. The structure is developed from an architectural plan of the city and the neighborhood of the theater, the intervals of which are used to determine the proportions of the grid that governs the layouts. Images and texts in different sections that refer to each other are joined by a system of typographic notation, allowing the reader to navigate in a nonlinear way through the material if they so choose. The running text is set in a modern serif with sharp terminals and crisp curves, while captions and notations appear in a sans serif or bitmap face, respectively. Each column is devoted to displaying the text in one language—English or German— running side by side. Thin rules printed in fuchsia add depth and texture to the pages. At the right edge of the spreads, the sections are denoted by tabs that are differentiated by individual icons.

Atelier Varga Mihaly Varga, Yves Gerteis, Timea Zeley |
Zürich, Switzerland

Headings and subheadings use the bold and black weights of the text serif face. Fuchsia rules throughout the book appear both as functional devices or as decorative elements that add texture and interest.

Wir sitzen in der Pause eines Marthaler-Stückes im Restaurant LaSalle, dem Glashaus in der Industriehalle des Schiffbaus. Im funkelnden Licht der Murano-Leuchters verfolgen wir das Pausenspektakel: Vor der Kulisse der Industriearchitektur aus den 1890er Jahren ziehen dunkel gekleidete Besucher und Besucherinnen vorbei. Sie tauchen als Bilder auf, geraten von den grossen Scheiben, schieben sich für einen Moment über unsere eigenen Spiegelbilder und verschwinden wieder. Ihre elegante Kleidung kontrastiert zur ruinösen Umgebung, die bis vor wenigen Jahren noch eine lärmende und stinkende Fabrikhalle war. Nun sind die Arbeiter und die Maschinen weg. Der mit Giften versuchte Boden ist durch einen dunklen Zementboden ersetzt. An den Wänden sind die Reste der abgeblätterten Farbe, die Spuren von Rost, die alten Kabelschächte und die Risse im Mauerwerk sorgfältig konserviert. Sie enthalten jene Aura von gespeicherter Zeit, die heute so kostbar ist.

Der Schiffbau steht in der jungen Tradition von kulturell genutzten Industrieruinen, einer Tradition, die untrennbar mit dem Niedergang der Schwer- und Leichtindustrie in den westlichen Ländern einerseits, dem Boom der Kulturindustrie andererseits zusammenhängt. Die Entwicklung begann denn auch nicht in den Zentren, sondern im Peripherie der Städte, in jenen unwirtlichen Industrieregionen, die früher allenfalls als Kulissen für Gangsterfilme kulturell genutzt werden konnten. Als in Paris Ende der 1960er Jahre die Pläne für das Centre Georges Pompidou reiften, dachte noch niemand daran, anstelle der Errichtung eines spektakulären Neubaus die nahegelegenen alten Markthallen umzunutzen. Ein guten Jahrzehnt später hätte man die Gunnesmesarchitektur des 'Bauelses von Paris' wahrscheinlich erhalten. Denn parallel zur Sorge um die Energiereserven wuchs in den 1970er Jahren auch der Respekt gegenüber der Vergangenheit und dem gebauten Erbe. Seit den 1980er Jahren erwachten in Europa und den USA die alten Fabrikhallen zu neuem Leben. Nach wie vor finden Initianten von Shopping Malls, Grosskinos, Musical-theatern, Kunsthallen und Museen auf den Industriebrachen günstige, grosse, gut erreichbare Räume. Die Kommunen wiederum sehen in der Umnutzung eine Chance, heruntergekommene Quartiere aufzuwerten.

Gerade in der Schweiz, wo der kulturelle Boom früh einsetzte, die Möglichkeiten von Neu- und Umbauten in den Innenstädten hingegen buchstäblich verbaut waren.

It's the interval of a Marthaler play, and we are sitting in the LaSalle restaurant, the glass house inside the erstwhile ship-building hall at the Schiffbau. In the sparkling light of the Murano lamps we watch the drama of the interval unfold: darkly dressed members of the audience pass to and fro against a backdrop of industrial architecture from the 1890s. They loom into view like pictures framed by the large panes of glass, momentarily obscuring our own reflections, and disappearing again. Their elegant clothes are strangely at odds with the decayed environment which up until a few short years ago was a cacophonous, acrid factory hall. Now the workers and the machines have gone. The floor polluted with toxins has been replaced by a dark cement floor. On the walls the flakes of old paint, traces of rust, old wiring ducts and cracks in the plasterwork have been painstakingly preserved. They have that aura of accumulated time which is so precious today.

The Schiffbau project is part of the relatively recent practice of using obsolete industrial buildings for cultural venues which has gone hand-in-hand with the decline of heavy and light industry in the West, on one hand, and the boom in the culture industry, on the other. Logically, this practice first emerged not in urban centres but on the outskirts of towns and cities, in those inhospitable industrial regions which in the past could at most fulfil a cultural purpose as sets for gangster films. When plans for the Centre Georges Pompidou were being made in Paris in the late 1960s, no one proposed converting the old covered market nearby instead of putting up a spectacular new building. A decade later, in all likelihood the cast iron architecture that was so typical of the 'belly of Paris' would have been retained – for, as concern was mounting over the world's energy reserves, there was also growing respect for the past and for our built heritage. Since the 1980s new life has been breathed into factory buildings in Europe and the USA. Planners looking for locations for shopping malls, multiplex cinemas, theatres, art galleries and museums are constantly finding large, relatively inexpensive buildings with good transport connections on defunct industrial sites. And local authorities see these conversions as a chance to reinvigorate run-down districts.

Particularly in Switzerland, where the culture boom got off to an early start – but where the chances of building from scratch or rebuilding in city centres were non-exis-

1 Fortschrittsglaube als Allegorie: Reliefgruppe 'Triumph' auf der Fassade des 1891 erbauten Zürcher Stadttheaters
Progress personified: 'Triumph', rilievto group on the facade of the Zurich Stadttheater, built in 1891

The essential page structure consists of two columns of running text set asymmetrically with a right margin for notation and inset pictures. Large images generally appear on the left side of a spread, with a simple caption system set below in two languages. The icon notation at the far right differentiates the sections of the book.

The inset images denote that the text on this page is keyed to those images in another section; setting these small images in a band of clear space, marked by fuchsia rules that appears to cut through the primary text structure, draws attention to them and creates a flexible, but consistent, way of introducing varying numbers of inset images without having to disturb the basic structure of the columns.

The inset notation in fuchsia connects this image for the reader to specific text or other images in another section; the notation allows the reader to navigate back and forth between related information.

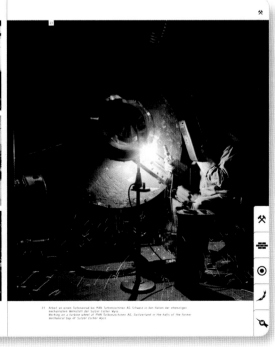

20 Kesselproduktion in der grossen Schiffbauhalle
Boiler production in the large shipbuilding hall
21. 22 Herstellung von Schiffsdampfmaschinen in der mechanischen Werkstatt in den 1930er Jahren
Making steam engines for ships in the mechanical bay in the 1930s

23 Arbeit an einem Turbonenrad bei MAN Turbomaschinen AG Schweiz in den Kulissen der ehemaligen mechanischen Werkstatt der Sulzer Escher Wyss
Working on a turbine wheel at MAN Turbomaschinen AG, Switzerland in the halls of the former mechanical bay of Sulzer Escher Wyss

Warhol: Paintings and Sculpture 1961–1963
The Warhol Catalogue Raisonné; Volume 1

This massive volume of cataloged works by Andy Warhol marries complex informational typography with the stylistic and conceptual properties of Pop Art. The book is structured on a four-column grid. Sections and columns are divided by bold dashed lines that cut across the format, turning the columns of text and the images into coupons. The text is set all uppercase in a condensed gothic sans serif in a nod to the deadpan personality of Warhol himself. Contrasts in size and weight, and the insertion of bold, linear elements into the text to separate informational components or to mark the folios, mitigates the monotonous texture of the text type.

Phaidon Press Julia Hasting | *New York City (NY), USA and London, United Kingdom*

In the table of contents, each section is encapsulated within a black rectangle that is subdivided into several parts. The section title and cataloging information occupy the right three columns of the rectangular space; individual works in the section are listed in the left-most column, along with the page numbers on which they appear.

The catalog pages display the intricate typographic treatment of the text and captions describing the various works. In this spread, the column of text at the left lists the publication of specific images in various periodicals; the entries are set in upper- and lowercase, each separated by a strong forward slash. The column on the right page is the beginning of a new entry for the next cataloged work; the title is set in a larger size, and the paragraph is divided by bold vertical marks that separate distinct sequences of information. Images related to the works, such as the publicity stills of Marilyn Monroe that Warhol used as source material, are integrated into the column structure, bound by black rectangles that contain captions.

The typography and production of the slipcase and cover are reminiscent of Warhol's Brillo and Campbell's Soup sculptures of the early 1960s. The clean, bold sans serif typography and the vivid red printing contrast with the rough cardboard surface of the covers and case.

Appendixes are divided by the bold dashed coupon-clipping lines that visually brand the entire book. The Abbreviations section uses a color distinction to set apart the abbreviation from its full description; a graphic arrow icon joins the abbreviation, in red, to its relevant information in the next column.

Working with a substantial amount of text (although not as substantial as a book), along with images and other kinds of graphic elements, requires a high degree of control. Unlike in a book—where the structure is often easily recognized and the information moves with a consistent cadence throughout—the typography in a brochure or annual report is usually driven by concept and image, and may be much more complex, involving captions, pull quotes, imagelike text treatments, graphs, and complex lists. The short form application, whose function is to provide emotional or intellectual impact at a rapid pace, enforces the need for typographic directness. The commercial aspect of making an impression on a targeted buyer means the typographic language must be resolved to the point that its visual qualities do not impair the viewer's sense of the client's credibility. The designer also must make the information accessible and user friendly.

TYPOGRAPHY IN PRACTICE

Collateral Texts

Brochures and Annual Reports

Faydherbe/deVringer is a design studio in The Hague, Netherlands, whose principals Ben Faydherbe and Wout deVringer have a long-established reputation for typographic playfulness and experimentation in the service of both cultural and corporate clients. Here, they discuss their approach to designing with type in short text applications.

How would you characterize your approach to typography? What's different about it? Our approach is always to make our typography look challenging. But at the same time, we want it to be clear. In contrast with many of our colleagues, we are more inspired by designers of the past. The experimental way that designers like Ladislav Sutnar, Lester Beall, Herbert Bayer, Paul Rand, Max Bill, Paul Lohse, and many others used to work in a still fairly unknown profession is a big inspiration to us.

What concerns you most when designing an annual report or an in-depth brochure? How is this different from using type in a book or a poster? Our primary concern is that the hierarchy of the text is always clear. That sounds easy enough, but it is harder than you might think, especially because you have to be very precise and systematic. Once you give a certain importance to a text it should be consistent throughout the whole annual report. You are essentially explaining the economic situation of a business. You don't have the same restrictions when you are designing a poster. The information is interpreted by the viewer on a more intuitive level. The type should attract your attention in a split second and, therefore, you work with text more decoratively or expressively.

How do you relate type to images? Is it just a visual relationship or also conceptual? We always try for both. If it's just a visual relationship, the design gets boring and shallow very quickly. We try to use type in combination with images in a way that one makes the other stronger. One can't be without the other. The combination of the two produces another, stronger meaning and message.

Describe your thinking in the SVB Annual Report.
We tried to create an interesting typographic language on a piece that might ordinarily be boring. Other goals were to use a typeface that not everybody was using but, at the same time, was not too trendy. We thought this typeface choice in combination with another type family would have enough possibilities to cover all the different typographic needs of the information. I'd like to mention Bob Van Dijk, with whom we collaborated on this project.

What inspires you in terms of typography? We are both inspired by modern art and architecture. We actively collect old design books by designers that we mentioned earlier. We aren't really interested in things happening on the street.

What do you think about following rules in typography?
That's something designers should figure out for themselves. Our experience is that if you're working for a long time, you find certain things that work and other things that don't. Trial and error is part of design. If you try something that doesn't work you just keep it in mind for another project. We have our own set of rules that seem to work for us.

What are your favorite typefaces and why? We like simple, "neutral," and elegant typefaces—Akzidenz Grotesk, Helvetica, Futura, News Gothic, Trade Gothic (mostly sans serif fonts). We don't like to use very outspoken typefaces. It is very difficult to make the design your own if you do. They are just not neutral enough.

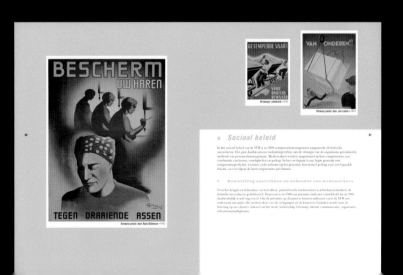

4MBO Annual Report 2002

The imagery and information in this annual report is all typographic. In the first section, the imagery consists of large-scale financial diagrams and charts whose geometric presentation is made into an image by its scale. Charts showing financial relationships are created out of dots, squares, and grids, integrating formally with their simple informational typography. The type is set in two similar sans serif faces—a condensed gothic and a rounded version that is somewhat more extended. Numerical figures are sometimes set in a classic serif, providing a change in texture for interest.

Strichpunkt | *Stuttgart, Germany*

In this left-hand page detail, the color break between the top portion and the bottom portion of the page is a visual representation of the percentage *information described in the text. It also defines and area for housing support text, in addition to creating a visual image.*

The stark geometric simplicity of financial charts is transformed into abstract images. The typography is informational and secondary to the chart images, which communicate information *in a primarily visual way. In the spread at top, for example, the fields of black and white abstractly communicate the numeric relationship of 6% in support of the enormous figure.* *In the spread immediately above, the different sizes of the red dots in the chart correspond to increasing stock prices.*

Hope Community Annual Report 2003

In this elegantly proportioned annual report for a nonprofit organization, a narrow three-column grid carries the text information, a narrow horizontal band carries photographs and color across the spreads, and acts as a timeline of important milestones in the organization's history. As the text moves from column to column at a regular pace, the images and color blocks in the band move in a syncopated rhythm. The type itself is a sans serif face that shares a number of the structural characteristics of serif typefaces, especially in the lowercase letters. The running text is set at a size that makes it easily read by people of various ages; the captions in the timeline are set slightly smaller, which is appropriate for small amounts of text. Section identifiers are set in the same face at the same weight, but much larger and tinted back in order to run across the spread immediately under the image-band. This light color causes a recession to another spatial plane somewhere behind the level of the image band and the columns of type. In the financial section, tabular data is integrated into the column structure in a clear and accessible layout.

C. Harvey Graphic Design | *New York City (NY), USA*

The horizontal band carrying images and timeline information creates a syncopated continuity across the spreads, in contrast to the regularity of the text columns. Entries in the timeline are keyed to a particular year, distinguished by a change to the bold weight in a contrasting color.

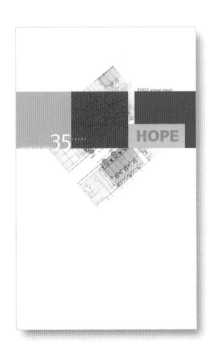

Typography on the report's cover is minimal—simply the organization's name and the report title (far left).

Subtle rules in the financial tables help separate rows for easy comparison of figures between columns (near left).

Penn Design Recruiting Brochure

This admissions recruiting brochure for a design and fine
arts program uses a two-sided binding to separate its
message-oriented information about the school's philo-
sophy and programs from the more complex, informational
presentation of course listings, faculty, and resource infor-
mation. The messaging section, titled Transform, describes
the design program in terms of opposing concepts—for
example, theory and practice. This section is produced in
full color, with vertical bands of color surprinting the
photographs. The vertical bands are translucent and vary
in width, creating a rhythmic movement across the spreads
that unifies the opposing concepts. The vertical bands
also carry text information. The course catalog section,
bound on the reverse of the brochure, is titled Inform,
and is produced in gray and black. Straightforward typogra-
phy is structured on a three-column modular grid that
allows course listings, examples of student work, and other
information to be integrated together in a clear and
accessible way. The concept of duality presented in the
messaging section is supported by the reverse binding of
the booklet itself; flipping it over gives the reader access
to the alternate sequence of information.

Ideas on Purpose John Connolly, Darren Namaye,
Michelle Marks | *New York City (NY), USA*

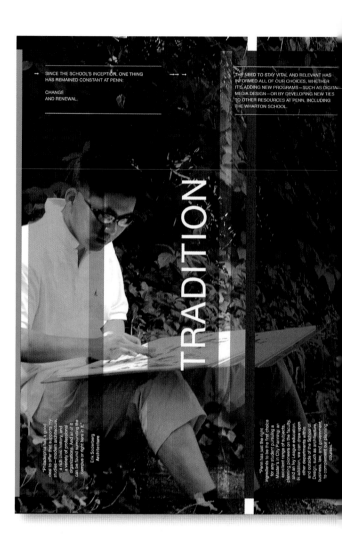

*The covers for the two sections
of the brochure are actually
joined together as one accordion-
folded cover.*

IN FACT, THE TRADITION OF WORKING ACROSS BOUNDARIES REMAINS THE SCHOOL'S CORE STRENGTH, AND OUR FACULTY CONTINUES TO INCLUDE SOME OF THE MOST INFLUENTIAL, GROUNDBREAKING SCHOLARS AND PRACTITIONERS IN THE WORLD.

EVOLUTION

The contents spread for the Transform section (top) sets up the vertical color band structure that will interact with photographs in subsequent spreads. The deep blue band that surprints the photograph allows the type for the contents listing to reverse out white.

A spread from the Inform section (bottom) shows a clear presentation of information. The course listings appear in a rectangular tabular format, set in black against the neutral gray of the pages. Typography, reversed out white, and the items in listings, are separated by thin horizontal rules for clarity.

This spread showcases the complex typographic and image relationships of the Transform messaging section. Opposing concepts—tradition and evolution—appear opposite each other, illustrated by a full-bleed photograph in the background. The major conceptual words are set all uppercase in a neutral sans serif typeface, running vertically up the center axis of each page. Across the top of the spread, supporting messages run horizontally in paragraphs that are marked by narrow

rules, crossing the vertical bands of color that are moving rhythmically over the photographs. Arrow details help guide the eye from paragraph to paragraph. Across the bottom of the spread, testimonials from faculty, students, and professionals attest to the strength of the program and its philosophy. These quotes are set in upper- and lowercase to convey a more personal tone than the statements at the top; they run vertically in relation to the conceptual words and the vertical color bands.

Rainforest Foundation Annual Report 2003

The typography of this annual report uses an an asymmetrical column grid with wide intervals between the columns to promote a perception of spatial depth and organic flow. Each column of type represents a single, coherent sequence of thoughts. The columns fluctuate in width as they travel across the page spreads, and the intervals between the columns also appear to change. The type within the columns is oriented vertically around a horizontal mean line, creating a horizon. In most spreads, the text either falls below or sits above this meanline, and the orientation with respect to the meanline alternates from spread to spread. Horizontal blocks of color contain callout information. Their flat solidity, in contrast to the shifting proportions of the columns, causes them to advance into the foreground. Background images and linear rules, interacting with the columns, occupy a third spatial depth.

Two type families—a relatively stylized sans serif and a crisp, modern serif—introduce additional texture. Each is assigned to one of the report's concepts—"Hope" or "Victory," and their interplay contributes to the spatial ambiguity of the pages. Vertical rules of varying weights are used to separate and mark individual paragraphs.

Worksight Scott W. Santoro | *New York City (NY), USA*

Alternating the placement of the running text relative to the horizon line creates a simple unifying rhythm. The column structure is contrasted by the flat-color blocks that contain callouts and by the textural movement within photographs. The photographs share an ambiguous spatial relationship with the typography, sometimes bleeding behind the text or being cropped unexpectedly.

In this detail of the contents page, ambiguous spatial depth and informational clarity coexist. The page numbers appear to float on a plane in the foreground but a thick horizontal rule, interrupted by the space around the column of numbers, flattens out the space and calls out a specific heading.

The arrangement of the numbers to the left of the contents, rather than afterwards, allows connection to the individual subjects to be seen clearly.

KingGee Clothing Brochure

The clothing catalog and supporting posters for KingGee workwear use an advertorial treatment for branding and an equally straightforward column structure for displaying the products within the catalog itself. The catalog/brochure cover begins with an editorial headline describing an experience by a worker wearing the company's clothing. The type spans the format horizontally the individual lines set justified with the type, changing size to fit distinct phrases easily on each line. The type reverses white over a full-bleed image. Promotional posters for the brand use the same structure.

Within the catalog, a four-column grid gives the designer flexibility for displaying articles of clothing, lifestyle shots, and product information. A single column displays one article of clothing, followed below by its name, features, product number, and informational icons that rank the article's protective qualities against exposure or damage. The information is set flush left, with bullets hanging left of the alignment between columns to call out each line of information. The product number is set in a light neutral color that drops it to a secondary level in the text hierarchy. Size information and other specifics are called out in bold weight. At the top of the spread, the product line is set all uppercase in the same sans serif gothic used for all the type but in the same light neutral color as the product numbers; it is noticeable as a header but light enough not to interfere with the composition of the page. The product line is repeated running vertically at the right edge of the spread, reversed out of a dark band that bleeds the right edge of the format.

Cato Purnell Partners | *Richmond, Australia*

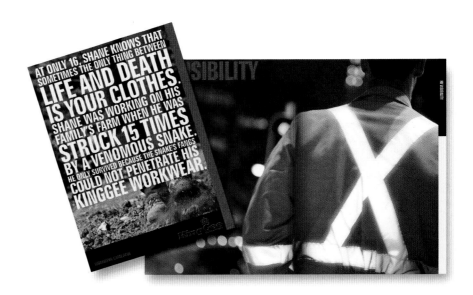

A complex grouping of silhouetted images, rectangular images, product information, icons, and supporting headers is organized on a simple four-column grid. The lifestyle images occupy a distinct area in the upper portion of the page, while the clothing articles and their information occupy the center and lower third of the format. Clear distinctions between informational components are achieved through restrained use of bold weight and color shifts.

SpecLogix Paper and Printing Handbook

An extensive overview of the interaction of paper and
printing techniques, this large ring-bound handbook
integrates photography, varied paper samples, diagrams,
tip-ins, and clean informational typography as a resource
for graphic designers. Each section explores one aspect
of paper and printing—color, formation, and so on—
denoted by a tab that sticks out from the main block of
the pages. Section introduction pages are set in friendly,
large-scale sans serif type with a bit of character—
Gill Sans—against vibrant fields of color that code the
sections. Subsequent pages use a three-column grid in
which the type is set in black; callout information is
set in the given section's particular color. The text type
is a comfortable size for extended reading, with ample
leading and a reasonable column width. Captions and
diagrammatic type are set a point size or two smaller.
Special attention is paid to the typesetting of complex
lists of paper specification information and diagrams;
internal hierarchies are defined through tabbing and
weight changes.

AND Partners David Schimmel | *New York City (NY), USA*

*The section dividers use the
primary text face at a larger size
to introduce new subjects. The
introductory text is set in black
against a color, with the section
title knocking out to white at
the paragraph entry.*

*Foldout pages demonstrate
printing quality through
beautifully detailed color
photographs, accompanied by
text that describes various
concerns that must be addressed
in selecting appropriate paper
stock for a given job.*

CBG Annual Report 2002

This unconventional approach to designing an annual report highlights the energy and work process of the company by creating fields of typographic texture from diagrams, handwritten notation, meeting notes, emails, and documents that interact with each other and the running text. The various elements often overlay full-bleed photographs, and are distinguished from each other by their color. The sense of the company's corporate culture conveyed is one of innovation and experimentation. The varying degree of legibility of the information, which can be scrutinized if needed or enjoyed as an overall visual expression, speaks to the unconventional nature of the company and its personality in a very different way than the straightforward messaging of American corporate reports. The financial data in the back of the report is, of course, presented in a more accessible manner.

Faydherbe/DeVringer | *The Hague, Netherlands*

Running text paragraphs are set in black against the colored background where needed, to bring important text forward.

The typographic texture of the report's interior appears embossed in the plain white cover; the company logotype and the year of the report are set apart from the overall texture in white and black rectangles, respectively.

The working spirit and energy of the company culture is expressed in the kinetic, over-lapping typographic elements— tabular list documents, notes from meetings, organizational diagrams—and photographs of

office environments. A dynamic overlap of linear elements and typography in different colors involves the reader in the excite-ment of the company's process.

Plasma Annual Report 2001

The layout of this annual report for a biotech company relies on two major compositional devices that divide the content into distinct sections. The contents and introductory spreads are characterized by a horizontal division. A colored band separates the upper part of the format, where titling and diagrams appear, from the lower, where running text is located. In the conceptual section that describes the company's activities, the axis is vertical, defined by a full-bleed image on the left page that divides the spread in half. The two pages in these spreads are joined by narrow rules that echo the horizontal division of the first section. The overall text structure is a two-column grid; the columns are set into wide asymmetrical margins that mirror each other from left to right page. A crisp serif face and a neutral sans serif are used in combination throughout. The serif appears in headlines, large-scale justified paragraphs that support the full-bleed images, and in the running feet and folios. The sans serif is generally used for the primary paragraph text, also set justified, as informational section markers at the top of the pages and in charts and tables. The serif face interacts with the primary text columns in the form of callouts that cross from the margins into the width of the running text columns. This violation of the primary column structure is also evident in the table of contents, where the section listings seem to float in a more horizontal orientation, breaking across columns.

First Rabbit GmbH | *Köln, Germany*

The narrow rule separating the image area at top from the content listings below sets up the first primary structure in the report, the horizontal band. The section page numbers are set in a slightly larger scale than the informational listing for each section, but they are displayed in red so they recede in space and allow the listings, knocking out in the sans serif, to come forward.

The horizontal band of color defines an area for diagrams and charts, while running text appears below.

The conceptual section of the report is structurally defined by a full-bleed image on the left page that is joined to the text on the right by various linear elements, colored bands, and patterns that cross the gutter. Each typographic element on the spread is given individual treatment to clarify its position in the hierarchy. Scale changes, alternation between serif and sans serif faces, and changes in color and density provide contrast between the informational components and a rich textural quality to the typography. The spread at lower right gives evidence of a four-column modular grid holding everything together.

The cover's centered title (shown below) is offset by the dramatic asymmetrical bubble image.

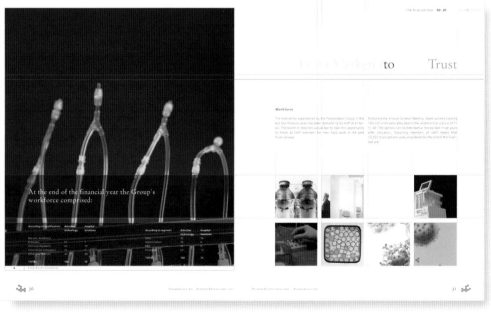

The nonlinear nature of interactive media poses a distinct set of problems for typographic designers. First, all the content in a website need not be shown all at once, and directing users to information through typographic links becomes of greatest importance. The treatment of these links—their size, location, style, and color—requires extra consideration to easily distinguish them from primary content. Complicating matters is the need to let the user know where in the site they are once they have left one area to visit another. Again, intelligent placement and styling of typographic links will help establish a visual record of the user's path from location to location. Third, the flexibility requirement of a site—for continuously updated content—means the designer must consider the structure of the page screens to accommodate information that will be changing on a regular basis. Added to this the variability of the browser window—and, therefore, the actual shape of the format—along with coarse screen resolution and the impact of inserted graphics on loading times, and it becomes clear how involved the typographic complications may become.

Website Design

cashmere.com

FOR HER
FOR HIM
FOR BABY
GREAT BUYS
ACCESSORIES

ABOUT US

CASHMERE 101

CUSTOMER SERVICE
CONTACT US
JOIN OUR CLUB

1.899.221.2518
9am - 5pm
EASTERN TIME

SHOPPING BAG

PRODUCT SEARCH
GO

Unrivaled as the world's most luxurious fiber, **cashmere** is one of life's true pleasures. We bring you the highest quality cashmere in the world at exceptional prices. Cashmere.com.
share our passion.

Our quality cashmere is 100% guaranteed

Subscribe to our email list to be notified of sales, new collections and news.
SUBMIT

For Him

Accessories

For Her

For Her

Great Buys

Gift Wrap

Cashmere.com, the web's most trusted cashmere sweater source.
© Copyright 2001-2003 Cashmere Web Sales

cashmere.com

www.rocholl-projects.de

A straightforward hierarchical structure characterizes this website for a design firm. The page is divided into a narrow column at the left, for high-level navigation, and a wider column at the right for changing content. The display typography is set in a neutral sans serif, colored a vivid fuchsia. A set of characters at the left, in the navigational column, is interactive; clicking on a number calls up specific content in the wide column. The column is defined by a geometric shape, and within, a strong hierarchy among informational components is achieved alternately with a simple quadrant grid, or by a set of proportional spaces. In the portfolio section, for example, a white rectangular area distinguishes the text from the image area and navigational buttons. Type within this area follows its own internal hierarchy—the project title is set uppercase and slightly spaced to improve character recognition; the text is slightly smaller. The hierarchy changes in promotional areas; images occupy the upper spatial unit and text is set below in the display type but in lowercase. The site is compact, clean, and allows its typography to be almost strictly functional. A cool, neutral palette combined with saturated display type keeps the site fresh despite its rigidly simple structure.

Rocholl Projects/KearneyRocholl Frank Rocholl, Heiko Gimbel | *Frankfurt, Germany*

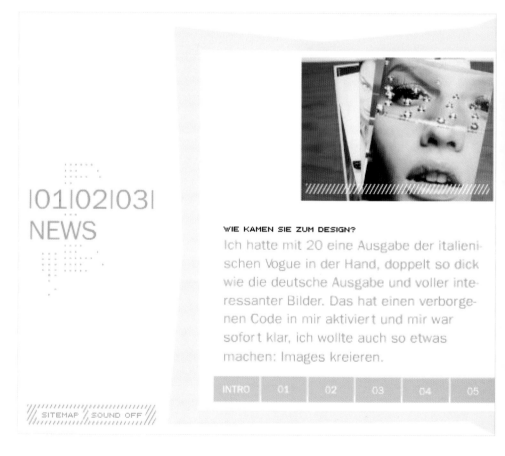

A promotional page offers a large image of current project work and a direct entry to the portfolio section through the horizontal band of navigational buttons toward the bottom of the frame. A sober gothic sans serif, set upper- and lowercase carries a general introductory message in the site's pink branding color, while bitmapped subheads and dot grids continue the textural contrasts established in the site's primary navigational area at the left side of the browser format.

The homepage is a spare, elegant composition of contrasts. Each element's weight, color, and position seem carefully considered, which creates an interesting tension between calmness and coldness. The mysterious, hard-edged geometric forms are softened by transparency, and they have the quality of letter-forms but do not seem to be letters. The company name, repeated as a texture, helps calm the effect of its shocking pink color. This texture is repeated as a grid of dots surrounding the large navigational type toward the left edge of the page format.

Clear, simple contrasts between text styles and colors are enlivened by textural graphic elements. The image and type occupy clear zones, and this structure distinguishes this particular area from others within the site. Each navigable area has its own structure.

The horizontal structure of the portfolio section (below) contrasts with the quadrant structure of the news section (below right); each is well suited to its contents and uses a different typographic link style that is also appropriate to its respective information.

www.aajdesign.com

The structure of this clear, elegant website for a design consulting firm showcases the studio's sensible, yet expressive, approach to information display. The site loads with a short animation of the firm's positioning statement—Connect with Clarity—set in a light-weight sans serif. The syntactic juncture between the two words connect and clarity becomes a dividing line that expands into a two-square configuration of colored fields, each containing specific information. The left square contains the firm's logotype and an informational marker that acts as a title for the content that appears in the right-hand square. The site navigation rests below the left-hand square, and a simple rollover expands the A-levels to reveal subpage links for appropriate sections—for example, the portfolio pages. Content on the right side scrolls inside the lightly tinted square. Informational type, in the form of captions and rollover tool tips, helps guide the user through portfolio and other content. A single weight and size of system text interacts quietly with navigational buttons.

Allemann, Almquist+Jones Hans-U. Allemann and Jan C. Almquist (art direction, design), Sal Nistico (design) | *Philadelphia (PA), USA*

An opening animation (top right) presents the studio's positioning statement. The conjunction "with" connects the two conceptual words—connect and clarity— before being replaced by a thin vertical rule that expands to form the site's structure, two square fields that carry distinct informational (middle right).

In the portfolio section (bottom), project images load upon clicking animated buttons in the left field. The portfolio subsection—print, identity, or Web design—is indicated by an informational marker at the upper right of the left-hand field, pointing directly to the content field at the right. Internal navigation and text-based tool tips help the user sort through projects.

www.bernhardtdesign.com

Product lines, finishes, specifications, and showroom information are cleverly combined in this simple, clean website for a furniture manufacturer. Structured on a 7 x 7 modular grid, the site uses this structure to maximum effect, organizing wildly varied information and images in a unified and easily navigable layout. The typography in the site is kept spare and informational to let the products take center stage, as well as to make the navigation as clear and accessible as possible. The navigation is accessed in drop-down menus that extend from the red navigation bar at the top of the screen. A highlight of the text indicates the active nature of the link on rollover; the type's change of color on rollover indicates a change of hierarchical importance, from listed item to selected item. Each page presents its respective information in a clear hierarchy, using only one typeface—the system sans serif—in two weights (and mostly one size) to distinguish informational components. When appropriate—section markers, for example—a graphic with type is used, rather than system text, for greater quality. In these cases, a sans serif with similar formal qualities to that of the brand's serif face is used. Bold type is used for section or paragraph heads, and for product names. Each kind of informational component has a home position on the grid to help the user locate it quickly. The section marker, for example, is always flush left in the left-most column, at the hangline that governs the text throughout the site. Images conform to the underlying grid, and occupy one, two, three, or more modules as needed.

Piscatello Design Centre Rocco Piscatello |
New York City (NY), USA

Aside from a large product image, the homepage contains only the client's branding— an uppercase modern serif, loosely spaced—and a red bar containing the A-level navigation categories. The vertical red rule separating the client name from the word "design" aligns these elements to the grid and defines the location and measure of the columns.

The flexible, modular grid organizes information in different ways. The contact page shows the grid used to create a two-column structure, with overall regions listed in the left column, and individual contact information for locations within a specific region in the right column. The drop-down navigation above takes up a minimum of space. Product names are set in a larger size in red. The product's specs follow the name, pulled out

of the descriptive paragraph for at-a-glance accessibility. Within the specs, bold weight is used to highlight important information.

The site also includes biographies about the company's furniture and textile designers. The wide left margin helps distinguish this section from the others; the section marker at the left occupies the same home position to aid the reader.

www.jonkrause.com

This promotional site for an illustrator uses detailed typographic navigation systems to organize and display the artist's work. Against a photographic backdrop of a warm, textured watercolor paper, simple slab serif type reverses out to white for clarity. The pages are divided into areas for project images, along with a title and publication venue; an area to the right for support information or navigation through multipart projects; and global navigation buttons at the far right of the screen. The main display area also houses biographical information, a catalog of the illustrator's awards, and other content. Portfolio pages display a selected project in conjunction with support information and secondary navigation. The viewer

has the option of accessing a personal account of the conceptual and work process from the illustrator by clicking one of the mood icons to the right of the project image. This text appears in a more prominent location, size, and weight than the title and publication information directly under the project, allowing it to occupy a greater level of importance in the hierarchy. In the Awards section, each year's awards are cataloged in a series of book pages with pullout tabs that the viewer can use to select a given award received in a given year by the illustrator.

Red Canoe Deb Koch, Caroline Kavanagh (design); Deb Koch, Benjamin Kaubisch (developers) | *Deer Lodge (TN), USA*

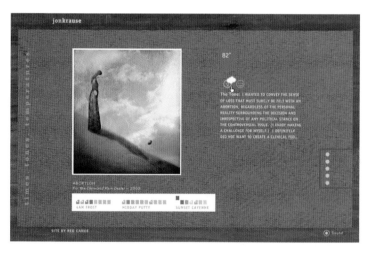

www.roemerapotheke.ch

Clean, white pages with simple, yet visually strong, navigation create an easily navigable experience through this site for an art gallery converted from a pharmacy. The history of the facility is acknowledged in the orange cross configuration of the navigational device, which remains in a fixed position as the user scrolls through the site's content. Large-scale titling typography, in a bold-weight sans serif, calls out exhibition information; the remainder of the site's typography is sans serif system text. Linear graphic elements, along with the geometric cross, convey a feeling of pharmaceutical packaging.

Atelier Varga Mihaly Varga, Yves Gerteis | *Zürich, Switzerland*

Artwork and text remain distinct from the navigational device. An HTML form drop-down menu above the work lets the user navigate among different exhibitions, while a text link below the work connects to information about the artist.

The homepage is regularly updated with bold exhibition announcements. The art for the typography scrolls behind the navigational device via dHTML to reveal current gallery exhibitions.

www.fpaa.org

This website for the Fairmount Park Art Association, a nonprofit group dedicated to public art awareness and urban planning in Philadelphia, is structured using a clearly proportioned hierarchic grid. A primary central content zone is flanked on the left by by a narrow column containing a tiered system of navigational buttons; a second narrow column area provides space for supporting imagery and captions. The navigational buttons are color coded into two major sections—links to information about the organization are a warm neutral gray, while links to information about public art are colored a pale bluish gray. The color distinction is subtle, but decisive. Navigation through the second tier of buttons is accessed through flyout menus that provide links to more complex areas in the site.

Within subpages, the central content zone and the support column at right may be spanned by images, but running text is constrained to the central zone. Captions for image groupings appear in the support column. The organization's branding typography, in a crisp serif face that is both classical and modern, is supported within a maroon tab by a secondary line of type, set all uppercase in a sans serif face. Directly below the tab, a horizontal green banner holds the section header for a given page—About Us, Public Art, and so on. The remaining typography is sans serif system text, used in both regular and bold weights, predominantly in one size. The text size for captions is somewhat smaller, and links within text or captions are underlined in the maroon branding color.

The site offers an interactive map of the local area that allows the user to locate and view specific works of public art, zoom into the map's areas, and call up historical and cultural information about selected works. The map is delicately drawn and subtly colored so that the features it portrays do not compete with red dot locators of specific artworks. On rolling over, the name of the work appears over the cursor. Upon clicking the dot, an image and information about the selected workloads into a column to the right of the map, mirroring the logic and structure of the primary portion of the site. Clear hierarchic distinctions and a simple structural system act in tandem with intuitive navigational devices like rollovers to help guide the user easily through a complex set of content.

Allemann, Almquist+Jones Jan C. Almquist (art direction), Sal Nistico (design) | *Philadelphia (PA), USA*

The homepage partially defines the primary page structure; the central content zone is clearly distinguished from background and navigation by conspicuously being loaded into a white frame, with the tiered navigation to the left. Unlike the subpages, the homepage does not display the support column to the right of the central zone, but it does include a gray frame below the introduction containing information that may be updated by the organization. Flyout menus may be accessed from the second tier of color-coded navigation buttons.

Three subpages show the flexibility of the hierarchic grid in displaying text and image content (above).

Different configurations of text and image are possible, but the support column at the right always carries captions or supporting links. The depth of this column can easily list captions for several images.

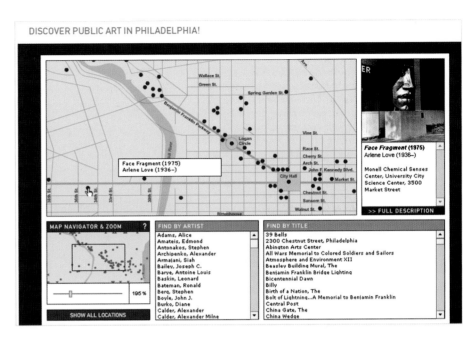

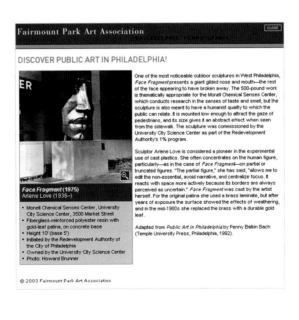

The interactive map (above) displays a view of the local area and uses red dots to pinpoint locations of public artworks. Controls to the left and below the map allow the user to zoom in closer so street and landmark details become apparent. The map also provides list-based search options on the page.

Selecting a work calls up the name, an image, and supporting information—first the name of the work, in bold; then the name of the artist and his or her birth and death dates; followed by a brief description of the work.

A full description button at the bottom of the frame spawns a pop-up window (left) that contains in-depth information about the work.

www.dixonphotography.com

Minimal navigation elements and typography distinguish
this portfolio website for a photographer from the vast
majority of such sites. Opening in a narrow, horizontal
window of elegant proportions, the site first presents
the user with contact information and two discreet dots
that can only be some kind of button, despite a lack of
information. On rollover, each dot brightens to white and
displays an indicator of the content to which it will link:
the portfolio or information. Clicking the portfolio button
brings the user to another minimal gray screen containing
a text introduction to the photographer's work. The button
remains bright and the text indicator visible. Three addi-
tional dots, now clearly buttons, appear in the lower part
of the frame. Each brings the user to a different body of
work—portraiture, still life, or location photography—and
the screen comes alive with an overall color that codes
each particular area. The photographer's work is show-
cased in a frame at the far left of the screen. The decision
to minimize typography is both a formal one and a
functional one. Working with an economy of means is a
typographic treatment, allowing the images to be
presented without interference and indicates something
about the photographer and his aesthetic vision by its
direct and un-fussy qualities.

Paone Design Associates | *Philadelphia (NY), USA*

*The portfolio pages (opposite,
top and left) are color-coded and
the navigational typography
within a specific body of work is
displayed as a series of small
circles extended outward from
the primary button that links to
a given area, with an uppercase
header in a tint of the back-
ground color to set it back.
Clicking on the circles brings
up another image in the same
body of work, whether portraits,
still life, or location images.
A caption next to the image is
set in upper- and lowercase,
in two lines of the sans serif.*

*Entry to the site is a quiet
introduction leading the user
intuitively from opening contact
information to the informational
areas through the subtle use
of buttons that change in
luminosity to indicate their
active nature as links. Minimal
typography, set in uppercase
in a sans serif face, creates no
distraction for the user.*

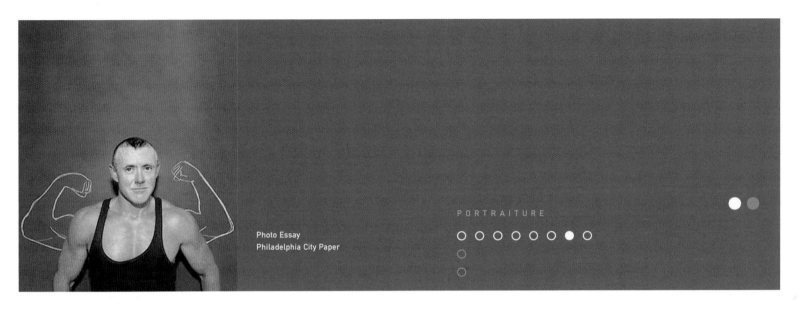

Information pages, with details about the photographer's client list and services provided (right), reflect the same minimal navigation; the screen color returns to gray to maintain the impact of color in the portfolio section. Type in three columns is reversed to white against a darker background so that the navigation buttons become secondary.

The design of transitory materials—such as announcements, calendars, or invitations—forms a relatively small portion of the typographic world. Most type appears in serial applications, such as books or brochures, and because it does, it has its own visual and informational requirements. Designing ephemera presents a designer with the chance to experiment, to push some boundaries, and to deal with a great deal less content than he or she would with an involved text application. The piece, by its nature, need not solve longevity problems, as in a corporate branding system; it will only be around for a short while. It can afford to be edgy or experimental, because most often its communication goal is less lofty. Effective typographic design in ephemeral media depends to a great degree on immediate visual impact, clear hierarchy, and simplicity.

TYPOGRAPHY IN PRACTICE

Ephemera

Announcements, Promotions, and Advertising

David Pidgeon is an Australian designer based in St. Kilda, where he is a principal of Gollings+Pidgeon, a multidisciplinary firm. Along with complex projects such as corporate identities and packaging, Gollings+Pidgeon also investigates smaller custom projects that include ephemera such as invitations, announcements, and calendars. Here, he discusses his direct, yet conceptual, approach to typographic ephemera.

What concerns you most when you're working with typography? The communication of an idea…that's it, really. The typography is a vehicle for the concept.

When designing something ephemeral—an invitation or other one-off—how does your approach to the typography differ from that of designing for a book or an annual report? It differs only in relation to the complexity and structure of the content. One-offs tend not to be as complicated as other kinds of material, but you still have to pay attention to the same kinds of problems: does the type read, is it too big or small, and so on.

Talk a little bit about the conceptual process for the Order of Service cards. How did you come to the solution, in terms of its typography? Getting married is usually a very formal affair. However, brides are notoriously late, so I thought I would give the guests something to do while they waited. The setting of the type pays homage to the occasion while the game adds a little personality of the couple. The puzzle solution reads: "Here comes the bride all dressed in white."

How do you feel about "rules" in typographic design? Are there any that should never be broken?
Typographic rules are only a safety net. All rules can be broken if they enhance the overall idea.

What are your favorite typefaces and why? How do you choose a particular typeface for a given project?
A typeface represents the personality of the job or client and is selected accordingly. The following are a few of my favorite typefaces and what I especially like about them: Georgia (old style figures); Champion (the heavyweight ampersand); Bembo (lowercase e), Bauer Bodoni (lowercase g and numerals); Hoefler Text and Univers (for their versatile families); Akzidenz Grotesk (light number 2 and 7), OCR A (form follows function); Melior (proportions) and hand lettering (personal expression).

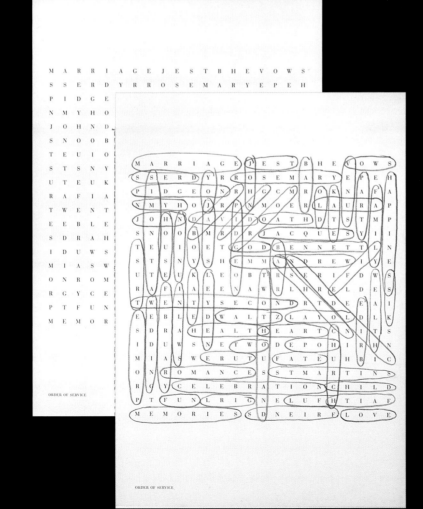

Swiss Postal System Stamps and Poster

The typography in this work for the Swiss Postal System is characterized alternately by a sense of restraint and dynamic compositional integration with the pictorial elements of each piece. Throughout, the designers have limited themselves to one typeface—a neutral sans serif, sometimes appearing only in capitals. This neutrality keeps the type simple, in contrast to the surrounding dramatic imagery and positioning within the compositions. Alignment and orientation correspond to the horizontal, vertical, and diagonal elements of the images. A sensitivity to scale relationships among the typographic material helps create strong, simple hierarchies and augments the sense of depth; the type does not appear to be laid on top of the images, but is actively a part of them, appearing at different levels within the image/type composite depending on color, orientation, opposition to solids, and transparency. Within the two stamps shown from the series, a vertical bar containing the word Helvetia (Switzerland) occupies a consistent position at the upper-right corner. This band quietly asserts the national origin of the stamps.

However, the vertical orientation of the type, which naturally slows recognition, keeps the marker at a secondary level in the typographic hierarchy. The dominant type—the subject matter of the individual stamps—changes alignment, size, and color depending on the requirements of the images with which they have been combined. In the promotional poster for a philately exhibition, the same contrast of restraint and dynamism is evident. One sans serif face, in a single weight, plays a quiet, informational role, but its unconventional positioning in the format creates interest and calls out a visual relationship to the mountains below.

Studio di Progettazione Grafica Sabina Oberholtzer, Renato Tagli | *Cevio, Switzerland*

The horizontally oriented column, reading left to right, repeats the logic of the mountain image below. The hard line of the alignment corresponds to the bottom edge of the format, while the rag restates the jagged forms of the mountain range. The alignment edge creates a proportional division that allows the space within the photo to interact with the space above.

The type in these three postage stamps responds to the visual stresses of lights and darks, as well as to specific elements, in their respective images.

Royally Fucked Performance Series Cards

The typography in these provocative cards mixes a raw, dirty quality with pristine serif typesetting, in varied alignments, and strong graphic elements. The subject of the three-part event is sex; its sleazy and sensual nature is presented by the degraded forms of the logotype and images and by the sensitive placement of paragraphs in space. The event logotype is a mixture of distressed type forms. An elegant script, its outline slightly altered and its counters filled in, displays a decrepit formality that contrasts the cut-out, individually spaced letters of the second word. Their disorganized arrangement is derived from flyers for underground sex clubs, conveying an irreverent quality often associated with punk 'zines and concert posters from the late 1970s and early 1980s. The serif face used for the event information is also slightly altered—somewhat condensed from its regular width and drawn to look a little uneven. Bold color and high-contrast images oppose the delicate quality of the type. Contradictory attitudes about sex are communicated through contrasts between classical and degraded forms.

Stoltze Design Clifford Stoltze, Violet Shuraka |
Boston (MA), USA

The central axis of the first card, featuring the event identity, alludes to formal invitations. The clean edge of the black rectangular background is compromised by the cutout strip of type and the vertically oriented pink type at the lower edge.

Again, a clean, rectangular background is violated by the irregular horizontal motion of the type. The series of alignments, almost tabular in effect, contributes to this movement. The reversed line of type, in white, is given prominence in the hierarchy through brightness against the similar values of black and fuchsia, and by the graphic icon that marks it from the left.

A decisive arrangement of positive and negative forms creates a spatially dynamic composition from a few elements. The vertical movement of the face image is joined by the lateral motion of the logotype, which occupies a plane in front of the face. The informational type to the lower left continues the lateral movement of linear elements through the relationship of the outdented subhead to the text, while the left alignment creates a second vertical motion corresponding to the image, but on a smaller scale.

PERFORMANCE PART I

KAREN FINLEY's *Shut Up and Love Me*
CYNTHIA VON BUHLER's *Countess*

Friday, June 29th, 2001
THE PARADISE
967 Commonwealth Ave, Boston
$17 Admission, 18 +
Doors: 6:30 pm
Advance tickets: 617-423-NEXT, nexticketing.com
or at the Paradise Box Office
Royalty Hotline: 617-783-2421

ARTISTS AS ROYALTY

THE EMPIRE S.N.A.F.U. RESTORATION PROJECT, KING VEL.VEEDA, THE PRINCESS PROJECT, CHRISTINA CARROZZA's *Royal Fashion*, and *images & ephemera from the* ROYALLY FUCKED PERFORMANCE ARTISTS

Thursday, June 18th, 2001
THE DIETRICH GALLERY
16 Ashford Street, Allston
Opening reception, 7 pm - 9 pm
Show runs from June 21st — July 21st
Gallery hours: Saturdays 2 - 4 pm
drawbridge.com/dvbgallery
Royalty Hotline: 617-783-2421

Annual Calendar Promotion

The designers of this annual promotional calendar have defined a visual language that depicts the passage of time as a rhythmic interplay of linear motion. The composition interprets a full year's calendar through the depiction of days in linear sequence. The horizontal motion is halted and resumed as the days of the week and weeks within months are separated and grouped. The composition is devoid of other elements except for the names of the months and demarcation of holidays. The horizontal motion is chaotic, as changes in the sizes and colors of the numerals create varying degrees of emphasis to alter the spatial relationships between the lines of numbers. The lines move in slight diagonal opposition to each other, adding to the frenetic quality of the composition.

Büro fur Gestaltung Christoph Burkardt, Albrecht Hotz |
Offenbach, Germany

A gestural quality to the typographic movement, created by the gently opposing diagonal thrust of the individual lines of numbers, distinguishes this calendar. In addition, size and color changes among the numerals cause them to be perceived at varying spatial depths in the format.

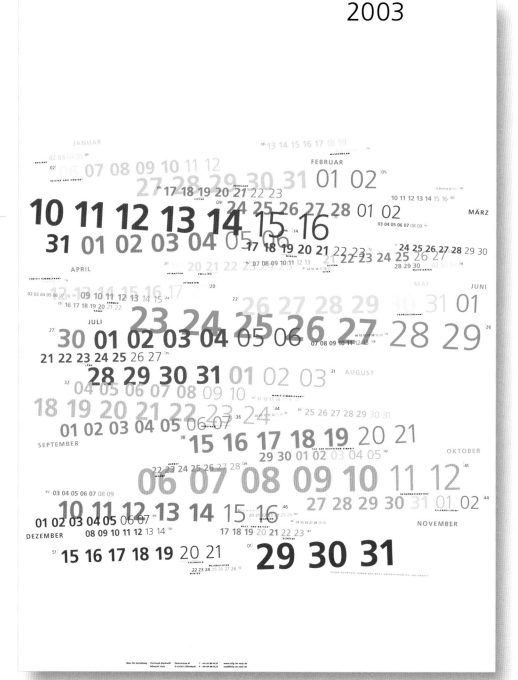

RAM New Year's Card

This ethereally delicate New Year's card derives its structure from die-cut, perforated numerals. When punched out from the flat card, the numbers can be arranged into a beautifully architectural configuration. The variation of the numbers' forms, including a black condensed sans serif form and a scrolling serif one, add interest, as does the interplay of positive and negative areas of the cutouts and voids in the card.

Gollings+Pidgeon | *St. Kilda, Australia*

Restaurant Branding Ephemera

Typographic and abstract imagery with typographic characteristics adorn numerous items of branded ephemera for a restaurant in Tokyo. The typography is minimal, interacting with drawn and brushed iconlike images. A single lockup of typographic elements, which shows an internal hierarchy, moves to accommodate the abstract images and integrate with those images into the space of the formats. The various formats contain dramatic negative space as a frame for type and image elements, providing rest and counterpoint to the positive forms, whether typographic or otherwise.

Graph Co., Ltd. Issay Kitagawa | *Tokyo, Japan*

Be Heard Self-Promotional Booklet

This design firm's promotional booklet targets educational institutions as potential clients. The booklet visually and verbally delivers messages supporting the firm's conscientious approach to designing recruiting literature that is meaningful, appropriate, and that will resonate with their clients' prospective students. A series of statements and questions, each centered simply on the left page of a spread, gives way to a cluster of musings, answers, and solutions on the right, delivered in a comfortable mixture of typographic treatments, which are formally integrated. Scale and orientation changes in two primary type families, a serif and a sans serif (along with their respective italics, bold weights, and small caps) create a controlled variety of experience among elements.

Robert Rytter & Associates | *Butler (MD), USA*

The dramatic cover of the promotional booklet pits a comfortable and confident sans serif against a storm of distressing issues set in a classic serif. The clustering and overlap of the serif forms create tension and confusion; the detailed quality of the serif enhances this busyness, as well as casts the distressing preconceptions that the firm will dispel as conventional, everyday thinking— the traditional approaches will no longer meet expectation.

The basic compositional structure: a simple statement on the left that is supported, pondered, and resolved in favor of the design firm on the right. The simple, one-face presentation on the left is contrasted by the multitypeface, textural, process-oriented typography on the right.

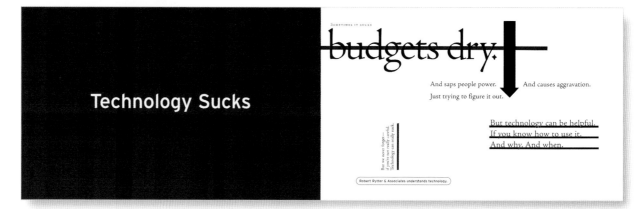

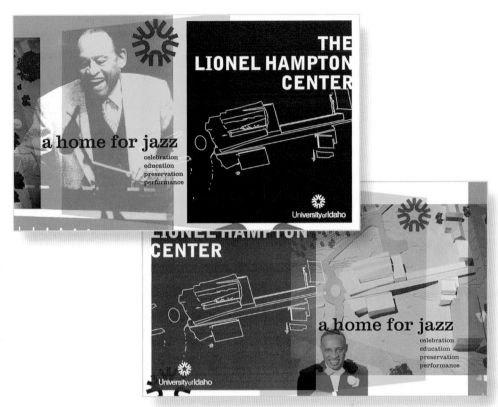

Promotional Cards The Lionel Hampton Center
at the University of Idaho

The typography for these promotional cards is reminiscent
of 1950s and '60s Blue Note jazz albums—a nod to the
music's history and an opportunity to resonate with jazz
aficionados familiar with the design language of those
albums. Updated with overlapping fields of vibrant,
unconventional color combinations and photomontage,
the typographic presentation relies on a mixture of
unadorned, condensed sans serifs and chunky, slab serifed
typefaces, popular choices for record album designers in
the mid-twentieth century. The gently rhythmic composi-
tions are unified by both color fields; placing the two
cards together joins both into one long composition.

Jack Design Jenny Chan | *Hamden (CT), USA*

New Year's Card 2003 Museum of Modern Art

The strength of this starkly designed New Year's card is
not so much a result of the typography—a stenciled cut-
out sans serif reminiscent of shipping crates—but the
formal qualities of the paper stock. The typography is a
vehicle for showing off the contrasting tactile qualities
of the card: a glossy metallic silver surface with a highly
reflective polish, cut open to reveal a blank, near-fluorescent
matte yellow surface. The conceptual underpinning of
the year acting as a window to show change is simple,
yet the execution and attention to the surface interaction
creates a visually arresting message.

Design Machine Alexander Gelman | *New York City (NY), USA*

Door to Door Club Promotional Card

This promotional card for a club event is a study in lateral rhythm. The change in scale between the letterforms in successive lines creates differing alternations of positive and negative strokes line by line. The pace and density of the alternating rhythm is compounded by the rectangular blocks that contain the letterforms and the negative white lines between them.

Around the line *Sommernachtsfest*, the color of the blocks is a more vibrant pinkish red than that which surrounds them. The blocked-out letters are somewhat reminiscent of lead typesetting slugs; in the context of this event, they also take on a kind of binary or digital quality, appropriate to the digital nature of the music being performed.

Martin Woodtli | *Zürich, Switzerland*

Gala Invitation Enterprise Foundation

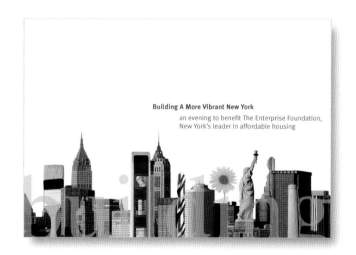

This invitation, for a nonprofit organization devoted to urban renewal, uses a bright palette, expansive negative space, and a whimsical pictorialization of typographic elements to convey a sense of optimism and progress. The cover depicts a skyline of familiar New York buildings and other objects—a flower, a hammer, a building level, and a drill bit—given architectural scale. The title of the event—"Building a More Vibrant New York"—is set in a bold sans serif face using a rich, warm red, supported by an explanatory line in the same face, regular weight, in blue. The word "building," in an elegant serif, appears among the skyline elements, the center of the flower cleverly substituting the **i's** tittle. Upon opening the accordion-fold card, the remainder of the event title continues in the large-scale serif, tinted to a pale blue and activating the enormous negative space around the discreet informational clusters dispersed across the format. The date of the event is set larger than the information around; calling it to the top of the information hierarchy, setting it in a medium warm yellow makes it appear less aggressive in all the white space. Color and weight change help distinguish different levels of information in the narrow column at the far right of the format.

C. Harvey Graphic Design | *New York City (NY), USA*

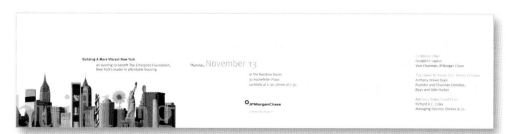

Advertising Campaign Seagate, Inc.

In this campaign of double-page spreads for a software and networking solutions company, type does double duty—both as the text of the ad, and as the illustrative component. Refreshingly devoid of photographic images, the typographic illustrations convey as much (if not more) information because the symbolic nature of letters and type symbols inherently carries conceptual messages.

Each ad focuses on an aspect of storage networking technology, the entire verbal message contained in a discreet paragraph of justified sans serif text with minimal treatment—a size and weight change in the ad headline and a color shift (black to knockout) in the tagline. Around this uncomplicated paragraph, however, the typographic illustrations roar across the spreads. The multitude of forms clustering in the dramatic compositions, along with their scale, repetitions, and interaction with the negative space of the spread, convey the sense of vast amounts of data that desperately need management. For all the space of the double-page spread, the paragraph occupies very little, but the directional thrust of the illustrations forces the viewer's attention from anywhere in the layout right toward the paragraph.

Templin Brink Design | *San Francisco (CA), USA*

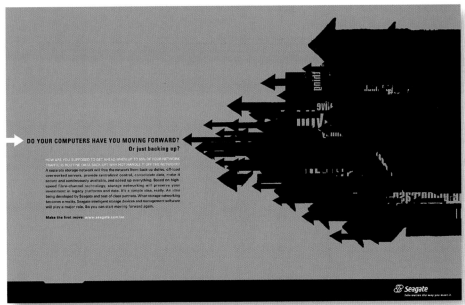

Choosing type to create images adds an extra dimension to the illustration. The words or letters chosen to construct the shapes in the image inherently convey information. In this case, the 1s and 0s are a quick read as binary data. Again, the distribution of weight and the thrust of the curves in this image focus the eye on the paragraph of headline and body copy. A slim black band at the bottom of the ads holds the branding.

The poster is arguably the single most dramatic typographic application in design—its large scale and street-level visual power have fascinated designers for more than a century. Not surprisingly, typography often dominates the design of posters. Perhaps it is the opportunity to use large scale type, or to combine it with images in such a direct, visceral presentation that draws designers to the medium over and over again. In addition to the top-level impact a poster requires to be effective at a distance, it offers the potential for nuance with secondary-level text setting, allowing the designer to involve the viewer on a more personal level once captured by its dynamic first statement.

TYPOGRAPHY IN PRACTICE

Posters

Leonardo Sonnoli is an Italian graphic designer known for his stunning poster work, which forms the majority of his portfolio. As principal of CODEsign in Rimini, Italy, whose clients include an international range of cultural, educational, and corporate organizations, he has created an impressive body of poster-based communications. Sonnoli is a member of AGI (Alliance Graphique Internationale).

What characterizes your typographic sensibility from that of other designers? From a stylistic viewpoint, my approach is influenced by twentieth-century European avant-garde art, concrete poetry, futurism, conceptual art. My work shows a certain consistency in color (black, white, red, orange, silver) in the use of existing typefaces (modern sans serifs like Franklin Gothic, Akzidenz Grotesk, Trade Gothic) and in designing my own lettering with very geometric, linear structure—a kind of reference to de Stijl [the Dutch design movement of the 1900s that included practitioners such as Theo van Doesburg and Piet Mondrian].

What kinds of typographic considerations are important to you when you are designing a poster? A poster has two reading levels. The first level intrigues the viewer, fascinates them; it's the level where the typography is the core of the visual communication—especially if the primary element is a single letter. The second level is informational and supports the first level with explanatory text.

Compare the typography in two of your posters from a conceptual, as well as visual, perspective. The two posters are very different conceptually. The Italian word for poster is *manifesto:* the Palindrome poster is both a poster and literally a manifesto. I present a palindrome alphabet (where each letter may be read in two directions) that I designed as an investigation into the connection between typography and rhetorical form of language. The IUAV poster announces the opening ceremony of the academic year at the University of Architecture in Venice. The two As stand for *Anno Accademico* (academic year). The structure of the two posters is similar: a big letter is the main focus, and the information is presented systematically below. The Palindrome poster plays with the spatial relationship of the photography and type to create an ambiguous space. In the IUAV poster, a similar spatial disconnect is achieved with geometric and plain surfaces. The typeface for the text in the Palindrome poster is Akzidenz Grotesk (to contrast the stylized headline type, I needed a neutral typeface without distinct qualities). In the IUAV poster, I used a very architectonic typeface: DIN Mittelschrift.

What are your favorite typefaces and why? I have three favorites. First, I like Fuller Benton's Franklin Gothic, because to me it perfectly embodies [Modernist architect] Mies van der Rohe's motto "Less is more." Second on my list is Matthew Carter's typeface Walker, because it was one of the first well-drawn digital typefaces. And third, I like Letterror's typeface Beowolf. I've never used it, but it's an interesting exploration into the relationship between bits and type—the computer redraws the outlines of each letter every time it is set.

Whose typographic design has influenced you most? I'm continuously influenced by contemporary designers. But I love history. I'm partial to the designer Dudovich, who was born in my hometown, Trieste, and others from elsewhere in Italy (like Grignani and Fronzoni). Culturally, I feel European, so I feel a connection to designers like Piet Zwart [Dutch designer, active in the early twentieth century]. And finally, I have to mention my friend Wolfgang Weingart [Swiss, b. 1941]. For me, he is the greatest example of someone devoted to discovering the hidden essence of typography.

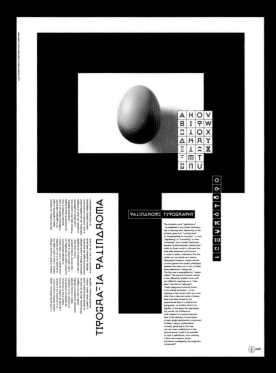

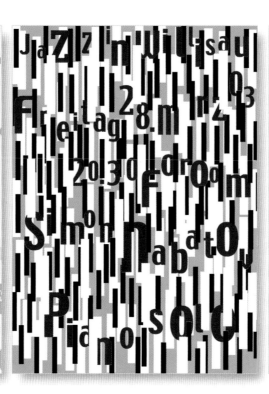

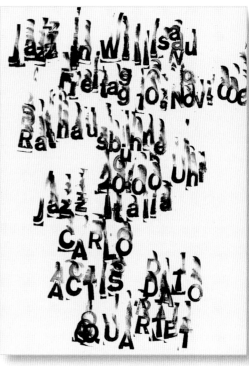

Willisau Jazz Festival

Every year, Niklaus Troxler creates a series of posters for the jazz festival in Willisau, Switzerland, which he also coordinates. Overall, the posters are a study in the improvisational nature of image making and as such are appropriate to their subject; additionally, the striking playfulness and energy of the compositions are clearly eye-catching. Within each poster, despite this fast-and-loose approach, the typography is always clear and center stage. The designer's control of the letters' formal qualities, spacing, and interaction with other elements allows this seamless mix of energy and information. Each poster investigates a single visual concept: this logic of distilling one formal performance unifies the individuals into a body of related work, despite the use of different typefaces or hand-drawn letterforms, colors, or abstract elements.

Niklaus Troxler | *Willisau, Switzerland*

In the first poster (left), the designer explores the relationship between system and improvisation. Splotches of what appears to be yellow and green paint are spattered evenly across the format, partially obscuring the type, which is set flush left, with even interline spacing and one size in a very restrained way off the left edge of the format. Closer inspection reveals that all the elements, including the paint splotches, are digitally drawn bitmaps. The pixel jaggies associated with low-resolution typesetting and images play an interesting game with the assumed intuitive quality of the splotches. The splotches are carefully placed to maintain the legibility of the forms, keeping critical strokes uncovered so they are easily recognized.

In the second poster (middle), abstracted black-and-white piano keys set up a rhythmic alternation of dark and light for this poster. The type follows the up-and-down motion of the keys, sometimes being partially obscured, sometimes moving into the foreground. The designer has selected a condensed sans serif of a weight similar to the black keys (and counters similar in width to the white keys) to correspond to those elements, both visually and conceptually.

The type in the third poster (right) slides within the format, as though inked and dragged across the page. The distribution of dark typographic matter is decisively composed, and the negative space that interacts with it from the top and outer edges is carefully considered. The form repetition that results from the stamping effect creates movement and depth.

Cosmology of Kyoto

A delicate network of lines and neutral color creates a complex textural backdrop for the title and secondary information in this poster for an exhibition. The typography is relatively straightforward, set in a classic serif that echoes the elegant precision for the background imagery. The title components are set justified, in two sizes. The secondary information runs along the bottom of the poster, also justified, calling attention to the linear quality of the type to visually correspond with the lines in the background.

Shinnoske, Inc. Shinnoske Sugisaki | *Tokyo, Japan*

Video Ex

The limit of legibility is stretched in this poster for a video art exhibition. The typography is joined to the background of test-pattern lines, alternately separating from it and being partially lost among the colored linear elements. The lines are divided into three overlapping bands, creating additional levels of spatial interaction. Ghosted diagrams of video equipment and textural type elements further contribute to the overall pattern of the presentation. The exhibition dates and supporting text appear in a bitmap typeface, reversing out white from the background and set against a black bar to aid legibility.

Martin Woodtli | *Zürich, Switzerland*

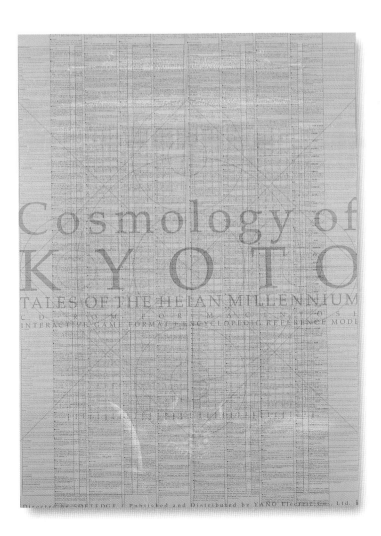

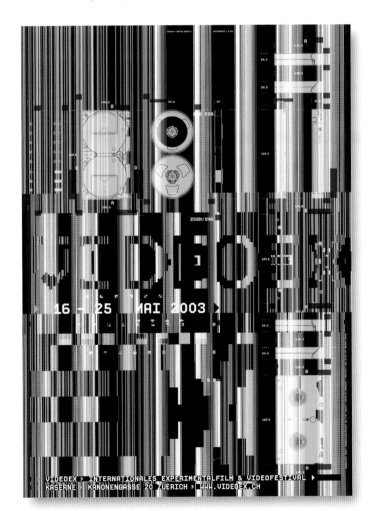

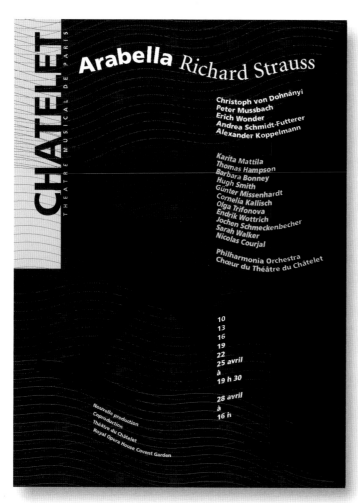

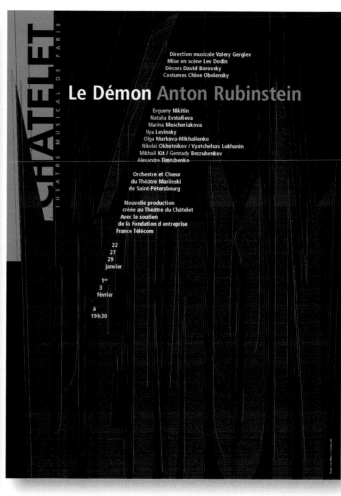

Season Performances Théâtre du Châtelet

These posters are part of an ongoing series created for a musical theater company, and they demonstrate the design flexibility that is possible in a branding system. The consistent use of a single sans serif type family—and a standard treatment for the client's name—forms the basic visual unifier of the system. In contrast to this consistency, the poster content changes stylistically and organizationally to reflect the subject of the individual performances they promote. Additional typefaces, illustration, and spontaneous compositional strategies are all permitted.

Rudi Meyer | *Lausanne, Switzerland*

The Arabella *poster (left) is composed around an enormous serif A, rotated against the right edge of the format. Across the field of color and the black letter itself, a pattern of wavy lines undulate from side to side. The performance title, composer, and all the secondary information flow along similar wavy baselines, with the list of performers set flush left to provide a recognizable structure that restates the vertical edge of the giant A's*

thick stroke. Within the column, a color change distinguishes informational indicators—musical direction, costumes, and so on—from the people to whom they refer. The Châtelet branding rectangle at upper left is a standard feature within the posters, and here its linear motion integrates with that of the vertical thick stroke of the A.

The title of Le Démon *(right) is presented in an illustrative treatment in the background of this poster, interacting with the Châtelet brand mark and the informational type. The forms of the letters in* Démon *are altered to communicate the idea of the Devil or Hell—the counters are stretched and the stroke weights are skewed, horns have been added to the initial* D, *and the tops of the letters have been pulled and de-formed to evoke flames and canyons. The secondary type is aligned flush left along a diagonal following the accent mark over the* E.

Biblioteca Multimediale

Two primary forms dominate this poster marking the inauguration of a university's multimedia facilities—the title block at the upper left, a square grid of dots; and an arrangement of colored planes. The dots and planes are the basic visual logic that governs the typography and represents the ideas of multimedia and library. The dots are binary code; the colored planes are alternately computer screens and book pages. The type follows this logic and sets up the same contrast in presentation established by the two primary visual forms. The grid of dots, which forms a flat plane, defines the title of the poster by changing the weight of specific dots to make letters. The secondary type below appears over the colored planes, set all uppercase on a grid—and by spacing them out, they begin to take on the quality of dots. Alternating and reconfirming the visual logic between the type components and the images contributes to the visual and conceptual unity of the poster.

CODEsign Leonardo Sonnoli, Pierpaolo Vetta | *Rimini, Italy*

The dot-plane logic is restated in the secondary information; looking carefully at the lines of type, it becomes apparent that letters between each line are aligning—the type is set on a grid, and the space between the letters horizontally compromises the line, enhancing the appearance of the individual letters as dots.

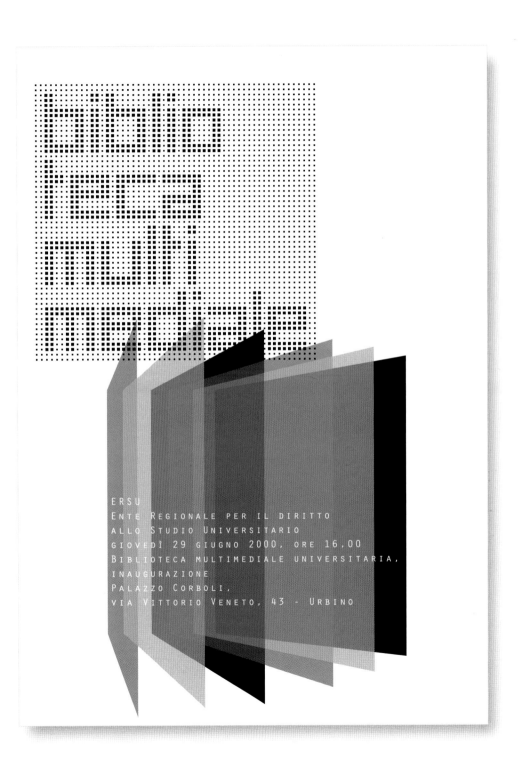

ERSU
ENTE REGIONALE PER IL DIRITTO
ALLO STUDIO UNIVERSITARIO
GIOVEDÌ 29 GIUGNO 2000, ORE 16,00
BIBLIOTECA MULTIMEDIALE UNIVERSITARIA,
INAUGURAZIONE
PALAZZO CORBOLI,
VIA VITTORIO VENETO, 43 - URBINO

Hommage à Gabriel Fauré

In this poster for an exhibition celebrating the French composer Gabriel Fauré, an intricate network of diagonal lines joins the background image, a portrait of the subject, to the type of the exhibition title. Narrowly spaced gray lines of one value cross from upper left to lower right, effectively tinting the image and sending it backward into space. A musical rhythm of lines in white and black streak from the title upward to the right, creating a cross-hatch effect that is reminiscent of engravings contemporary to the composer. The alternating black and white letters in the title set the word in motion, creating the appearance of multiple spatial levels, and define the logic for the white and black lines—white lines proceed from white letters, black lines from black letters. The flush-right alignment of the title components creates a geometric border that accentuates the movement of the lines and relates to the format edge.

Along the left of the poster, the exhibition information is divided into three components: the museum's address; the dates of the exhibition; and at the top, information about the exhibition sponsors. The date component set in larger type achieves the same optical width as the other two and simplifies the vertical movement of the support text. The museum's logo appears in a grid formation toward the bottom left of the format.

Studio Apeloig Philippe Apeloig | *Paris, France*

The linear texture, interacting with the photograph and the title type, joins the two elements and alludes to the rhythm and expressive qualities of music. As the lines gather in density, they begin to obscure the type, but not enough to impair the recognition of the letters.

The title, set in a sharp, classic serif, all uppercase, relates stylistically to the period of the composer's life. The informational type is set in a modern sans serif, relating to the present frame of the exhibition, contrasting stylistically to distinguish it and to help improve legibility against the background texture.

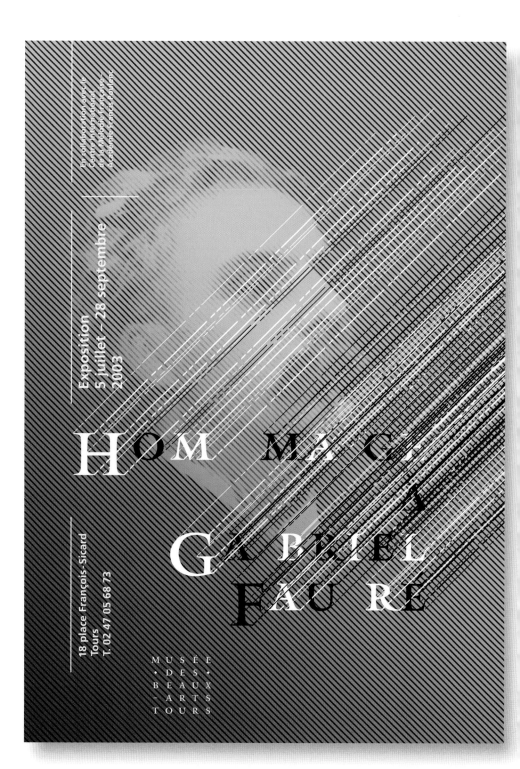

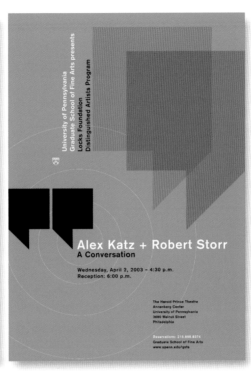

Vårsalongen Liljevalchs

A simple composition, enlivened by ornate detail and color, calls to mind the European horticultural prints of the eighteenth and nineteenth centuries that were prevalent in England, France, Sweden, and the Netherlands. The floral blackletter **V** occupies a central position. The naturally organic, plantlike forms of its drawing integrate seamlessly with actual leaf drawings composed in a profuse pattern around the letterform. The **V** becomes part of the foliage, but its heavy strokes allow it to separate and be perceived without confusion. The exhibition title and supporting information are set in two lines of sans serif type, upper- and lowercase, in two sizes that justify the lines with the illustration.

Fellow Designers | *Stockholm, Sweden*

Alex Katz + Robert Starr Lecture Poster

Enormous quotation marks form the primary visual elements of this typographic poster for a lecture, alluding to the subject in the title, *A Conversation*. The title and secondary informational type for the event are set upper- and lower-case in the same sans serif face throughout. Color plays an important role in establishing hierarchy and spatial depth among the elements. Against the green background, the title and most important secondary information are reversed to white, moving forward in space and occupying the domi-nant hierarchic level, above even the bold black quotation marks at the left, which act as a focal point for entry into the information. The remaining type, in black, is closer in value to the background color, and so appears to recede. The large-scale quotation marks in the upper right appear translucent, overlapping each other in differing values, cre-ating yet another spatial level. At the upper left, the vertical type joins the upper part of the format to the lower, creating an angular, stepped movement across the format to the paragraph at lower right and repeating the angular geometry of the stylized block quotations.

Paone Design Associates | *Philadelphia (PA), USA*

50 Years: Rock 'n' Roll Realschule

In a vibrant homage to the psychedelic rock posters of the 1960s, the designer has created an updated rock sensi-bility through color and type treatment to commemorate the school's fiftieth anniversary. The primary image is a gigantic **50** set in a serif face that is stylistically related to the period, augmented by concentric repetitions of the num-bers' outlines in alternating hues of yellow and orange. The title and support information are set justified in a sans serif typeface, knocking out of extruded drop-shadows in a rich fuchsia. Alternating the direction of these shadows, the designer creates a frenetic back-and-forth rhythm that enhances the rock 'n' roll attitude of the poster.

Fons Hickmann m23 Barbara Baettig, Fons Hickmann | *Berlin, Germany*

Körpersprache ("Body Language") / Enjoy

These two posters are characterized by designer Uwe Loesch's fascination with wordplay and symbolic representation. Each poster focuses on a syntactic and pictorial relationship to convey intellectual meaning.

The type in the black poster Body Language creates a subtle intellectual game: the same information appears both in German and in English. Each body of text occupies a plane rotated on its axis into perspective; the two planes cross each other in the center of the poster—separated by value. The game takes place in the fact that each body of text is set in a different language. The information is repeated in both paragraphs, and the interline spacing is carefully controlled; the English text is still legible because its lines do not interfere with those of the German in the foreground. A single line of information in yellow at the right edge of the poster defines a horizon related to the perspective of the type planes.

The red poster is for an exhibition of posters by the designer in Tehran. The Arabic script titling, in the context of the red background, is a visual pun on the branding of a ubiquitous cola. Lifted from one of the brand's advertising campaigns, the flowing white script is similar to the brand's iconic logotype. Taking these kinds of commercial metaphors out of their regular context is a hallmark of Loesch's work. It speaks to the omnipresence of advertising, celebrating the sense of international community that accompanies it. The verbal/visual message is clearly a powerful tool, and Loesch uses it to comment on the communication industry and his place within it. The secondary type exists in a subtle color relationship with the overall red background. A slight change in value and a shift in temperature toward the blue range of the spectrum allow the type to be seen but does not interfere with the primary image of the Arabic script. It is set in the same bold sans serif as Enjoy, and at the same size; its color causes it to recede into space. Its similar value to the background creates some optical buzzing that helps its legibility, and its linear arrangement both complements and opposes the linear forms of the script.

Uwe Loesch | *Düsseldorf-Ekrath, Germany*

National Portfolio Day
Syracuse University School of Art

Three distinct zones divide the format of this horizontal poster. The top and bottom are reserved primarily for image, a montage of students and photographic elements that bleed into each other through the middle zone, where the typography is located. The large-scale title, set in a geometric sans serif, runs forward and upside down, playing off the image reversal in the background and the idea of photography. The information is constrained to a column structure hanging from a flowline. Bold subheads call attention to specific content in the columns of informational text. To the lower left, the date and sponsor of the event appear in a contrasting OCR typeface, set in three staggered lines that relate to the back-and-forth motion in the images, and join the middle type zone to the lower zone.

stressdesign Marc Stress | *Syracuse (NY), USA*

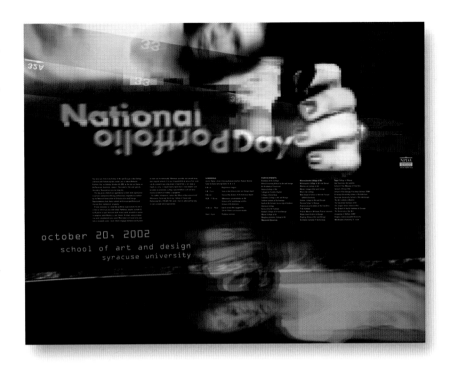

WW Typo Lecture, Carnegie Mellon University

This poster for a book lecture by typographic visionary Wolfgang Weingart uses a bold-weight sans serif gothic at dramatic scale to create a dynamic space. The hierarchy is unquestionable: WW and Wolfgang Weingart, by virtue of the scale of the two **W**s, are joined into a unit that dominates the format. A column of descriptive words, set flush left, connects top and bottom spaces, traversing the horizontal structure of the title. A third paragraph, also flush-left, contains information about the lecture. In the background, enormous yellow letters spelling "typo" both join to the WW lockup but remain at the lower level of the hierarchy because of their value similarity to the white page. A small, rectangular cropped image of one of Weingart's own works and a silhouetted image of his book add tonal depth and detail to the composition.

Daniel Boyarski Carnegie Mellon University | *Pittsburgh (PA), USA*

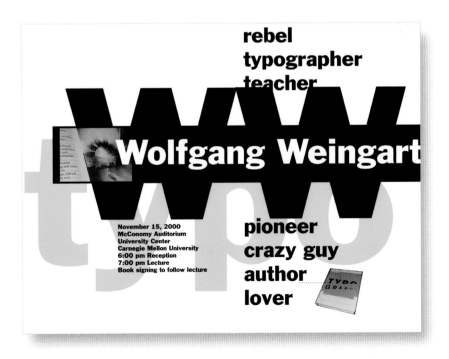

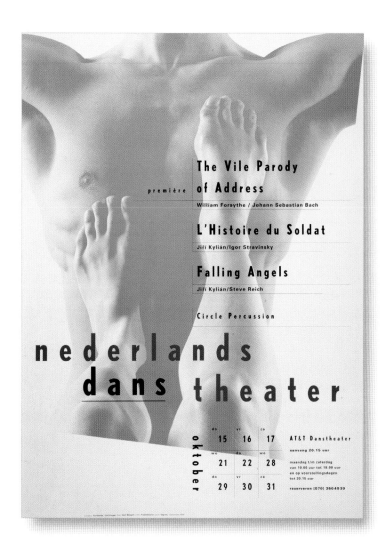

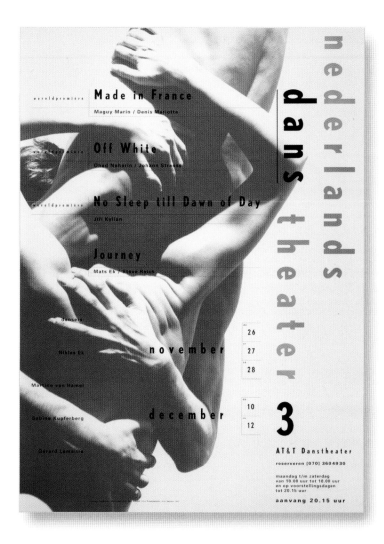

Netherlands Dance Theater

In this series of posters for the Netherlands Dance Theater, the designers explore a starkly simple, yet dramatic, typographic system. The posters feature ethereal colorized images of the dancers, with the information related to each particular performance dominating the foreground. Through color variation in the typography and in the photographs, the posters maintain a clear branding unity for the client, but show the flexibility that is intrinsic to system-oriented typography. The type in each poster reflects the same hierarchical structure: the title is assigned a specific size and typeface; the performers in the season are listed in a columnar lockup and also appear in specific sizes and weights; the performance dates are clustered in a modular system that is treated consistently and always occupies the third level down in the hierarchy. The flexibility occurs in the system's response to the photography in the background—the typographic components, at all levels of the hierarchy, change configuration to accommodate the formal dynamics in the images they overlay—diagonal movements, curves, lights, and darks of the dancers' bodies. In some cases, the type complements the motion of the bodies. In others, it acts in opposition to the directional movement. A subdued, consistent color scheme, with subtle shifts in hue between the background images and the type, further help integrate the typography and image into a dynamic and unified whole.

Faydherbe/DeVringer | *The Hague, Netherlands*

Agent Orange Concert Poster

This poster promoting a concert event uses typography and vivid color to startling effect in very direct and aggressive compositions. The poster is silk-screened in two colors for maximum saturation. Overlapping, decon-struction, and collage all characterize the use of type. The large red **A,** in an extruded, slap serif typeface reminiscent of early American wood type, acts as a focal point for the poster. It overlaps the second initial of the band's name, the enormous **O,** which is reversed out white from the shocking cyan background. The secondary type uses the diagonals of the **A** as a cue for their alignment. Repeating this information at the lower right adds texture and detail, as well as restates the overlap of the **A** and **O.**

Stereotype Design Mike Joyce | *New York City, USA*

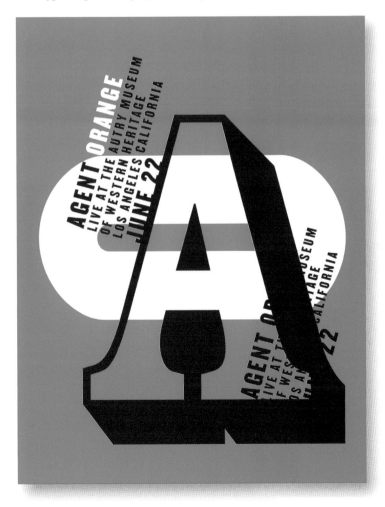

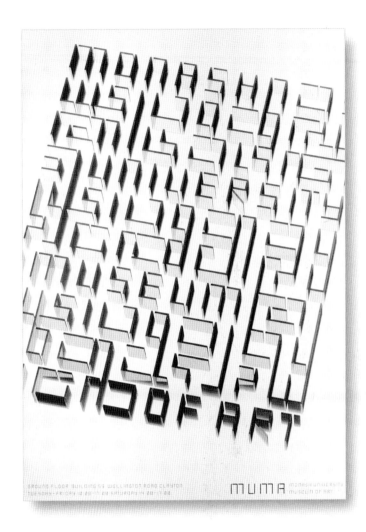

Monash University Museum of Art

The type in this poster is, at first glance, hidden—an appropriate entree for the viewer, given the visual concept of the maze that dominates the poster. On closer inspection, the letterforms spelling out the museum's name reveal themselves—hiding in the maze as part of its walls. The letterforms are drawn as architectural elements with a geometric construction. The angle of the maze in the photograph and the lighting of the surfaces aid in legibility. Secondary information appears in two lines near the bottom edge of the format in a graphically stylized sans serif that mimics the form of the letters in the maze.

Gollings+Pidgeon | *St. Kilda, Australia*

With the advent of film and, later, digital design tools, the opportunity to explore the visual and conceptual potential of typography that moves has presented designers with newfound possibilities—and equally unusual concerns. Added to the spatial and verbal considerations of print is the quality of time and actual movement. The impact of these two concerns on type is profound. How long do words appear before the viewer? In what order do they appear? How does their movement change their legibility— or their meaning? How does it enhance the ideas that the words already represent?

TYPOGRAPHY IN PRACTICE

Type in Motion

Animations and Film Titles

Dan Boyarski is Head of the School of Design at Carnegie Mellon University in Pittsburgh, Pennsylvania. His work in information design and education is highly respected, winning numerous awards in his 30-plus-year professional career. The aspects of motion and time in typography are a focus of his recent work and his teaching.

Describe your approach to typography in general.
I mix an intuitive approach to typography with a pragmatism that "brings it down to Earth." By that I mean that an early typographic idea—usually a sketch by hand on paper or a quick composition on computer—is clarified with an understanding of how it will be produced and delivered. I certainly consider what the piece is meant to achieve early on, but at the same time, I'll take the germ of an idea and freely explore it, sometimes (I have to admit) disregarding the goal of the piece. I love to explore, as that elicits the widest range of ideas. The next stage then involves evaluating what I've come up with and selecting the typographic idea that best meets that goal.

How does designing with type that moves differ from designing for print? The element of time is the major difference. Time offers two options when presenting type: one, sequencing the appearance of type, and two, moving the type. With the first option, the type may stand perfectly still as it is presented in a particular sequence, where speed, pacing, and rhythm are important factors. This sequence may resemble the sequence of pages in a book, but when designing with time, the designer controls what is shown and precisely when it is shown to an audience. The second option—moving type—is new territory, closer to choreography or filmmaking than book design. Movement, transition, appearance, and performance all have the potential for communication and meaning.

Does the way words "sound" affect how you manipulate their typography? Yes, most definitely. At the start of a monologue project I give my students, I ask them to read the words of a quotation they'll be working with out loud several times, listening carefully to its speed, volume, and pacing, as well as pauses. They soon realize the importance of pauses and silences—the spaces between the movement. Then they begin to explore visualizing that reading in dynamic typographic form, often returning to reading the words out loud.

Describe your process for a kinetic type project.
In this personal project, I was attempting to visualize a sound montage—the cut "Revolution 9" from the Beatles' *White Album*. As I listened to this piece over and over, I began to sketch frames for a typographic film that visually represented what I heard. Because this was a rather free-form sound piece, with a collection of all sorts of sounds, I decided to use type as my primary visual element, not unlike Dada typography. I wanted our eyes to hear sounds … kinetic typography as a visualization of the spoken words.

Whose typographic design has influenced you most?
Wolfgang Weingart [designer noted for his experimental work and teaching at the Basel School of Design, Switzerland] and Robert Massin [a French designer whose typographic book work uses unconventionally dynamic text layout] for their spirit of exploration. I was introduced to Massin's interpretation of Ionesco's *The Bald Soprano* in college and was forever changed! Years later, I studied with Weingart in Basel, and his approach to typography—visual, intuitive, intelligent, playful, and brave—taught me that one can simultaneously engage and challenge the reader.

How do you feel about rules in typography? Are there any that should never be broken? I don't believe in hard-and-fast rules in typography. We have guidelines when it comes to text setting, like letter- and wordspacing, line length, and line spacing. And we certainly do our best to instill best typographic practices in our students. Once students gain confidence in their typographic skills, they venture beyond the guidelines, hopefully knowing why they challenge the norm and "break the rules." I hope that students gain a respect for letterforms and typographic history, mixed with a healthy skepticism for rules.

Wer Weiss Wohin Branded Promotion

Illusory space is used to profound effect in this animated spot for a German cultural festival. The typography, which is the only visual element in the materials, is structured in exaggerated perspective that focuses on a vanishing point in deep space. The forms change scale as they move toward the viewer—literally. The digital typeface Chicago, usually ignored by designers because of its oddly drawn forms and irregular spacing, is used here fearlessly—it is not merely used, it is grand. At this scale, the type becomes a display face; the irregularities that make it a hideous type for text are transformed into stylistic details. Varying levels in depth and color separate the individual lines of information into accessible parcels, as does the changing angles of the lines resulting from their perspective relationships. A sharp, acid green lifts off the black background, while lines in a vibrant red and a rich cyan recede. Although all the type is arranged around the central axis created by the vanishing point, the composition ultimately appears asymmetrical; changes in scale, height, distribution of weight, and length of the lines breaks the central axis.

Qwer Design Michael Gais, Iris Utikal | *Köln, Germany*

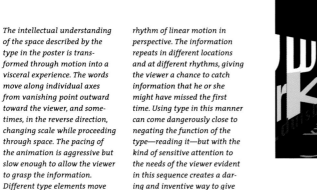

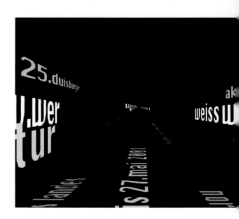

The intellectual understanding of the space described by the type in the poster is transformed through motion into a visceral experience. The words move along individual axes from vanishing point outward toward the viewer, and sometimes, in the reverse direction, changing scale while proceeding through space. The pacing of the animation is aggressive but slow enough to allow the viewer to grasp the information. Different type elements move along their tracks at different speeds, creating a complex rhythm of linear motion in perspective. The information repeats in different locations and at different rhythms, giving the viewer a chance to catch information that he or she might have missed the first time. Using type in this manner can come dangerously close to negating the function of the type—reading it—but with the kind of sensitive attention to the needs of the viewer evident in this sequence creates a daring and inventive way to give life to typographic material, both in and outside of print.

Become Whatever Music Video

A straightforward use of type brings an added dimension to the simple visuals of a band's performance in this unpretentious music video. The song lyrics appear in the foreground of the frame, overlaying the photography of the band members singing and playing instruments, set all uppercase in a neutral sans serif. The white type is clearly separate from the background video action, simply existing to be read as the song is heard. The words appear letter by letter in rapid succession, as though being keyed in. Some sequences are joined by words that remain after the lyric has been sung. Where appropriate, the type is allowed to move out of the frame, be wiped away, or dissolved as the action continues in the background.

Fellow Designers | *Stockholm, Sweden*

On the Edge of Time Conference Video

For a series of video shorts shown during a conference of marketing and media professionals, the designer used the textures and qualities of various media for interaction and transformation from simple and practically undesigned typography into visual metaphors for the media being examined. The digital jaggedness of computer monitors; the bloated texture of printed type; the blurred edges and static fuzz of video—morph the neutral sans serif used throughout to create transitions from one subject to another. The EX conference tag remains a constant element altered by the textures and additional type that comes into contact. It can become part of another phrase or act as an object that is morphed by texture or lighting effects to communicate a sense of technology. Overall, the color of the sequences is restrained and often minimal; a wash of blue or a sudden change from light neutral background to vivid red is used as visual punctuation to add interest and distinguish one portion of the sequence from another.

Interkool Christoph Steineger | *Munich, Germany*

Kulturregion Hannover Tourism Branding

A playful sequence of type and typographic elements creates a fun branding animation that promotes the Hannover region of Germany. The clean white frame comes alive as punctuation, dots, lines, and other typographic symbols move around the format; the elements change in scale and color, and combine and recombine in a playful dance of shapes that ultimately converge to become the region's logotype. The elements in neutral sans serif face provide a strong, simple visual unity that is offset by the continuous interaction of the different type forms. Metaphorically, the selection of type elements—monetary symbols, bar coding, letters, dots resembling postal stamps—and their movement around the format allude to human activity—shopping, dance, theater, art—and a sense of the bustling cultural center that is Hannover.

Qwer Design Michael Gais, Iris Utikal | *Köln, Germany*

The simplicity of the Hannover logo—a modern, uncomplicated sans serif combined with icons and punctuation in a justified lockup—is fresh and direct, yet allows for variety in designing applications like this animation: the iconic elements can be recombined in different pieces so that the identity may constantly be updated.

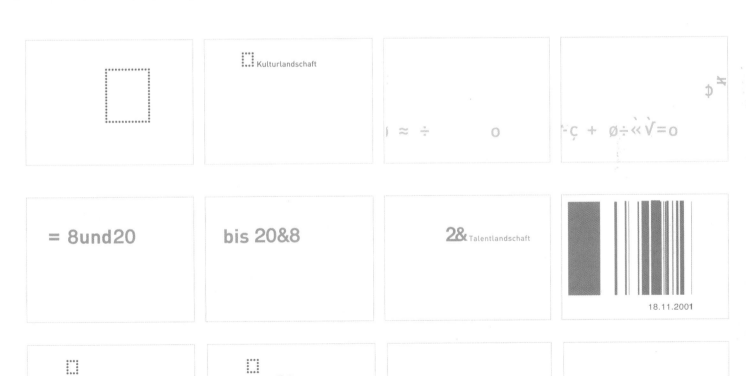

The Sky Kinetic Poem

A poem exploring the sky's expansive nature is drama-
tized through kinetic typographic manipulation in this
animation sequence. The words and cadence of the
poem are a source for their visual treatment—smaller
scale type, moving at reading pace along a baseline
in the middle of the screen, begins to overlap itself as
the thoughts progress from simpler pondering to more
complex metaphoric abstractions. Transparent words
and changes in density allude to shifting winds and
clouds, moving more erratically as the poem's intensity
increases. The rhythmic variation, changes in density,
overlap, and alteration of the type builds into a kind of
storm; individual words and lines of the poem blow
forward from the background, shifting and breaking
apart as though being tossed about in a hurricane. The
edges of the type blur from the force of confronting
the absolute and it begins to come apart. Attention to
the timing of these effects on the words ensures they
remain legible long enough to be read and understood
before they are broken apart by the kinetic energy.

Heebok Lee Carnegie Mellon University: Daniel Boyarski,
instructor | *Pittsburgh (PA), USA*

The Sky (excerpt)

But, sure, the sky is big, I said;
Miles and miles above my head;
So here upon my back I'll lie
And look my fill into the sky.
And so I looked, and, after all,
The sky was not so very tall.
The sky, I said, must somewhere stop,
And sure enough!? See the top!
The sky, I thought, is not so grand;
I 'most touch it with my hand!
And reaching up my hand to try,
I screamed to feel it touch the sky.
I screamed, and lo infinity
Came down and settled over me;
Forced back my scream into my chest,
Bent back my arm upon my breast,
And, pressing of the Undefined
The definition on my mind…

Edna St. Vincent Millay (b. 1892, d. 1950)

Double Indemnity Film Titles

The mystery, intrigue, and danger of a film noir classic is dramatized through slowly shifting, broken planes of type against a dark background, intermittently illuminated by vague bursts of light as though by car headlights or a flashlight. The credits appear out of the background, starting out dark and lightening up in a steady, sonorous pace, or flashing brightly and suddenly into focus from within one of the lighting effects. As the type slides across the screen, indeterminately moving back and forth, it breaks against invisible angular elements that have the quality of shards of glass. As the type breaks and reforms, it remains legible enough to read but comes close to illegibility at various points. The effect is a sinister uncertainty and a sense of violence to come. A flash of luminous red solarizing the title of the film is the only appearance of true color in the sequence, distinguishing the title from the remainder of the credits and creating a break in the overall darkness of the frame.

Josh Reynolds University of Tenessee at Knoxville: Sarah Lowe, instructor | *Knoxville (TN), USA*

An unexpected glare of light gives way to an actor's name, which slowly moves downward and out of the frame as it fades out into the black background.

An alternate treatment involves the type being fractured against invisible shards; the actor's name in this particular sequence seems to be sliced apart by sharp edges and reform after it passes around them.

Tungsten Educational Presentation

In this animated presentation covering the scientific properties of the element tungsten, the designer brings together neutral informational typography and textural typographic and diagrammatic elements scanned from old textbooks and other sources. The goal of the animation, to present the scientific information in a way that is accessible for high school students, is achieved through the use of rich color and the blending of the two typographic languages—new and old—to create a visually complex but easy-to-understand overview.

Scanned typography from the periodic table, molecular diagrams, textbook charts and tables, and partially obscured photographs form a textured backdrop to the informational type in the foreground. Featured content is called out in a slightly condensed, uppercase sans serif while the textural type and pictorial elements move underneath. Sometimes, the informational type is set in serif italic for variety. As the information being presented segues from one important point to the next, the informational type begins to integrate with its textural background, dissolving or kinetically interacting with the diagrammatic elements as the next important point moves into position.

Matt Tragesser Carnegie Mellon University:
Daniel Boyarski, instructor | *Pittsburgh (PA), USA*

The Phantom Tollbooth Film Titles

This title sequence for a film of the classic children's book is playful, dynamic, and fun. A whimsical sound track provides cues for the movements of the type, which sails around the screen at breakneck speed and communicates the exciting and surreal adventure of the movie, a story about a young boy who drives a toy car through a tollbooth into a magical world of the imagination.

The sequence focuses on a lowercase **m** as a main character whose adventure through the sequence begins by flying through the main title into a world of rich color and kinetic typography. The lowercase **m** joins up with other letters to complete the names of actors and other contributors, moving from name to name on a farcical journey in which words swing wildly into the frame, break apart, rejoin and dance around. Secondary type appears in a casual, hand-drawn script that helps keep separation from the primary bold sans serif of the information. The animation comes full circle as the lowercase **m** returns from its adventure and takes its place in the title, coming to rest center screen in the final frames.

Ben Jurand University of Tenessee at Knoxville: Sarah Lowe, Julie Rabun, instructors | *Knoxville, (TN), USA*

Establishing a visual voice for a client is a serious undertaking; the design solution represents the client's identity and values in public consciousness. Very often, typography forms the basis of such an identity, whether in the form of a letter combination based on the client's name, a symbol that shares space with typographic material, or a wordmark— a custom treatment to the client's corporate signature. The hallmarks of successful typographic branding are simplicity, easy recognition, and memorable form, and, in the case of overall systems, flexibility and ease of use.

TYPOGRAPHY

Visual Identity

IN PRACTICE

Logos and Corporate Identity Systems

Frank Rocholl is a partner in KearneyRocholl—a branding and communications firm in Frankfurt, Germany—recently evolved from Rocholl's already-established studio, Rocholl Projects. His sensitive, yet progressive, typographic branding work for cultural, lifestyle, and corporate clients has garnered numerous industry awards.

What concerns you most when designing with type?
In my opinion, the choice of typeface determines 60 percent of the look of a layout. Somewhere along the way I concluded that it is very hard to do something new with a commonly used typeface, because we are too familiar with it. So I wrote on my office wall: "No more Helvetica or Meta—use your time to do something more interesting!" I feel that very often, popular typefaces are used as homages to iconic designers—a waste of time and energy. I think communication design should find solutions for current visual needs—very hard to realize with tools that are thirty years old. Adrian Frutiger developed [the typeface] Univers as the solution for his needs in the 1960s—not for every design problem.

So I see my approach to typography as involving several activities: mixing familiar typefaces with unknown but interesting ones; extensive research to find obscure, yet interesting, typefaces; and designing signature fonts—for example, my font Nuri—or modifying details in typefaces I like. KearneyRocholl Copytext is a hybrid of two mono-spaced typefaces; we needed a readable text face, so we kerned the whole character set and added a light, an italic, and a bold version.

How do you feel about rules in typographic design?
After thirty years of "anything goes" in graphic design, the phrase "rules in typographic design" reminds me of Jan Tschichold's book, *The New Typography* (1925). I think the basics of layout like informational priorities and the use of grids are so omnipresent that they are a subconscious vocabulary. Typography, in my view, can be a tool for image differentiation between brands. These are the typographic rules I use:

1) Never use more than three different type sizes in one project: 7, 11, and 24 points, for example

2) Give yourself exercises in the use of faces that aren't in your aesthetic—torture yourself. Search for combinations with your favorites, and the look of your new designs will mix your personal style with something fresh and unexpected.

3) Check every sign and ad you see and guess what the typefaces are. Make it a sport. Learn the vocabulary of all market segments from heavy metal to high style fashion typography. Then—avoid clichés at any price!

Describe your approach to designing a typographic logo—how does it differ from designing something like a poster? In logotypes, I like to mix different visual approaches and the recently established look of a company with newer graphic elements that allow me to play around a bit in the applications—like giveaways, bags, etc. For example, I designed the Packard logo with the intention of later die-cutting the folders or stitching the logo in labels. The shapes I used lend themselves to these kinds of applications, and they help distinguish the form of the logo to make it more easily identifiable.

In designing something like a poster, my approach is quite different. Here, my goal is to find a harmonic overall composition, which means the most important element—such as a headline—is accompanied by other elements in a logical way. For example, the deepest color and the lightest color occur in the most interesting typographic areas.

What are your favorite typefaces and why?
I'm partial to my own type family, Nuri, because it's timeless and modern without being invisible like Helvetica. I like a few typefaces from the Dutch Enschede Type Foundry—for example, Trinité, Ruse, and Collis—that have a lot of beautiful details in the character constructions. I'm not a big fan of serif types, but these are special. Maybe I will use one of them before I'm fifty. I also like Fig Script from the Process Type Foundry.

adding:blue Restaurant Branding

The logotype for this restaurant in Japan uses English form and syntax in a simple understatement of form that then becomes the basis for a richly varied graphic identity in the print applications. Set entirely in lowercase, the elegantly defined serif face is a bold weight with a great deal of contrast in the strokes. The serifs are sharply articulated against the curving modulation of the stems and terminals. This sharpness is repeated in the juncture between the bowl and top counter of the lowercase **g,** as well as in its quirky ear. The letters are spaced slightly looser than normal, exaggerating the alternation of positive and negative, setting up a distinctly deliberate cadence. However, the identifying visual kernel is the colon between the two words and this syntactic element defines the entire system.

In the menus, cards, and other ephemera, the colon is repeated in a larger scale that transforms it from mere punctuation into a bold and easily identifiable graphic form. Its relationship to the format and to the other typographic elements changes in every application, as does the colon's formal treatment. Sometimes it is a flat rich blue or articulated with a luminous gradation, while at other times blurred around the edges. The bold nature of the two dots contrasts the delicate, formal nature of the informational type, which is set in the same serif face in a minimum of sizes and weights. The colon appears as die-cuts in the cover of the menu and invitation cards, and is referenced in the small round stickers, as well as in the repeated dots of the blue match heads and the screw-post binding of the menu booklet. A vertical blue bar is introduced for contrast in the wine list, while the proportion of the open matchbook repeats this idea in three dimensions. The informational type is consistently set flush left.

Taku Satoh Design Office | *Tokyo, Japan*

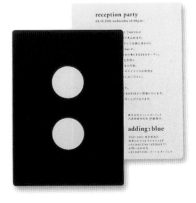

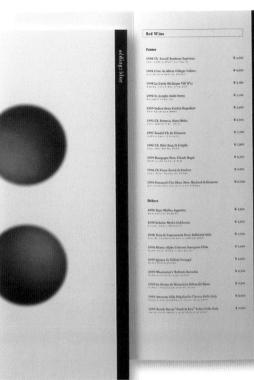

Alice's Wonderland
Brick Church School Auction

This branded system of campaign materials for an auction event based on the story of *Alice in Wonderland* uses type in a pictorial way, calling to mind the surreal journey of Alice after she enters the famous rabbit hole. The primary branding components are photographs of small figurines depicting characters from the story, a rich red, and the systematic use of a curling type configuration referring to the smoke from the Caterpillar's pipe and the swirling tumble down the rabbit hole. Against an otherwise straightforward presentation of information that is set in a schoolbook serif in flush-left alignment, the asymmetrical, curling type configuration for the event title and a call to action adds a playful, yet mysterious, quality to the components of the system. The treatment is flexible; the designer is able to use the idea to set lines of differing length and complexity on different pieces in the set, and scale changes allow the treatment to evolve and interact with the figurine photographs in different ways. By paying careful attention to the weights, sizes, and general shapes of the letters in the words in these curling configurations, the designer is able to create fluid curves in the type despite the irregular shapes of the letters at different sizes. The context of the treatment changes its meaning. Next to a photograph of Alice or the rabbit and a die-cut circle, the type becomes a depiction of the journey down the tunnel. Next to the Mad Hatter, the type becomes the smoke from his pipe.

Lynn Fylak | *New York City (NY), USA*

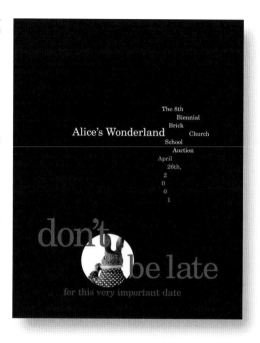

The front of the save-the-date invitation to the event features a die-cut circle offering a glimpse into the rabbit hole; the title of the event undulates seductively toward the image of the rabbit viewable through the hole. The larger type uses the back-and-forth motion of the type in the swirl in a slightly different way, integrating the important phrase "don't be late," which is too short to make curl like the title. Another die-cut invitation features a quiet, mysterious composition. Alice is partially obscured within the die cut; the potential for the curled type *treatment to be very flexible is demonstrated in the much shorter, smaller text reversing out white. It is still clearly the same idea, but the actual shape of the configuration is allowed to change to suit the individual content in each piece.*

Making sure to vary the use of the treatment, the designer avoids tiring the viewer of the idea. Here, the information about the event is set flush left, with clear hierarchic distinctions achieved through scale and color change in the complex paragraph of information. The curled type treatment makes a minimal appearance in the RSVP line at the lower left.

Even longer texts are able to be integrated using the same concept. The distinctly unaligned outline shape of the text in this configuration begins to take on a surreal spatial quality. Separate text components, treated similarly but in different colors, interact with the negative space of the format and the photograph to form a coherent composition.

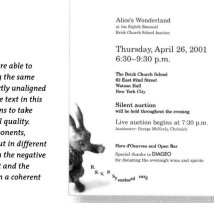

FLUX Restaurant Branding

Picking up on the name of the restaurant, the designers have created a system of endless opportunity, embodied in a pattern of different typographic treatments. Although one particular treatment is used as the signature on items like the menus and napkins, the pattern of logo treatments (all somewhat retro in feeling and calling to mind diners and fast-food eateries of 1930s–1950s America) appears at different scales and cropping on the restaurant entry, in ads, and on the backs of menus. The signature invokes a kind of word play in its more simple treatment. The word "flux" means change, but is similar to another word, flex; the box surrounding the type appears to be doing both. However, the lockup is strong and simple, combining the pattern and more informational text with ease.

Korn Design Denise Korn, Javier Cortés | *Boston (MA), USA*

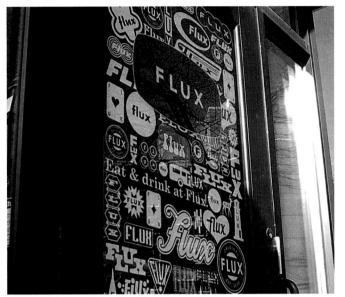

Oracle Mobile

Pure geometry, as a metaphor for wireless technology, informs the typographic presentation and structure for this identity system. The logo, featuring the initial letters of the company name, is drawn using geometric strokes, resulting in a sleek, extended combination of forms. The **M** is drawn with semicircles, instead of diagonal strokes, to formally integrate with the **O**. A system of rectangular spaces, articulated in pale colors and negative spaces, organizes the typography and provides a framework for print materials. The geometric components of the logo itself are used in repetition to create branded imagery for marketing communications.

Templin Brink Design | *San Francisco (CA), USA*

Ariane European Space Agency

An extensive identity system for the European Space
Agency revolves around a custom typeface and letterform-
derived logo, a futuristic lowercase a. The logo is con-
structed out of two geometrically constructed strokes with
sharply cut terminals. The strokes curve around right
angles, feeling as though they are machined out of metal,
and do not actually connect with one another. The sharp
points of the terminals on the bowl create a strong
visual tension against the vertical that optically holds the
form together. Comprehensive manuals lay out the
visual guidelines for using the mark, color, and typography,
which involves not just custom letters derived from the
logo form, but two type families, an extended squared-off
sans serif display face and a text-application sans serif.
Information in the applications takes on the appearance
of engineering diagrams as the result of informational
components being enclosed by or joined by thin-ruled
boxes and lines.

Eggers+Diaper Birgit Eggers, Mark Diaper | *Berlin, Germany*

*The custom display typeface for
the identity uses a grid-based
geometry to construct its letters.*

*Promotional materials for the
Ariane Cup, a boat race spon-
sored by the space agency,
including a poster and racing
rules. In the poster, the connec-
tion between the adventure of
sailing, an ancient travel
method, and the next frontier of*
*space travel, is made through the
imagery. The coloring of the bowl
of the logo a creates a c out of it,
alluding to the title of the event.
The poster title uses the agency's
custom typeface. The rounded
ruled box enclosing the event
dates and information brings*
*engineering diagrams to mind,
and the linear curves are formally
congruent with the curves of the
logo, the rocket, and the sail.*

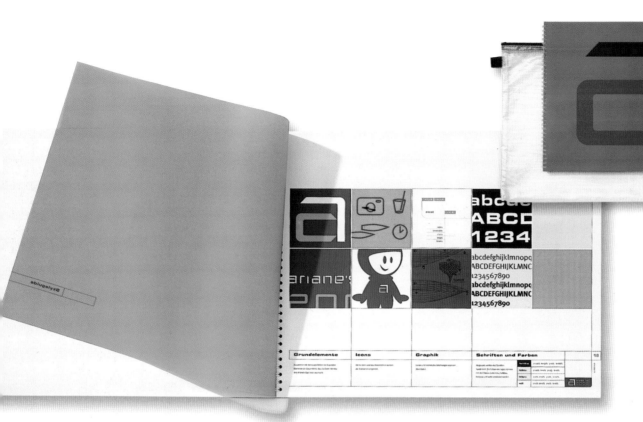

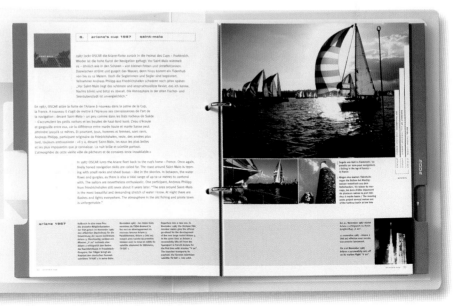

The cover of one of the manuals, with a silvery mesh carrying case, promotes the science-fiction qualities of the identity.

The identity manual illustrates the basic construction of the logo form and provides information about its use, together with color, graphic elements, photography, and typographic styles for a unified communications program.

Typographic Identities Cluster Formations

Clustering forms together creates unique shapes, allows complex names to be visually simplified, and may permit more complicated combinations of form or styles to coexist without competing. In the *Moonwalk* logo, the letterforms are arranged on a grid having no relation to the number of elements in the word. The word breaks and moves backward from line to line and then ends abruptly, creating an unexpected shape but also forcing the viewer to read the logo kinetically and perceive the word in the action it describes. The *Gatto* logo clusters its letters within an overall box, but allows them a freeform composition. The *Sounds French* logo, for a cultural organization that promotes French music, features a clustering of disparate type forms into a square that minimizes their formal variation, allowing the different styles to coexist and interact without competing. The *Musee des Beaux Arts* logo creates a square from the letters as well, but the effect of generously spacing the letters on a grid is a stately cadence of dots. The *TikiTi* logo is a free-form cluster of letters that are different sizes and weights; by clustering the letters, a distinct single image with a kinetic internal rhythm is created.

Gatto
Studio di Progettazione Grafica |
Switzerland *far left*

TikiTi Theatre
Timothy Samara | USA *left*

Sounds French
Philippe Apeloig | France *below, left*

Musée des Beaux Arts Tours
Philippe Apeloig | France *below, middle*

Moonwalk
Fellow Designers | Sweden *below, right*

Museum Moderner Kunst Kärnten

In yet another flexible logo concept, the typographic components of the identity are able to be varied in relation to each other while retaining their essential character. In this case, the individual words of the museum's name, set all uppercase in a sans serif, define the identity in terms of a spatial relationship: they interact in an illusory perspective with each other. Whether the words rotate in perspective toward or away from each other has no bearing on the perception of the identity of the mark. The words are always legible, always reading in the same order, and their dimensionality is the identifying characteristic. The designer carefully considers the alignment relationships between the beginnings and ends of the lines of type so that the exterior shape, as a unit, is always decisive and legible.

Fons Hickmann m23 Chrisina Gräni, Christof Nardin, Simon Gallus, Fons Hickmann | *Berlin, Germany*

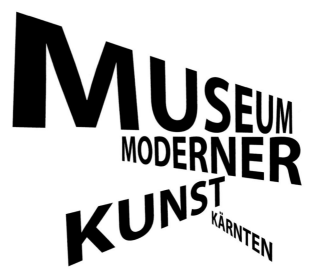

Stephanie Odegaard

The defining element of this identity system for a furniture and textile collection is the logo, composed from a rotating configuration of overlapping script letterforms—the initials of the company's principal. The elegant decorative scrollwork produced by alternating and interlocking the swirled strokes of the script **S** and **O** is appropriate to the collection of furnishings it represents, modern yet classical, decorative, and well made. The logo may be used as a signature or as a supergraphic, enlarged and cropped as it is on the compliment card and the folder cover, so that it begins to disappear into an abstract pattern. Classical small caps and a bold sans serif work together to add texture and contrast to the straightforward arrangements of secondary information.

Ideas on Purpose John Connolly, Darren Namaye, Michelle Marks | *New York City (NY), USA*

Levi's K-1 Dockers Apparel Branding

The typographic branding for this retail apparel line extends from print into the products themselves. A system of early American gothic typefaces—specially drawn sans serifs originally used for newspaper production and advertising—is exploited for its variety of weights and widths: bold, light, condensed, extrabold extended. The choice of family conveys a casual, industrial heritage germane to the American experience. The primary K-1 logotype features the most condensed variation in the typeface. Within any given article—print or product— several of these variations are mixed to create a rich typographic texture. The typography is enhanced with stickers and other details containing diagrams, icons, and support information.

Templin Brink Design | *San Francisco (CA), USA*

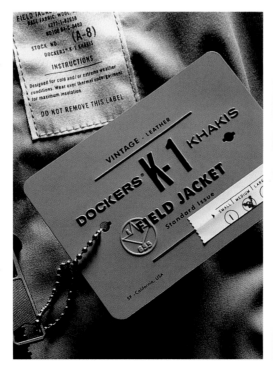

Köln Bonn Airport

The typographic branding for this airport in Germany is dramatically designed to evoke the fun of travel. Its typographic system hinges on a custom-designed sans serif typeface that incorporates a family of graphic icons into the construction of the type itself—the icons, while pictorial, are made up of the same line elements and curves as the letters. They are purposely constructed this way to become an integral part of the typography. Often appearing in the middle of text, the icons replace words or add to the verbal communication through repeating the sense of the language symbolically.

The typeface for the airport system is constructed from a few geometric line elements, much the way optical character recognition alphabets, used by scanners for automated mailing and similar applications, are drawn. This is entirely appropriate, since character recognition on signage in a busy airport is an important and often frustrating aspect of trying to navigate through a terminal when rushing to catch a plane. The typography is constructed with the end user in mind in an attempt to ease the stress of the airport environment. Clearly, this is in tune with the use of the icons, which also appear in applications like signage, as branding elements on planes and products, and on the uniforms of airport personnel.

Intégral Ruedi Baur+Associés | *Paris, France*

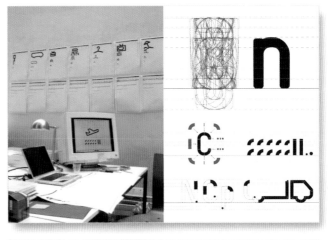

The modular construction of the letterforms is similar to that used to create OCR (optical character recognition) alphabets used by digital scanners. The net effect is an alphabet whose forms are extremely legible. For example, the characters are easily differentiated in rapid reading when racing to find a departure gate in the airport.

The identity manual for the airport details the whimsical use of the custom typeface and its icons, showing them in situ in signage, on the runway, applied to doors and products, and in print applications.

▷ Abflug ▷ Departure

▷ Ankunft ▷ Arrival

▷ Mietauto ▷ Car rental

▷ Taxi

▷ Post ▷ Post office

▷ Gepäck ▷ Luggage

▷ Souvenirs ▷ Shops

The quirky, humorous quality of the icons and type becomes apparent in signage and environmental applications. As the scale of the icons and type increases, their rounded edges and stroke terminals become friendlier, even cartoonish. Oddly, they lend an extremely sophisticated sensibility to environmental applications, despite how fun they appear. Icons used to represent actual objects in the environment, at actual size, add to the whimsy of the system.

Köln Bonn Airport

CGN

Köln Bonn Airport

Köln Bonn Airport

Wolfgang Klapdor
Geschäftsführer
Managing Director

Köln Bonn Airport ✈ 🚗 🧳 ✈

Waldstraße 247, D-51147 Köln, Postfach 98 01 20 D-51129 Köln
Telefon +49 (0) 22 03-40 40 40, Fax +49 (0) 22 03-40 40 44
wolfgang.klapdor@koeln-bonn-airport.de, www.koeln-bonn-airport.de

Werner Falkenhain
Leiter Geschäftsbereich Technik / Umwelt
Business Unit Manager Facilities / Environment

Köln Bonn Airport ✈ 🚗 🧳 ✈

Waldstraße 247, D-51147 Köln, Postfach 98 01 20 D-51129 Köln
Telefon +49 (0) 22 03-40 40 24, Fax +49 (0) 22 03-40 27 73
werner.falkenhain@koeln-bonn-airport.de, www.koeln-bonn-airport.de

*Intranet and Internet sites
continue the evolution of the
identity's visual language,
becoming friendlier in use.
The typography in the Web
applications, however fun,
is eminently clear. Clearly-*
*defined hierarchic grids and
distinctions between buttons
and content allow for efficient
navigation through the reser-
vation and ticketing processes.*

*Airport stationery uses a
number of different layouts,
icon configurations, and color
schemes to keep the print
communications lively and
consistently surprising.*

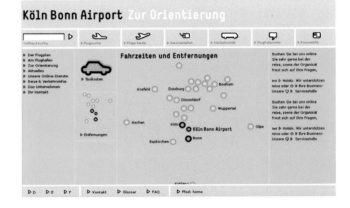

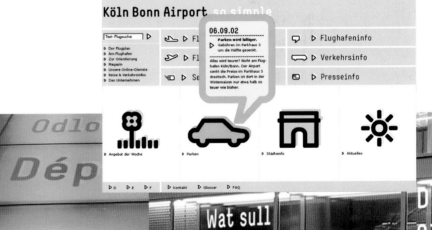

Typographic Identities
Letterform Symbols and Customization

In this grouping of logos, letterforms are either created out of unconventional geometric marks, or they may create a symbolic image through their unconventional drawing or arrangement. In the Lowe Associates mark, for example, a logo for custom builders, the repetition of the Ls creates an architectural cornice or frame symbol. The A3 Architects logo is drawn with modular square forms; the **A** and the **3** are the same form, one simply rotated into an orientation that changes its identity. In the cashmere.com logo, two opposing **C**s interlock by a threadlike device; taken as a whole, the shape becomes an abstracted skein of wool or a knitting stitch. The Vertikal logo uses organic strokes and adds a third element to the drawing of the **V** to create a human figure.

The logos in the second grouping are word sequences, styled in different ways for greater customization or composed of disparate elements to create a complete image. The Hybrid logo is formed from a gridded system of dots whose context allows them to be perceived as letters. The form in this particular case echoes the meaning of the word. In the Avaya logo, the letters are created from strokes whose angles repeat; the gap between the crossbars of the **A**s and their right stems adds to the custom quality of the type. The Indiscipline logo uses a minimum of marks to indicate the letters; the placement of the marks creates a regimental quality to the rhythm within the word. The Hype logo is built from repeated outline forms, so the interior of the forms is reversed from positive. The sense of augmentation in this example also conveys the meaning of the word.

A3 Architects
Markus Moström Design | Sweden
top left

Lowe Associates
stressdesign | USA *top right*

Cashmere.com
Korn Design | Boston *middle*

Vertikal
Creuna Design | Norway *bottom*

Avaya
Templin Brink Design | USA *top left*

Hybrid
Fellow Designers | Sweden *top right*

Indiscipline
Interkool | Germany *middle*

Hype Magazine
Rocholl Projects | Germany *bottom*

Typographic Identities
Illustrative Combinations

The logos in this grouping share illustrative inclusions or combinations with the typography. In certain instances, the type is neutrally integrated with an image form; in others, the drawing of the type itself begins to deviate from the archetype and takes on the qualities of a picture.

In the 118118 logo, the neutral sans serif of the numerals is joined to the outline of a Rolodex card. The Fantastic Fiber logo integrates type forms, drawn to be formally similar to the lines of the image, with a recognizable image in an overall shape. The B&G Sawin logo adds image inclusions to the basic type forms, transforming them into branches. In the Server Habitat logo, a surreal floating roof is joined by neutral typography that allows the image to dominate, but is formally congruent in its angular terminals. Songwriter Records integrates quirky, almost hand-drawn letters with a similarly drawn bird image through formal congruence. In the Destiny Dance logo, the drawing of the **D** begins to unravel from the archetypal structure of the letter; its sinuous, disconnected strokes begin to move and allude to a figure. The Smart Meeting logo places bold sans serif type inside a stylized speech balloon, the outline of which is the same weight as the letterform strokes.

118118
Fellow Designers | Sweden *far left, top*

B&G Sawin
What!design | USA *far left, bottom*

Fantastic Fiber and Fabric Festival
What!design | USA *near left*

Server Habitat
C. Harvey Graphic Design | USA *left*

Songwriter Records
What!design | USA *above*

Destiny Dance
Rule 29 (Justin Ahrens) | USA *far left*

Smart Meeting
Fellow Designers | Sweden *near left*

Bringing typography into the experience of architectural space—whether as signage to help direct visitors around a building—or as an expressive element in an exhibition, affords designers a unique opportunity. By virtue of its scale and presentation through varied media—lighting, fabrication in steel or plastic, wrapping around architectural surfaces— commonly seen typographic form takes on a visceral dimensionality. Designing type to work effectively in space involves a detailed survey of the site to understand where a visitor will come into contact with it. Considering the scale of typographic elements in the context of their locations, as well as other factors such as viewing angle, the effect of light and shadow, and the aspect of flow—how the type leads the visitor from point to point—is especially important. Similar to the use of type in a poster, typography in an environment may be accessed at several levels, from long-distance reading in signs down to the intimate reading level of an informational kiosk.

TYPOGRAPHY
IN PRACTICE

Environmental Type

Signage, Exhibitions, and Architectural Branding

As the principal of Atelier Poisson in Lausanne, Switzerland, Giorgio Pesce (whose name means fish in Italian, as *poisson* does in French) has established a reputation for his quirky and very user-friendly typographic approach to branding and environmental work. Here, he discusses his typographic ideas as they relate to three dimensional design.

Describe your personal approach to typography.

I don't know if my typographic sensibility is different from that of other designers… I pay a lot of attention to the style of the type, what its form says, its legibility, how it will fit into the project. A beautifully designed typeface can become horrible and ridiculous, and an awful one transformed into a sensitive and powerful piece of design. It depends on the context.

What are your greatest concerns when using type— in general and, specifically, when designing an exhibit or other environmental project?

The most important thing is to have the project goal clearly in mind, and make decisions based on that goal. You can be distracted by a beautiful typeface that will turn your design into something very lovely or powerful, but only in a decorative way, and then you've lost your idea. But I'm careful when that happens, because it can give you new ideas! As for designing an exhibit or other environmental project, the concerns are mainly the same as any other kind of project. The difference lays in scale: you know that people will see characters in big and small sizes, so it's important that the type you select works at those different sizes. It's crucial to test the size of the text on the spot: even if you simulate the environment in a photo, you always need to see it at actual scale in the space.

Discuss your approach to typography in designing the exhibit Éspace des Inventions. How did you think about scale? How did you use type to direct people around the exhibition areas?

For that project, I was looking for a font that was, as I said above, legible and beautiful in all sizes, and would fit that project—a scientific space for kids. It had to be rigorous but friendly, and not childish. I chose Interstate because it has the simplicity of faces used in scientific manuals, but with more rounded forms. With signage, the most important thing is to find the locations where text will be seen most clearly, and then develop a logic of scale for messages at each level. For example, a small size for door numbers or names, a medium size for directional signs, and a big size for main messages to be seen from a long distance. From a conceptual standpoint, we decided to also include scientific captions at a very small size on many different hidden locations. It's a game for the kids who discover one and try to find the others. It's always important for me to add something unexpected—that's what connects with the public.

Are there any rules in typography that you feel should never be broken?

Everything is always linked to context. For me, anything gratuitous has to be avoided during the creative process—when it comes to typography I never choose a typeface without having a reason. Legibility is an important consideration, especially for texts. But I hate projects where you can feel that the designer's main concern is about arranging all the elements on the page so that the final layout is just cute, cool, and avant-garde, without any consideration for legibility or clarity for the reader.

What inspires you in terms of typography? |

Everything inspires me, especially traveling around the world and seeing images and type in different cultures. The work of other designers is also important—seeing how taste evolves—but the inspiration I get from things I am curious about, or see all the time, is much greater. Politics, sciences, press (good or very bad), techniques, crafts, toys, art, literature, TV, music, watching people— everything is good. Antique fairs are places where I can find a lot of all that.

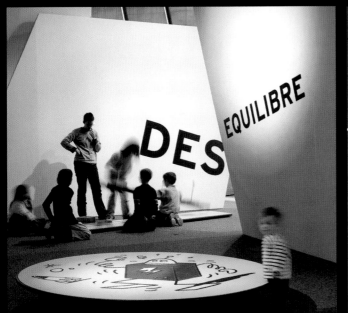

Pushing the Envelope: The Art of
the Postage Stamp

This elegantly conceived exhibit of postage stamp art uses a sophisticated typographic language that carries distinct messages without competing against the exhibited material. A warm, neutral palette acts as a backdrop for display cases and wall-mounted podiums, which are relatively bright within the overall space. Between these two values, the typography used on the gallery walls occupies a third level of contrast, bright enough to be noticed yet subtle enough to sit back out of the way once acknowledged. There are many details and references to the subject matter and related context. In the entry gallery, a central kiosk holds the exhibit title within a rectangular format, which is perforated around its edges similar to a stamp. The typeface, a hybrid sans serif with specific serif qualities, shows characteristics of a typewritten telegram or postal note. The spacing is deliberately loose, as though created by the undifferentiated keystrokes of a typewriter. The forms are a relatively light, uniform weight and sometimes exhibit a slab serif, qualities also associated with the type created through this obsolete technology. The effect is both industrial and elegant.

On the walls, a restrained sans serif carries quotations that create linear motion around the room. Their attributions appear above, flush left, in a smaller italic version of the title font used as the primary information type throughout the galleries. A bold version of this face is used to identify categories of study, housed in a dimensional repeat of the stamp frame from the kiosk. On the wall-mounted podiums and within the display cases, a simple two-column structure carries specific information. The left column denotes attribution and specifications for a given work while the right column carries the descriptive text. A change in alignment and a drop in hangline between the two columns enlivens the composition of these informational materials without creating a distraction.

Poulin+Morris L. Richard Poulin, Jonathan Posnett |
New York City (NY), USA

Subtle formal details carry the brunt of the messaging in the entry-gallery kiosk. The idea of pushing and pulling is quietly conveyed through the dimensional treatment of the title. The perforated edge of the format creates just enough texture to be interesting and relates to the colon between the title and subtitle. The chosen typeface is reminiscent of typewriter forms.

Wall-mounted podiums are canted at an angle to improve reading and refer to the lecterns sometimes found in nineteenth-century American post offices. The two-column structure, flushing right in the first column and left in the second, presents the type in a clear hierarchy through weight and size change. The right flush is appropriate for short amounts of text and contrasts here with the flush-left description. The change in hangline between the columns creates more play across the central axis of the column gutter.

The running quotes on the gallery walls near the ceiling are noticeable but restrained. It is relatively bright compared to the value of the walls, but the combination of light face and size make the running quotes more subtle. The placement around the upper part of the walls refers to the lofty statements about postal work that typically appear in American post offices, running around the cornices and moldings of the architecture: "Neither rain, nor snow, nor dead of night will keep us from our appointed rounds."

Urban Art Commission Window Signage

This designer makes dramatic use of a single typeface by varying the scale and spacing of the typographic elements in the composition. Around the base of the windows at the site, a corner building with two façades, enormous letterforms carry a simple message: *Create. Design. Make a mark that will last*. The type wraps around the corner, joining both axes of the façade into a coherent whole. Around the main phrase, in a much smaller scale setting, questions about the role of the architect and the public travel across the windows, inviting a public discourse on urban planning. Red bars, an element added on-site after the initial layout was approved, highlight specific questions and create a rhythmic motion of broken lines that occupy a third informational level.

Option-D David Thompson | *Memphis (TN), USA*

9'2" / 2.8 m

create

urbanartcomm | ssionamericani

6'3" / 1.9 m

1.75" / 4.4 cm

6'3" / 1.9 m

66 Restaurant Branding Signage

In trademark restraint, the designers of the typographic branding for an Asian restaurant in New York elected to keep the designed elements to a bare minimum. The use of a single red color and an alternation of Roman and Chinese characters creates a subtle progression from Western to Eastern upon entering the space. The first typography encountered is the restaurant name (and its street address), **66,** set in a light-weight sans serif in vivid red. Walking through the doors, a discreet vertical alignment of Chinese characters, etched in gold in the marble wall to the left of the entry, becomes apparent. Viewing the Chinese characters through the door as it opens momentarily joins them with the sleek sans serif type. Leaving the doors behind, only the Chinese is left of the visible typography, until the main dining space is entered. Here, amid a starkly modern white and black environment, a series of vivid red banners displaying Chinese again welcomes the clientele; the transition from Western outside world to Asian interior experience is complete.

Piscatello Design Centre Rocco Piscatello |
New York City (NY), USA

Stairway Mural New York Public Library
for the Performing Arts

Simple and dramatic arrangements of large-scale type create a mural on the walls around a staircase for a library in New York. The type represents the names of famous performing artists, from musicians to dancers and actors, and runs along the walls, beginning at the floor and extending upward to the ceilings. The choice of Times Roman, a typeface associated with journalism, casts a literary and historical perspective on the names as context and source for the existence of the library. The type is arranged in linear rhythms whose movement is dependent on the interrelationship of size; smaller lines contrast with large forms that become almost architectural in scale. The scale changes create a sense of spatial depth and a continual refocusing between line and individual character. Seen from a distance, the letterforms and their linear movement offer a counterpoint to the industrial hardware of the staircase banister.

Poulin+Morris L. Richard Poulin, Brian Brindisi |
New York City (NY), USA

Contrast between the typographic structures of different walls corresponds to a change in wall color. The light walls use larger type overall, with individual linear groupings that seem to float around the larger-scale type. On the dark walls, continuous ribbons of type in regular intervals create a striped pattern that flattens the wall out but allows the large names to come forward, connecting these elements between walls of different color. To enhance the linear stripe effect on the dark walls, the type is set in uppercase so the lines hold together.

Geelong Gallery

An austere grid of letterforms creates an elegant branding statement for an Australian art gallery. The name of the establishment, Geelong Gallery, is set in widely spaced uppercase serif letters to conform to a square grid of points. As the name Geelong runs out in the first line, the second word of the name, Gallery, begins, but runs vertically down the right edge of the matrix. The interaction of right-reading and vertical-reading letters creates a subtle twist in the pattern. The letters are fabricated from extruded steel and mounted a few inches out from the wall. The contrast between the polished sheen of the metal letters and the matte paint of the wall, as well as the interaction of light and shadows cast by the three-dimensional forms, play a role in creating a complex visual experience of the typography.

Gollings+Pidgeon | *St. Kilda, Australia*

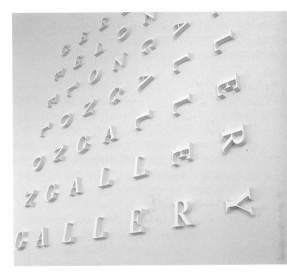

Symphony Space

For a performance venue in New York City, the designer opted for a casual, friendly typographic system that was brought to an unexpected level of sophistication through lighting and surface treatment. The Symphony Space typography is set primarily all lowercase, in a very rounded, somewhat extended sans serif that is light, elegant, and comfortable. The forms are generously spaced, reflecting the internal rhythm of the large counters in the letters. The simplicity is transformed by innovative lighting techniques on the marquee and box office façades, where the back-lit letters appear almost neon. Compositions of words running horizontally and vertically frame the box office windows and tower, also lit from within the walls. On the steel entry doors to the venue, the typography is set in an extremely large scale, dissolving at close quarters into a pattern of curves and lines; their matte finish contrasts subtly with the polished surface of the doors.

Pentagram Paula Scher, partner | *New York City (NY), USA*

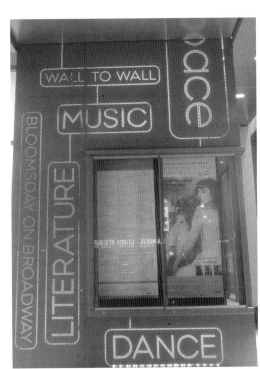

Salt Lake City Public Library

Appropriately, a sleek typographic system for branding and signage brings sophistication and style to the environment for this public library. The selection of a simple, light-weight sans serif typeface for logo and signage focuses on the integrity of the written word with minimal embellishment. In the library's logo, the typographic element is set in upper- and lowercase, the rounded forms contrasting with the clean linear geometry of a stylized translation of book spines. The signage uses the same uppercase face set generously spaced for a quiet, stately presentation. The primary informational word in a sign is set in shallow, three-dimensional white letters against a brushed steel plate, visually separating the word from its background just enough to be legible; additional letters are cropped and cut out of the edges of the sign formats, creating an understated decorative border. Words related to literature and reading adorn the tops of tall glass partitions in the main space, their caplines cropped elegantly by the top edge of the glass plates.

Pentagram Michael Gericke, partner |
New York City (NY), USA | Photos: Peter Mauss/Esto

Hanging and wall-mounted signs follow a similar logic: the informational word is set three-dimensionally in white against the brush steel of the facia, another subtle contrast in form and texture. Around the edges of the steel facia, additional letterforms are cropped and cut to create a linear textural pattern.

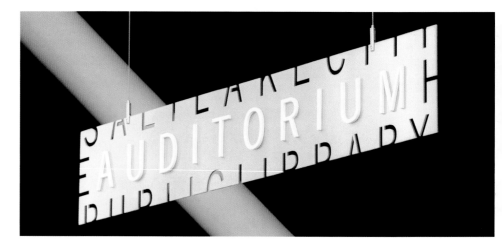

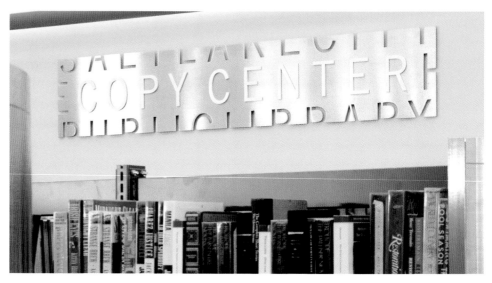

The library's symbol and logotype is a study in the subtle contrast of geometry and organic, rounded lowercase forms. Exterior and interior applications make use of contrasting materials—stone and steel, for example.

Neutrally colored uppercase words, cropped by the top edge of glass partitions, continue the logic of the hanging signs, as well as the subtle interplay of contrasts: in this case, opacity and transparency.

Designing a serial publication, such as a magazine or newspaper, places distinct burdens
on the typographic designer. The structure of a publication is integral to its functionality.
The publication's grid has to be flexible enough to accommodate different kinds of content—
short texts, long texts, complex texts, images, captions, or advertising. Some content will
reoccur from issue to issue—newspaper sections or magazine departments—and needs to
be identifiable as different from that which changes—feature articles or special sections.
Especially when it comes to magazines that focus on fashion, culture, or lifestyle subjects, the
need for flexibility is extreme, given the transitory nature of the subject. A well-designed
magazine will present generations of art directors with opportunities for exploration without
giving up the magazine's recognizable branded structure. Typeface selection and the way
the typefaces are used to differentiate information are two of the most important branding
features of a publication. Even a black-and-white publication will be easily recognized for
its typographic language.

Publications

Newspapers, Magazines, and Newsletters

Michael Ian Kaye is a creative director at AR Media in New York City, an advertising and communications firm with clients in the publishing, art, fashion, and consumer product industries. His reputation as a skilled typographer developed during his tenure as art director at Little, Brown Publishers and before that at Penguin books, where he designed book interiors. Here he focuses his attention on the design of editorial projects.

Describe your approach to designing with typography.
I really try to use an analytical approach where the client's needs drive the project stylistically. I strive to leave my personal hand out, to be as invisible as possible. I don't see the process as being about me.

What's important to you in designing a magazine or other publication? I think the goal for a magazine is to never have to be redesigned; it should have a style that is timeless, so it can stay around and evolve. Flexibility is important so that the style can evolve based on the content and how it has to speak.

Describe the concept behind the typographic texture of *Influence.* Editorially, it was conceived of as a magazine with no beginning and no end, yet I know that readers look for visual clues as to where to enter and exit a given

text. The concept had to resolve these two things, so I developed a type language that could vary drastically yet texturally feel the same—the reader would feel a difference as one story gave way to the next. Changes in contrast and in the use of space become signals. The type choices had to be flexible to convey a breadth of emotions but limited so that the whole felt unified. The integrity of the type was essential; we used specific cuts of Caslon and Univers. Integrity to me is about a good cut: about line weights and how the letters work together. By using a number of column structures we could enhance the feeling of difference between texts, but the texture is made the same in all column widths through changes in type size and spacing. The design also had to address the fact that a large portion of the content would be dialogue. To avoid awkward spacing issues, there are no paragraph breaks; the speakers' texts run into each other, signaled by their initials. It speaks to the fluidity of conversation.

What was the concept behind the *Influence* masthead?
I was trying to achieve a literary, authoritative identity that felt timeless, informed, and educated. The idea of the fl ligature spoke not only to typographic craft but also to the idea of connectivity, one thing moving into the next. For these reasons, I used Caslon, but especially because of the ligature. I discarded a different iteration in another typeface once I saw the ligature in Caslon.

What do you think about rules in typography?
There are exceptions to every rule, depending on who's driving the typography and how the concept enters into the communication. You can't break the rules until you know what you're sacrificing or gaining based on the decisions you make. What troubles me is misuse from an uninformed point of view.

Fitréttir Newsletter
Icelandic Association of Graphic Designers

In this design for a design industry newsletter, elegantly
detailed typefaces and structure share equal ground
with simple, humorous configurations that celebrate
designing with type. The logotype sets up a juxtaposition
of seriousness and fun. A beautifully spaced lockup of
Bodoni—spare, quiet, and credible—is given a twist: two
of the syllables in the configuration have been reversed
in their direction, relative to the other. "Fit" is oriented
upside-down to "réttir," to share the same baseline and
meanline. The flip almost goes unnoticed because of the
careful attention paid to the spacing of the characters,
as well as their vertical orientation. Both parts read
up and down, so the fact that they have been reversed
is likely to be overlooked.

The newsletter pages continue the opposition of serious
and humorous. Delicately spaced lines of type, paragraphs,
and elements share space with quirky pictorializations
and abstract shapes that one might assume have an
Icelandic character. Sometimes, the type leaves conven-
tional arrangement to play among columns that have
been broken, shifted, and separated by enormous letter-
forms and line elements. Large expanses of color hold the
compositions together and play with the nature of the
typographic space, sometimes receding into the distance
or flattening out the pages in cutouts of deep, flat hue.

Einar Gylfason | *Reykjavik, Iceland*

*The interplay of large and small
scale, structure and violation,
continues on an inside spread
(above right). The remnants of a
column structure interact with
an enormous H on a block of
color; textural contrasts help the
eye move about the composition.*

*The cover of one edition (near
right) plays with the viewer's
sense of foreground and back-
ground, texture and line—and
legibility.*

*Forms reminiscent of natural
shapes such as deer horns or tree
branches cut into the column
structure of another cover (far
right). A step back reveals its
hidden identity: it is a gigantic,
deconstructed capital F whose
shape is almost that of a black-
letter or engraver's capital.*

Dagen Newspaper

The striking layout of this Danish newspaper owes its visual impact to a dramatic use of typographic color. A family of sans serif News Gothics faces, in a number of sizes, weights, and widths, permits a wide range of bold, linear texture, while retaining a clearly unified feeling. The majority of the headlines and subheadings are set all uppercase, with each line justified to those above and below. Clear hierarchic distinctions within subheadings is achieved through the contrast of bold and regular weights.

The paper follows a hierarchic compound five-column/six-column grid. Flowlines denote major content areas, creating a sense of horizontal bands that are clearly marked by a visual change in scale or structure. The use of the columns within each area may change for different purposes. In the heading area at top, for example, the six-column grid is used, but images and headings span two columns each, creating a narrow band of three apparent columns. The primary headline area uses the five-column grid, and the lower area with a secondary story returns to the six-column.

E-Types | *Copenhagen, Denmark*

J | DAGEN

TORSDAG | 24.10.2002 | No.003 | PRIS: 15 KRONER
www.dagen.dk · Mutari in dies

| Politik **A6** | **MORTEN KORCHS FORSAMLINGSHUS** Stop den snak om spindoctorer | Økonomi **A12** | **PROZAC VIAGRA OG LOSEC** Vi bliver rigere, men mere triste | Global **A2** | **FORFÆNGELIG OG BEREGNENDE** Osama lever |

Europa | Thomas Lauritzen, Bruxelles

UDVIDELSE

Anders Fogh Rasmussens store europæiske udfordring

CHIRAC
KAN IKKE SE EN KO
UDEN AT KLAPPE DEN BAGI

Frankrig mangler vilje til at ændre på EUs landbrugsstøtte forud for dagens topmøde om østudvidelsen

Leder **A8**

→ **"Hver er du heldig at have en mand som mig,"** siger Jacques Chirac hver morgen på badeværelset i Elyséepalæet, har ham hustru benadærte fortalt. Selvtilliden hos Frankrigs præsident fejler ikke noget, men der er efterhånden mange andre europæiske ledere, som næppe finder det specielt heldigt at have en mand som Chirac i Den Europæiske Union lige nu.

To ting går altid igen i beskrivelserne af den fantastisk adrætte politiker Jacques Chirac: At han er en charmør, og at han elsker landbruget. "Manden kan ikke se en ko uden at klappe den i roven," sagde en EU-kommissær for nylig. En anden europæ-

isk topleder har i en afslappet stund sagt om den franske præsident: "Det eneste, han er mere besat af end sex, er koer."

Selvom Jacques Chirac fylder 70 år om godt en måned, er hans forbrug af kvinder stadig legendarisk.

Det er dog tvivlsomt, om paristernes charme bider på den tyske kansler, Gerhard Schröder, når de to i tobet af dagen i dag mødes i et forsøg på at finde et kompromis, der kan gøre de næste par dags EU-topmøde en chance for at lykkes.

Den tyske forbundskansler har ikke glemt, hvordan Chirac snød ham for en grundig reform af unionens bekostelige

landbrugsordninger på et topmøde i Berlin i 1999. Gerhard Schröder husker også kun alt for godt, hvordan han måtte sluge en natlig studehandel om magten i EUs institutioner året efter i Nice.

Der er flere af de største sække med EU-milliarder i spil, når de 15 landes stats- og regeringsledere over en middag i aften tager hul på slagsmålet om, hvor mange penge der forventede til nye medlemslande skal have efter udvidelsen mod øst. Men det helt afgørende er, om Frankrig og Tyskland kan blive enige om landbrugsstøtten. Og om statsminister Anders Fogh Rasmussen

kan få den aftale forvandlet til et kompromis mellem alle EU-landene.

I årtier har Tyskland været langt den største betaler til den landbrugsstøtte, som især franske landmænd tjener mange penge på. Men nu vil Gerhard Schröder have sin reform - eller i hvert fald meget detaljerede løfter om den - før ikke at skulle underskrive en blankocheck til millioner af småbønder i Central- og Østeuropa.

Her er det bare, at Jacques Chiracs glødende interesse for landbrug står i vejen. Blandt diplomater i Bruxelles bliver den franske præsident ofte sarkastisk omtalt som "landbrugseksperten", fordi han kon-

sekvent blander sig i det område med henvisning til sin tid som landbrugsminister i 1970erne. Godt nok er det næsten 30 år siden, men Chiracs fine fornemmelse for republikkens folkedyb har sørget for, at han aldrig har glemt at tage sig af koerne. vinen og den rustikke camembert. Han går aldrig glip af de kæmpestore, årlige landbrugsmesser i Frankrig, hvor man altid kan se ham portrætteret i selskab med et prægtigt stykke kvæg.

Jacques Chirac ved, hvor stor en magt den franske landbrugslobby har, og han har altid spillet effektivt på den. Derfor er det

Fortsætter · A4

INTERVIEW

Telebranchen | Sune Aagaard

DYREMOSES PERLE SAT TIL SALG

Trods prædikater som stokkonservativ og dumdristig er TDC nu blevet et attraktivt salgsobjekt for den amerikanske ejer

På hjørnekontoret i Nørregade i Kobenhavns indre by sidder Henning Dyremose, TDCs koncernchef, og pudser en perle. Perlen er TDC, og den skal være blankpoleret, for telekoncernen skal sælges.

TDC passer ikke længere ind i den globale strategi for ejeren, det amerikanske teleselskab SBC Communications, der er verdens fjerdestørste. SBC har droppet sine ambitioner om at være en global storspiller. En strategi, der blev betragtet som uomgængelig for de største aktorer, da

telehypen var på sit højeste for to-tre år siden.

SBC har solgt ud af sine aktiviteter i Ungarn, Schweiz og Norge og er nu også definitivt på vej ud af Frankrig.

I dag står Henning Dyremose i spidsen for et selskab, der har klaret branchens nedtur langt bedre end de fleste.

Selvom aktiekursen er faldet til blot et femtedel af værdien i foråret 2000, står TDC bedre rustet til fremtiden end konkurrenterne,

blandt andet takket være in investeringspolitik, der skiftevis er kaldt stokkonservativ og dumdristig, men som har båret TDC fornuftigt gennem branchens ekstreme turbulens i de seneste par år. Og det er i hvert fald en del af anledningen til, at Henning Dyremose nu for forste gang melder klart ud, at TDC skal sælges.

"SBC kan se på os som en lille, velfungerende perle, de kan pudse og pleje, indtil de kan få nok for den.

For SBC er ikke et selskab med en offensiv europæisk strategi," siger Henning Dyremose og ser ikke ud som om han har b200 TDC formætligt gennem kymnet ud ved tanken om en ejerskifte.

Situationen er et paradoksal for TDC. Selskabet tjener penge og betragtes af analytikere som veldrevet. Gældsætningen er beskeden sammenlignet med konkurrenternes, og TDC er på mindst to afgørende områder et særdeles moderne teleselskab: Dels er TDC en af de gamle, nationale telesel-

skaber, der er totalt privatiseret. Dels betaler TDC hele 55 procent af sin omsætning uden for oprindelseslandets grænser og har altså realiseret branchens ambitioner om internationalisering i højere grad end de andre gamle nationale teleselskaber.

En lækkerbisken, med andre ord, og gearet til fremtiden. Men foreløbig pudser Henning Dyremose på sin perle uden at have nogen at vise den frem til. Der er reelt ingen

kobere til TDC. Spørgsmålet er så, hvor længe Henning Dyremose behøver at vente på en kober. Den mest oplagte er Deutsche Telekom, og Henning Dyremose er ikke blind for de forretningsmæssige gevinster ved et sådant salg.

"Der ville være bunker af industriel logik for Deutsche Telekom i at kobe os. Vi passer fint ind i deres forretning," siger han.

Fortsætter · A13

INDEX

30 timer bag kulissen
Vi tegner et sjældent nærbillede af de hårde forhandlinger mellem unionens ministre og embedsmand - og af en kvinde fra Hirtshals, der ikke finder sig i ret meget.
Dagsorden **B8**

Tyske luftkasteller
65 år efter Hindenburg-ulykken vil tyskerne bygge verdens største luftskib. CargoLifter hedder firmaet, der drommer om flyvende kraner med en konkurs i horisonten
Kultur **B1**

J | DAGEN
Kanonbådsvej 8 · 1437 København K
Løssalg: DKK 15,00 · € 2,00

Bibliotech Newsletter

A simple, elegant design for a university's library newsletter incorporates a stately typographic masthead and quiet serif text in a two-column structure. Set in two distinct widths, text in the wide column is used for article introductions and running text, while in the narrow column it is used for callout information or textually different material, like interviews. Sometimes, the running text of a single story will span both columns, jogging back and forth between the two alignments to accommodate images or simply for compositional variation. A horizontal band bleeding the top of the format carries the color for that edition of the newsletter from the cover into the text spreads. The text hangs from two points—an article title from the top hangline, followed by the running text from the second when the story begins; the text continues into subsequent columns from the top hangline.

Korn Design Denise Korn, Ruth Boerger | *Boston (MA), USA*

Dictionary-influenced typographic treatment, with syllabic breaks, diacritical marks, and syntactic substitution of letters with phonetic symbols, creates a literary elegance in the newsletter masthead (left).

The cover is printed with a flat bleed of color, from which the contents are reversed out in a deconstructed version of Bodoni called Filosophia that mixes upper- and lowercase forms.

Each edition is produced in two colors—the masthead color, a rich burgundy red, is constant; the second color changes with each issue.

The varied widths of the columns on the text pages (above) allows for different kinds of content to be distinguished from running text, images, and compositional variety among the pages.

Die Rote Fabrik Newspaper

This newspaper makes use of a new font, Newut (see pages 116–117 in Typeface Design), also by the same designer as the paper. A three-column grid is used in a powerfully graphic way, with text allowed to start and stop in columns to bring great rectangles of the page's negative space into the text areas. Images and graphic symbols, large-scale typographic compositions that are sometimes article titles and sometimes illustrative, create a visually aggressive black-and-white environment.

André Baldinger Conception Visuelle | *Zürich, Switzerland*

Text primarily runs in three columns, but on occasion, it is allowed to leave this structure to be arranged as the designer sees fit in support of the article or to vary the pacing from spread to spread.

Enormous inclusions of negative space interact with the text structure, providing an almost architectural quality to the pages. The alternation of mass and void directs the eye around the page spreads and allows supporting graphic elements, both illustrative and typographic, to participate on equal footing with the text.

The cover features enormous typographic branding and bold iconic shapes to create a dramatic street presence.

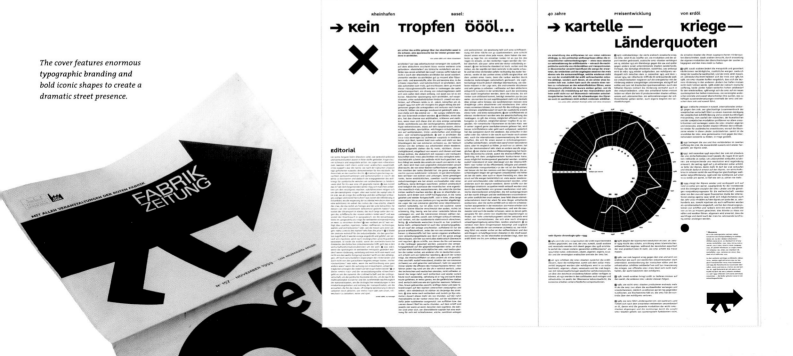

Japanese and Swiss Typography
Edition of *Typographische Monatsblätter*
[*Swiss Typographic Review*]

This edition of the *Swiss Typographic Review* uses an asymmetrical four-column grid. The first column is used mainly as a margin but also for text callouts. The second column, for the primary text in German, is wider than the others. The third and fourth columns contain the Japanese and English text, respectively. All the text is set in a neutral sans serif typeface, but at slightly different sizes. The English text is smaller than the German. The Japanese appears slightly larger than either of the roman texts—its characters occupy the full body height—but its stroke weight is roughly the same. Within the roman texts, size change is used as a titling device, with bold for subheads after a proportional return between paragraphs. Text falls from a hangline near the top of the format and runs out naturally, creating an organic up-and-down rhythm across the pages. Vertical images occupy the second column, where depth is the dominant feature; horizontal images occupy the two remaining columns. Captions align left with images at the beginnings of their respective columns.

Helmut Schmid | *Suita-shi Osaka-Fu, Japan*

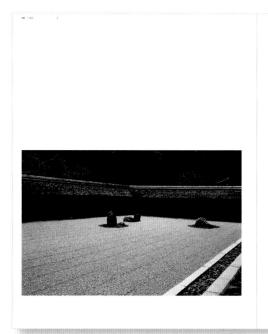

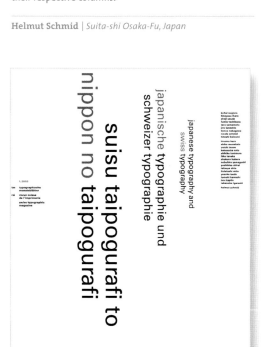

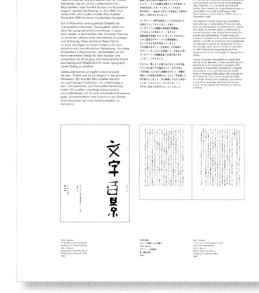

ESPN College Football Preview Magazine

Bold typography integrated with photography and bright primary colors lends a playful, sporty edge to this editorial section devoted to American collegiate football. A selection of geometric typefaces, sans serifs, and typographic details are mixed and matched as needed. No grid is apparent, although paragraphs of text, set justified, seem to find the right places to go based on their size, shape, and the elements around them. Abstract shapes and icons in flat color provide visual counterpoint to the photographs, and the compositions overall are spontaneous and kinetic, with elements crossing the gutter to unify two pages in a spread.

Stereotype Design Barbara Reyes, Peter Yates;
Photo illustration: Phil Mucci | *New York City (NY), USA*

A full-bleed photograph on the right page is joined to the flat-colored left page by abstract shapes that start as yard lines on the field in the image. The geometric uppercase headline spreads across the left page, *overlayed by lines that echo those of the bleachers. Arrows direct the reader to the entry-point of the text, a justified paragraph set toward the lower right of the left page.*

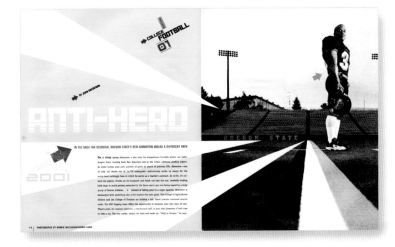

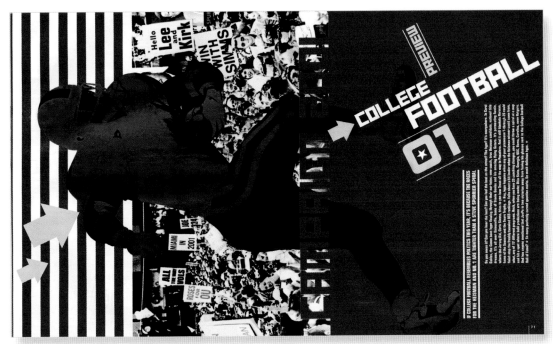

The section opener sets up the overall visual language, introducing a diagonal lockup of geometric capitals, heavy rules, arrows, stripes, and an unconventional sense for laying out photographs. The paragraphs to the right run vertically, participating with the rotated photograph and stripes to create an up-and-down rhythm.

Wire Magazine

This music and lifestyle magazine makes use of boldly scaled headlines and unusual compositional structures to communicate its hip vantage point as a journal of popular culture. These layout strategies change as the magazine evolves, continually refreshing the look of the periodical from year to year. Feature articles open with dramatic full-spread compositions of image and type, while departments follow a standard four-column modular grid using a modernist sans serif.

Non-Format Kjell Ekhorn, Jon Forss |
London, United Kingdom

Covers for Wire *feature a full-bleed photograph in conjunction with a statically located masthead, in black-weight sans serif capitals.*

The table of contents, nonfeature articles, and department pages are structured on a four-column modular grid. The type family is Helvetica, used in various weights.

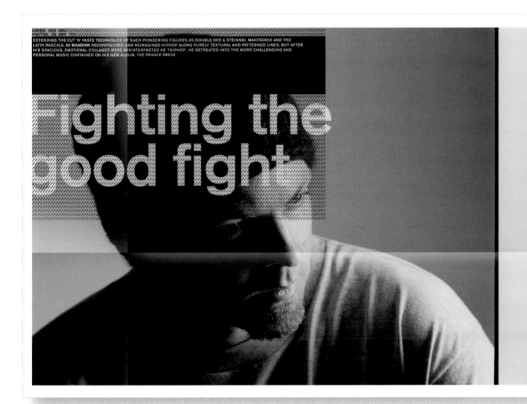

The typographic styling for features changes from volume to volume, keeping the magazine as hip as possible.

One treatment for feature titles involves overlapping it on the image or translucent rectangles; another creates compact rectangles of information that are based on product hangtags, bank machine receipts, stickers, tickets, and other ephemera. Yet another sets a photograph off-grid against bold sans serif titling that crosses the boundary of the image and interacts with graphic linear inclusions of dirt and scribbles.

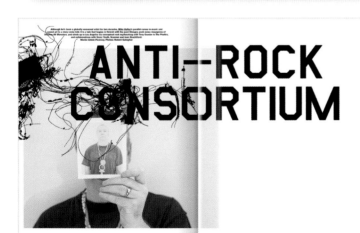

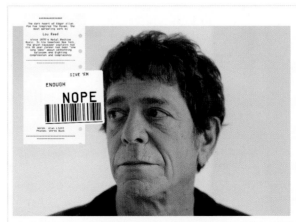

The design of packaging brings the two extremes of typography's dual nature into sharp focus. In this context, typography must fulfill its utilitarian function, indicating the contents of a package and informing a buyer about ingredients, proper uses, and so on. But "shelf appeal" is also of paramount importance. The typography of packaging is almost always geared to selling, and nuances of color and treatment subtly encourage the consumer to buy one package over another. Even considering the necessity of difference, the design of packaging follows conventions within its particular domain—cosmetics vs. wine and spirits vs. golf balls. The shape of the package plays a role, governed by production and, in turn, governing potential treatments. Packaging clearly bears the visual stamp of its surrounding culture. European food packages seem relatively reserved, both in their typography and imagery—pictures of the contents accompany direct, almost documentary, typography. In comparison, American packaging is glitzy, with extravagant type treatments and almost frenetic layout. Asian packaging alternates between the serene and the wildly expressive.

TYPOGRAPHY

Packaging

IN PRACTICE

Taku Satoh is widely regarded as a specialist in packaging design. Based in Tokyo, his office is routinely commissioned to package a variety of products—from cosmetics to food and spirits to housewares—in addition to other commissions for identities and posters. His packaging designs are minimalist and detailed, focusing on typographic nuance, color, and fabrication. Here, he discusses working with typography as it relates to packaging.

How would you describe your approach to typography, and what distinguishes it from that of other designers? My personal approach is purely trying to accurately express information to be conveyed. I do not focus on specific character styles or typefaces; they evolve, and my standards also change. I want to always control myself so that I can accept these changes. I want to think with a clean slate every time I handle typography. At least, I try to do so. What I really want to avoid is forcing a personal style on viewers. The difference between other designers and myself may be my consistency in this attitude. As such, my design does not show if I was involved or not. In terms of packaging, I concentrate on trying to design typography that expresses the content. And for characters that correspond to the branding, I always create original characters unique to the product, because this creates individuality for the product that will quickly distinguish it from anything else.

How does designing with typography for packaging differ from designing with type for a book or a poster? I think a package and a book are more similar, compared with a poster, in terms of being a product people pick up and hold. With type, however, the difference between a food-related package and a package for some other kind of product is much greater than the difference between a package and a book. In Japan, the key for successful food-related packaging is to make the consumer salivate. Consumers won't pick up just any pretty food package with a modern design. In this regard, bottles, etc., for cosmetics, can be in any form, as long as they are beautiful. I think, therefore, that typographic design for food products is naturally much more difficult.

Talk a little bit about the challenges of working with typography for a Japanese audience, as opposed to a Western audience. In Japan, the number of people who can understand foreign languages is unusually small compared with other nations. Nonetheless, various character sets—and foreign characters—are used, which is not often seen in other countries. In the Japanese language, hiragana, katakana, Chinese characters, and English numbers are often mixed in a sentence. It may appear strange for consumers in countries that use only uniform characters, and designing of Japanese characters may look very difficult. Japanese people, who understand these respective characters, use them according to specific information. Skillful use of this aspect of typography is required in Japanese graphic design.

What inspires you in terms of typography? Everyday life inspires me. I can learn many things from the ordinary environment. By carefully observing not just special things, but ordinary things, I can find unlimited possibilities for designing with typography. Characters themselves are constantly changing, depending on materials, light, space, shade, and other factors, and provide endless possibilities.

What is your favorite typeface and why? My favorite type forms come from Asian calligraphy. The reason is that I can never design such characters, no matter how much I study. Asian calligraphy must appear the same to Westerners —complex, perfect, unattainable.

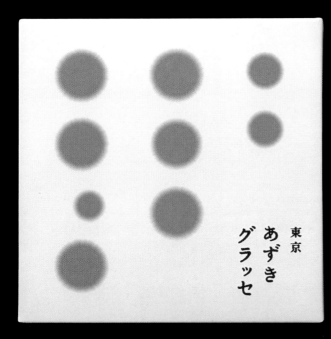

Frost Malt Beverage Bottling

Distinguishing itself from the confusing and overly decorative labels associated with beers and malt liquors, the typography of the Frost bottle makes a forceful statement without trying too hard. A single typeface, in a single weight, has been silk-screened onto the surface of the glass, resulting in a clean, crisp presentation. The choice of typeface and its treatment convey a chilly, refreshing message. A condensed sans serif as a base form helps convey the frozen quality of compacted ice. An illustrative reference to ice or crystals deforms the letters slightly but leaves their legibility intact. At a quick glance, the treatment may not reveal itself. The rhythmic alternation in sizes between the lines of type which are justified and well spaced is the remaining stylistic consideration. The single color, a matte metallic ink, lifts the type above the surface and contrasts the deep color of the bottle without being cheap and shiny.

Creuna Design Stein Øvre | *Oslo, Norway*

A slight deforming of the typeface creates a feeling of being frozen over with ice.

OCO Sparkling Sake Bottle

The OCO bottle contains a sparkling sake, a less rugged drink that requires a fresher presentation. The bottle declares that the beverage is made from "only the finest natural ingredients" in an all-uppercase centered setting of an extended, light-weight sans serif. The upper counters of the letters tend to be a little larger than those below—unlike strictly conventional forms—and the flip in balance lends a quirkily elegant flavor to the type. The focus of the label, though, is the OCO logo form that appears in the center, drawn in geometrically abstract strokes. The clean circular forms in black, together with the gold **8** form to the left, are bold and simple. Immediately above, a small metallic gold icon that appears to be an abstraction of rice grain—sake's primary ingredient—defines the center axis of the label's typography. The remaining element, the alcohol content, sits below the brand in a light sans serif.

Graph Co., Ltd. Issay Katagawa | *Tokyo, Japan*

Elegant detailing—a modern update of Old World styling—lends a stately strength and sense of tradition to the presence of this contemporary bottle (opposite, near left). Careful attention to the visual qualities of very different faces—in the choice of scripts for Sterling and Lager, for example, ensures variety as well as unity.

Sterling Lager Bottling

A more decorative, yet still restrained, typographic approach is evident in the Sterling Lager bottle. The metallic wrap around the neck contains the logo, derivative of old European brewhouse typefaces but having a cleaner, almost automotive quality. The forms link dramatically along the baseline, leaving the main strokes free of detail, save a thin edge line that lifts the type off the label. Along with a delicate script describing the freshness and quality of the ingredients, the typography recalls classic English packaging without being a direct lift of historical reference. Around the base of the bottle, an elegant black band, rimmed in silver, denotes the brew as a lager, in a similar elegant script face.

Cato Purnell Partners | *Richmond, Australia*

A fresh white label with minimal, simple black text and two metallic details speaks of the freshness of the contents.

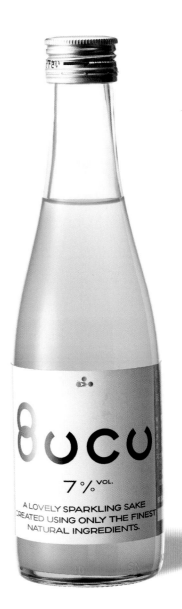

Symbion Project CD Packaging

A minimal, yet rich, typographic presentation gives identity to the packaging of this CD. A cold, neutral sans serif, reminiscent of optical character recognition forms scanned by computers, conveys a mechanistic atmosphere. On the front cover, the name of the band and the album are joined through a syntactic deconstruction, which is both visual and verbal. The **O** of the word "Project" is shared by the word "Immortal," expressing the essential quality of the word "symbionic"—mutually dependent. The typeface and the loose spacing of the letters are stately and austere, having a deliberate rhythm unexpectedly disturbed by the shift of the linear tittles off the stems of the lowercase **I**'s.

In stark contrast to the linear pattern of the type itself, abstract geometric elements—which have some typographic characteristics—are arranged across the cover and onto the back. Along the spine of the case, an open area reveals a typographic texture contrasting the sheen of the metallic ink and the flatness of the black geometric forms. The sleeve insert within the jewel case organizes the liner notes into a checkerboard of modules, in which the type alternately prints black or reverses to white from the silvery background. The justified text exhibits bad spacing and rivers, but in this case, the mechanistic quality of the overall presentation is compounded by this aspect of the type. Two sizes—one for song titles and a smaller size for credits and lyrics—clarifies the content but remains minimal in treatment.

Stoltze Design Clifford Stoltze | *Boston (MA), USA*

Ennio Morricone Remixes CD Packaging

The vivid yellow jacket for this CD is broken by random white rectangular inclusions and distressed type forms in black. On the cover, the type carrying the artist's name changes orientation between vertical and horizontal, configured in an angle in the lower left corner. Secondary type appears upward and toward the middle right, slightly askew. All the type is set in a sans serif face, mixing upper- and lowercase. Once the flaps of the case are opened, the random white rectangles become a housing for the lyrics and production notes, set in a small-size sans serif that alternates between bold and regular weight. The text paragraphs are rotated in various directions across the format, set against vivid yellow forms.

Factor Product Design Agentur | *Berlin, Germany*

Red Snapper CD Packaging

The cloth wrapper packaging—embroidered with the title typography—is irregular, leaves threads to cross over the letterforms, and unravel between the major elements, creating an additional element. Along with this industrial mistake, the typographic labeling on the exterior surface of the case consists of bar coding and OCR (Optical Character Recognition) type forms, as might be used in a supermarket checkout. Taken together, these typographic effects convey a conceptual message about quality and the role of technology and industry in everyday life.

Non-Format Kjell Ekhorn, Jon Forss |
London, United Kingdom

Right, a detail of the sleeve's embroidered typographic title.

The bar coding and OCR characters create a stark mechanical texture against the white case; the red cloth label contrasts in color and texture, announcing the CD to be a "lo-quality product" [sic].

RMK Cosmetics Packaging

Stunningly simple typography makes for an elegant solution in this line of skin care cosmetics. Each product is labeled with its name, set in a single sans serif typeface, all in caps, screen-printed along the center axis of each bottle's or tube's format. The letters of the product names are slightly condensed, distinguishing them from the brand, RMK. There is no other visible typography on the fronts of the packages.

Taku Satoh Design Office | *Tokyo, Japan*

The soap's transparent package is printed in white, which participates in the overall simplicity.

Clear plastic bottles display the color of their contents behind the minimal typographic treatment of the label.

In the Skin Tuner series (far right), each product level is coded with a colored serif numeral. The numerals are condensed to hold the narrow shape created by the vertical line of type.

In the Cleansing series (near right), the plastic of the bottles, rather than the contents, subtly changes color to differentiate products.

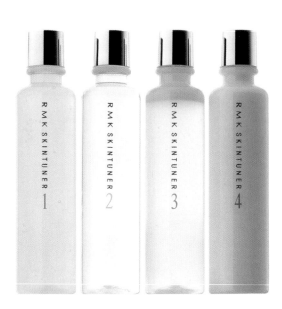

Project 5 Software Branding

The transparent package carries typographic branding and information while creating interesting design opportunities for the surface. The logo and typographic elements seem futuristic, deviating from traditional archetypes by exploring angularity, the junctures between strokes within letters, combinations of forms, and the extension of the letter bodies. The logotype is the primary visual element applied to the packaging, along with a symbol derived from the combination of the letter **P** and the number **5,** centered over the software product, which is visible through the box. Opaque fields of a lighter blue enclose portions of the box, adding to the interplay of spatial depth between surfaces.

Stoltze Design Clifford Stoltze, Brandon Blangger | *Boston (MA), USA*

Nestlé Wicked Ice Cream

A mixture of typographic styles, skillfully chosen for their individual rhythms with the intent of combining them, is dominated by the product name set in the center of the ice cream cartons. For the product name, a customized light-weight sans serif—oddly displaying a subtle contrast in the strokes of the letters—is selected. The designers have exaggerated the contrast, adjusted the letter widths, and added elements to the lockup to give the words more of their own character. Most notably, a crescent tittle has been added above the uppercase I, making the word more casual, and linking the word image to the photography of the ice cream ball in the background—shot against a dark background and lit from the side to resemble the moon. The nocturnal character of the image and the gothic quality of the type support the sense of wickedness declared in the product name.

Cato Purnell Partners | *Richmond, Australia*

Exaggerating the contrast in the strokes, as well as adjusting the widths of the letters for more variety—note the E—introduces a more custom presentation for the product name. Extending the leg of the K below the baseline also helps differentiate the logotype by breaking the horizontal line of the word sequence.

Under the product line, the flavor name is set in a decorative script with a great deal of contrast. Its sensuous curves and bloated, embossed quality are distinctly different from the main product name in its texture, and further communicates the decadent nature of the treat.

DiStasio Wine Bottle Labels

The labels designed for these wine bottles seem distinctly undesigned… and this is their charm. The bottles appear wrapped in half-sheets of ruled paper—like one might find in a student's school notebook—and written on by an unsteady hand. Actually printed, the labels do vary from vintage to vintage and between varietals. The author of the writing is unknown. Perhaps it is the patriarch of the family who bottles the wine, adding his name to the final product he taught his children to craft. Perhaps it is a small child who is only beginning to write, entering into an awareness of the family's business. Either way, the labels have a casual, friendly, and unpretentious feeling that speaks of good times with wines made by hand with love.

Gollings+Pidgeon | *St. Kilda, Australia*

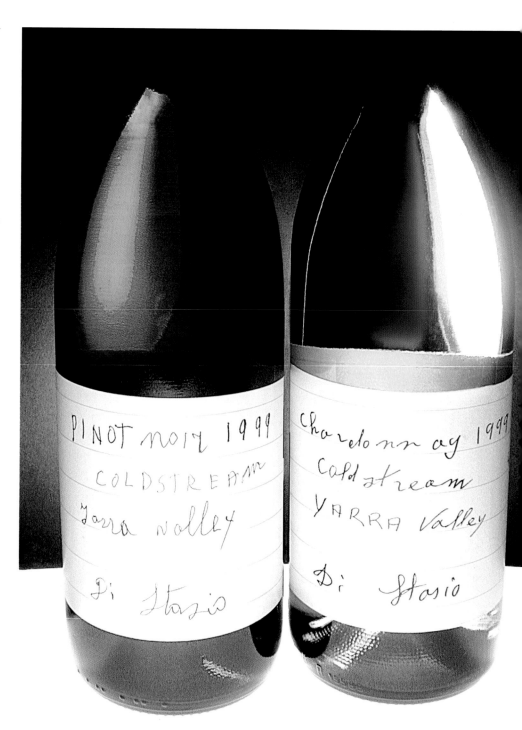

Callaway Golf Ball Packaging

This packaging system for high-performance golf balls focuses on a typographic symbol for the brand line, combined with an abstraction of one of the golf ball's divots, along with engineering diagrams and informational text. Along one side of the package, a lockup of large-scale letterforms in opposing orientation stands out from a linear texture of the divots. Another panel of the package carries features in uppercase—Tubular Lattice Network—in two languages, the primary engineering feature of the ball. The diagram type, reversed out to white from the clean blue surfaces in a strong sans serif set all uppercase, creates an active texture and evokes the image of blueprints. The diagrams describe the golf ball's feature characteristics that enhance its performance. Other packages in the overall system feature an embossed pattern.

Pentagram Woody Pirtle, partner | *New York City (NY), USA*
Photos: Chris Gentile

The outer carton wraps the interior smaller packages in the embossed texture of the golf ball. The blueprint-like diagram type on the packages alludes to the ball's superior engineering.

Index of Contributors |

About the Author

Timothy Samara is a graphic designer and educator based in New York City, where he divides his time between teaching at the School of Visual Arts, NYU, and the Fashion Institute of Technology; and writing and consulting through STIM Visual Communication. His design work focuses on identity development and information design for corporate and nonprofit clients, in projects spanning print, environmental, and digital media. He has taught and lectured at U·Arts, Philadelphia; Newhouse School of Communications, Syracuse University; Alfred University; Western Michigan University; Rensselaer Polytechnic Institute, Troy, New York; and SUNY Fredonia.

Making and Breaking the Grid, his first book, was released by Rockport in 2003, and is now in its second printing. Samara graduated a Trustee Scholar from U·Arts in 1990 with a BFA in graphic design. He lives in New York's Chelsea district with his partner of four years.

Producing a book of this kind involves a lot of busy people. My sincere thanks to all those designers who submitted examples of their work— assembling projects to contribute to a book like this is time consuming. Special thanks to those who participated in the short interviews that appear. In particular, many thanks to Philippe Apeloig, Dan Boyarski, Michael Ian Kaye, Giorgio Pesce, and Taku Satoh for their time in providing extensive responses to my questions. Additional thanks to the team at Rockport—Kristin, David, Rochelle, Silke, and Kristy—for all their help along the way.

This book is dedicated to Sean, who squeezes me and endures my long hours without complaint; to my parents, who always cheer me on; and to my wonderful friends Catherine, Lynn, and Greg. Last, but not least, I dedicate this book to all my students at SVA, FIT, and NYU.

Bibliography

Aldersey-Williams, Hugh et al | *Cranbrook Design: The New Discourse.* New York: Rizzoli, 1990.

Bosshard, Hans Rudolf | *The Typographic Grid.* Sulgen/Zürich, Switzerland: Niggli AG, 2000.

Bringhurst, Robert | *The Elements of Typographic Style, Version 2.4.* Vancouver, Canada: Hartley & Marks, 2001.

Celant, Germano et al | *Design: Vignelli.* New York: Rizzoli, 1990.

Dair, Carl | *Design with Type* Toronto, Canada: University of Toronto Press, 1992.

Gerstner, Karl | *Designing Programmes.* Teufen AR, Switzerland: Niggli AG, 1968.

Hiebert, Kenneth | *Graphic Design Sources.* New Haven, Connecticut: Yale University Press, 1998. | *Graphic Design Sources.* New York: Van Nostrand Reinhold, 1992.

Hoffmann, Armin | *Graphic Design Manual.* Sulgen, Switzerland: Verlag Niggli AG, 1998.

Jury, David | *About Face.* Mies, Switzerland: RotoVision SA, 2002.

Kinross, Robin | *Modern Typography.* London: The Hyphen Press, 1992.

Kuns, Willi | *Typography: Formation + TransFormation.* Teufen, Switzerland: Verlag Niggli AG, 2003. | *Typography: Macro- + Microaesthetics.* Teufen, Switzerland: Arthur Niggli Verlag, 1999.

Morrison, Stanley | *The First Principles of Typography.* London: Cambridge University Press, 1967.

Müller-Brockmann, Josef | *The Graphic Artist and His Design Problems.* Teufen AR, Switzerland: Verlag Arthur Niggli, 1968.

Noordzij, Gerrit | *Letterletter.* Vancouver, Canada: Hartley & Marks, 2000.

Ruder, Emil | *Typography.* Sulgen, Switzerland: Verlag Niggli AG, 2002.

Samara, Timothy | *Making and Breaking the Grid.* Gloucester, Massachusetts: Rockport Publishers, 2003.

Tschichold, Jan | *The Form of the Book.* Vancouver, Canada: Hartley & Marks, reprint edition, 2000. | *Die Neue Typographie (The New Typography).* Berlin: Verlag des Bildungsverbandes, 1928.

Tufte, Edward R. | *Envisioning Information.* Cheshire, Connecticut: Graphics Press, 1991. | *The Qualitative Display of Quantitative Information.* Cheshire, Connecticut: Graphics Press, 1991.

Weingart, Wolfgang | *My Way to Typography.* Baden, Switzerland: Lars Müller Verlag, 2000.